Birds
OF THE
WEST COAST

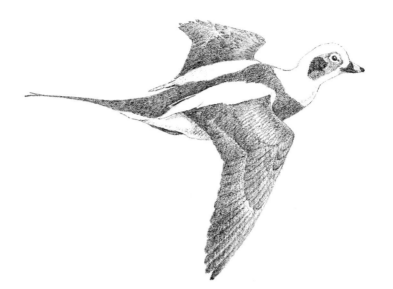

Paintings, drawings
and text by
J. F. Lansdowne

Foreword by
H.R.H. The Prince Philip,
Duke of Edinburgh,
K.G., K.T., O.M., G.B.E.

Birds
OF THE
WEST COAST

VOLUME TWO

Houghton Mifflin Company
Boston
1980

ISBN 0-395-29546-7
Printed and bound in Italy

Frontispiece: Oldsquaw duck, male. January 30th, 1980.
J. F. Lansdowne.

Contents

BUCKINGHAM PALACE.

Paintings of birds are works of art in their own right, but for those who like to go bird-watching they have an extra quality which makes a book, such as this one, a companion rather than a collector's item.

Any bird-watcher knows that magic moment when a long sought bird is finally seen in its characteristic setting. In certain rare cases the moment is made indelible by the particular qualities of the light, the background and the circumstances. Fenwick Lansdowne has the exceptional ability to capture such moments with a seemingly effortless assurance but which can only come from intimate knowledge, immense care and remarkable talent.

Fashions in art may come and go but the painting of birds goes on demanding the same qualities of perception and understanding, skill and imagination, yet the work of every bird artist remains unique. Other painters in other times may have painted the same birds with the same skill, but Fenwick Lansdowne's pictures will always reflect his own very special qualities.

Philip

1979

Introduction

The forty-eight birds in the following pages are all common, frequently seen species on the Pacific coast of North America. They may be found, each in its season and in its particular place, somewhere between British Columbia and California. Some of the more interesting or attractive birds have been chosen, but many others might have been included, for the variety of birds that occurs through the year is considerable. In all, a hundred species are shown in this book and its companion, but that is less than a third of those it is possible to see and perhaps fewer than might be encountered in a good day's birding. Together the two volumes of *Birds of the West Coast* present a picture that should be considered more as a rough sketch than as a portrait.

The coast, as a meeting place of two distinct environments, those of the sea and of the land, is richer in bird-life than either one alone. Not only does each have its own properties and specialized denizens, but at the point of their coming together these elements form a third environment, the shore. This ribbon-like, intertidal zone, so narrow and so straitly bound, supports an interesting fauna of its own that includes birds not found elsewhere throughout most of the year.

Differences in climate and topography between the northern and southern extremities of the range covered by this book ensure a further diversity and the comparatively mild overall temperatures allow an ever-changing but constant abundance of species. The north Pacific is host to millions of seabirds: shearwaters and dainty, wave-walking petrels at times cover the surface of the water, while murres, puffins and their auk relations find limitless food in the frigid seas. In spring, these birds come ashore to nest on the gale-whipped, bleakly unapproachable outer coast. Cormorants hang their wings out to dry from Alaska to Mexico and breed in rocky, reeking colonies that form a broken chain thousands of miles long.

The northwest is a stronghold of the scarce Peale's falcon, a dark-plumaged race of the peregrine that builds its eyries on sheer, Queen Charlotte cliff faces and preys on murres and auklets. In dark-walled, deep fjords the bald eagle may still be seen as plentifully as it once was on all the waterways of the continent.

Small land birds are here, too, and in spring and summer there are many nesting songbirds, particularly in the more southerly regions not covered by a mantle of coniferous forest. The warblers and some other small birds depart in fall for Central American wintering grounds, but though these little passerines are absent then, winter is perhaps the time of the greatest concentration of bird-life on the coast. At this season the waters of California, Oregon, Washington and British Columbia are the resort of countless waterfowl that arrive to take refuge from the inhospitable conditions to the north and east. Virtually all the diving ducks that have bred in the western Arctic, as well as fresh water species and grebes from the interior, arrive in autumn and remain until the following spring.

Other species are only spring and fall transients, passing along our shores to and from their winter retreats in Peru or Patagonia. For a few hectic weeks each year they are all with us, winter visitors and birds of passage alike. Geese and ducks and loons move by in arrows and files offshore, while little waders sweep the beaches, temporarily the companions of herons and gulls on the sands and clam flats of the coast.

On an early trip through the western states, I fell in love with the California coast and most of all with that part lying north of San Francisco. I knew little about it beforehand, and with preconceptions of a dry "Spanish" landscape that in reality belongs farther south, had my head filled with desert birds and missions. I found instead a surf-wreathed, green and broken coastline which entranced me. Along the exhilarating, vertiginous sea slopes of Mendocino I gave my heart to the pelicans standing on the sugar-loaf rocks. Their carven profiles were as bizarrely exotic as African tribal masks, and I have loved them ever since.

At the same time was formed my attachment to Point Reyes. That mist-enshrouded and rather eerie peninsula was, when I first came upon it, dripping, green and thickly wild-flowered; it seemed to me then, as it does still, an elemental and deeply beautiful place.

Those early experiences were really the origins of this volume of *Birds of the West Coast,* and my excuse for doing a second when, in the opinion of others, one may well have been enough; I have pictured a few of the most striking of the birds whose acquaintance I made those twenty or more years ago. All the paintings began as images of actual birds and situations I have come across at one time or another and are attempts, though very imperfect, to convey at least something of the essence and beauty of the birds as I saw them. To do them justice a dozen volumes such as this and a far greater ability than mine would have been required.

Paintings

1 Red-necked Grebe

Podiceps grisegena holbollii

When I first started to know the birds, I knew this species as Hollboell's grebe, although only from my books. In Taverner's *Birds of Canada* there appears a pen and ink drawing of two heads, summer and winter, and to me that illustration represented the bird, for it was not until later that I saw one or rather, perhaps, recognized what I saw.

Now that I am a little better at identification, I know this stocky diving bird for what it is, a common winter visitor that nearly always may be found feeding with the miscellany of marine birds just offshore. It is midway in size between the delicate, little eared grebe, which in winter it somewhat resembles, and the big, rakish western grebe, but it is less fond of company than either. Whereas eared and especially western grebes are usually with others of their kind in loose but apparently happy association, red-necked grebes keep to themselves. They travel singly and stay close to the water. Only when migration is imminent do they lose some of their reserve and then may be seen a dozen or so at a time or sometimes, according to some naturalists, in much larger flocks.

A few days ago–it is early April as I write–I turned my glasses on some red-necked grebes that were passing an easy morning on the murky waters of Victoria's Inner Harbour. Close under the stern of the Seattle ferry that loomed cliff-high above them and around the docks of sleek, berthed pleasure craft the grebes hunted or idled at buoyant rest. They seemed indifferent to the activities of the harbour going on about them; a float-plane churning a wake across the water scarcely moved them from its path. The forces of spring pulsing through them, changing their bodies internally, were already altering their outward appearance, so that the drab greys worn for months were now being replaced by the ever more clearly defined patterns and strong colours which are the mark of the breeding season. Supple necks, while not yet the hot mahogany of June, were tinged unmistakeably with reddish brown, a promise of summer elegance.

This is the time that many species feel the urge of migration and prepare themselves for the annual journey of return on which each bird contends against uncalculable dangers as it homes unerringly to the place of its nativity. This ancient restlessness draws red-necked grebes from warm southern California waters, from sheltered bays of the Oregon coast and still fjords in British Columbia to the rich and teeming marshes of the far interior. Their young will be raised on a thousand lakes and sloughs and on slow-running backwaters of streams from Alaska to the Great Lakes.

They are quiet birds, except in summer, when they find their voices and make up for months of reticence. Then their notes carry far, and although red-necked grebes are notably shy birds and generally in reedy concealment, their presence is revealed by the brays and wails that are their love song. At the peak of seasonal excitement the cries continue throughout the long hours of summer daylight and into the night, with evening a time of particular activity.

Red-necked grebes build nests resembling those of others in the family, that is, islands of vegetable flotsam lightly anchored to growing plants. The nests are about two feet across and a few inches high with a slight central depression to hold the clutch of four or five whitish eggs. At the least alarm, the incubating bird will stand up and with rapid flicks of the bill cover the eggs with weed and bits of material from the nest. All in a moment it has happened, and she has slipped off with no ripple to betray her going.

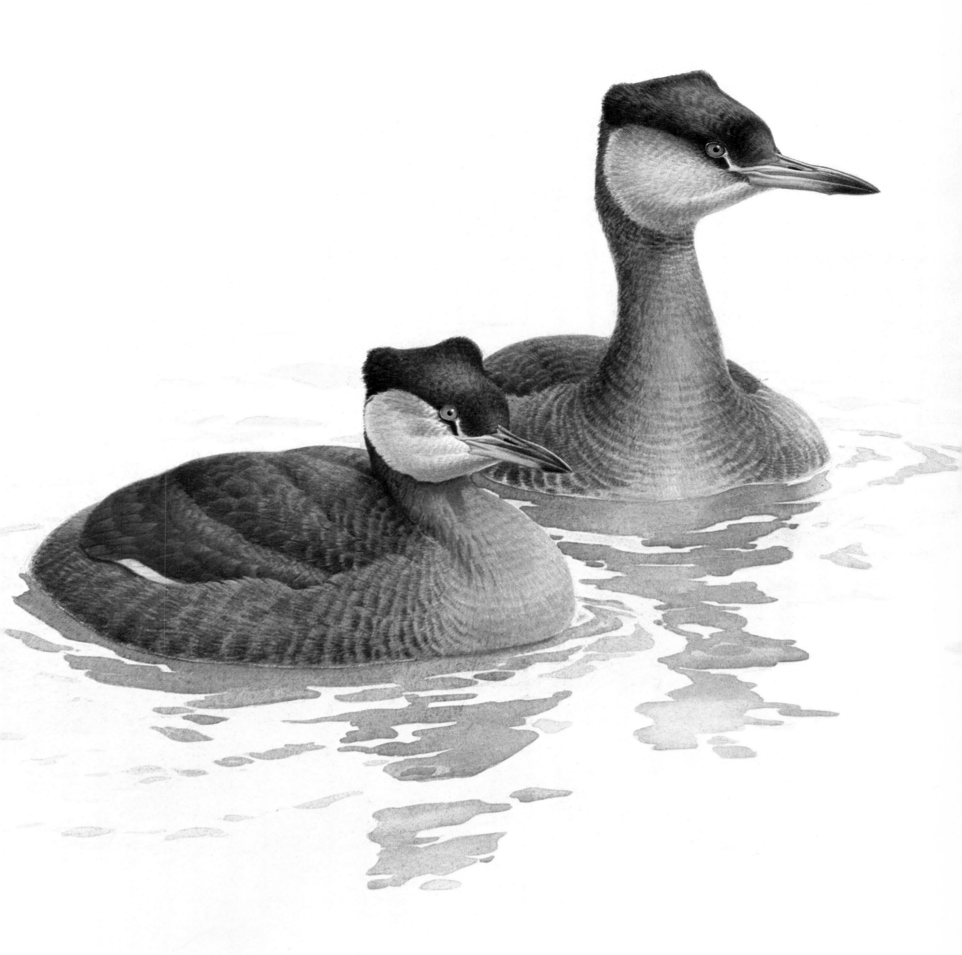

2 *Eared Grebe*

Podiceps nigricollis

Eared grebes are very much a part of things along the coast in winter. They are slim-necked birds, quite small, with straight bills and abbreviated bodies that are practically without tails.

Of the five species of grebe that winter with us, the eared and horned are the most numerous. At the onset of cold weather thousands abandon the soon to be ice-covered bodies of fresh water inland for the more hospitable marine environment. At this time, when not in breeding plumage, the two species look enough alike that inexperienced birders may have difficulty telling them apart. On closer acquaintance, however, several differences become apparent: there is a generally duskier colouring in the eared grebe and its carriage is different. Also, in this species the bill has an upward-angled appearance, whereas in the horned grebe it does not.

Grebes must run along the water to rise and are unable to take off from dry ground. When airborne, however, they are strong fliers and have no difficulty on long migrations unless they should mistake a wet road for water and attempt a landing. Awkward ashore, it is for an aquatic life that these birds are designed. Beneath the water's surface, the grebe's satin-feathered body becomes as sleek as that of a fish. With wings to aid the rapid and powerful strokes of the feet, they are tremendously agile and swift.

Early in the year, eared grebes start to shed their sombre winter plumage and to assume the striking appearance of spring. By the beginning of March, they are well into the moult, and for me it is a pleasure to note the grebes' changing and to know that nature is still ordering the seasons as she should. As the birds acquire full nuptial dress, they are transformed. Now they are quite unlike their muted selves of the short, dark days. With crested heads and black necks, chestnut flanks and amber cheek plumes, these elegant creatures are ready for courtship and migration.

The grebes then leave their winter retreats and start the overland journey to the western plains. From California, British Columbia and points in between, they follow aerial paths over the mountains, stopping along the way to rest, feed and indulge in the rituals of choosing mates. By the time they have reached their destinations, the pairs have formed for the season.

There is much calling, for all grebes on their breeding grounds are noisy birds. As spring advances into early summer, the innumerable ponds and sloughs that dot the fabric of the plains are loud with the voices of toads, frogs, insects and marsh birds. Reaching a crescendo as twilight falls, the cacophony of voices is swelled by the rising, two-syllable cries of eared grebes.

This species has a liking for colonial breeding, and its communities may be quite extensive. The nests are closely packed in places and clustered where wind-driven plant matter has caught in the reeds. The grebes' floating, lightly anchored nests are similar to those made by a number of birds as an adaptation to life in the marshes where the water level may fluctuate. A certain freedom of movement saves the precious eggs from fatal inundation or from being left high and dry to bake in the sun.

Young eared grebes are small and dark with a pattern of broken streaks and dots. Taking to the water very soon after hatching, they are almost the equals of their parents in swimming and diving. When danger threatens, or simply when tired, they scramble onto their mothers' backs and can be seen with their heads poking out from the feathers, riding in ease and safety.

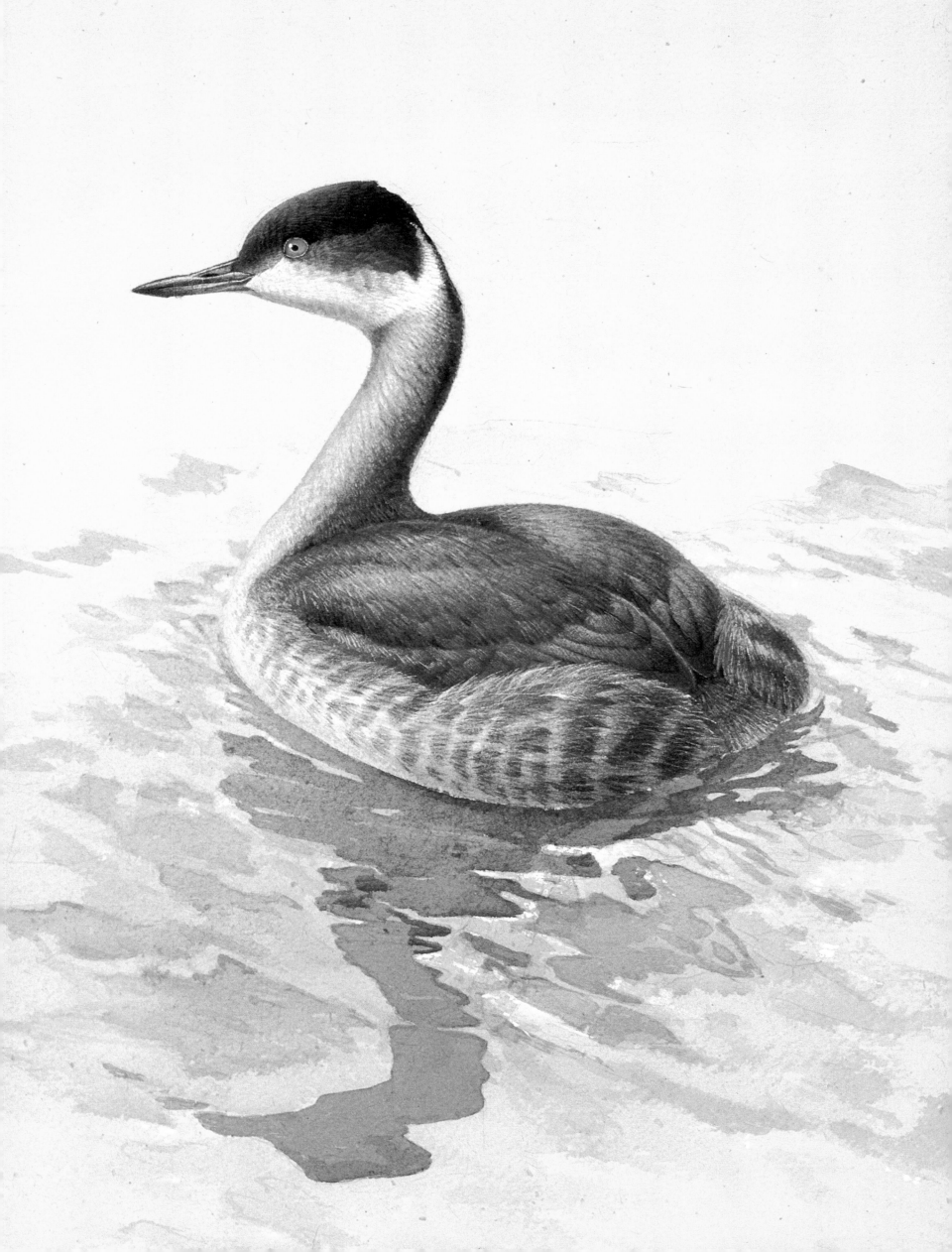

3 *Brown Pelican*

Pelicanus occidentalis

How ungainly the brown pelican seems and how comical the solemnity of its features! "Grotesque" is a word that comes irresistibly to mind and appears often in descriptions of this bird, as in A. C. Bent's voluminous *Life Histories of North American Birds* that refers to the pelican's "grotesque, quiet dignity". In *The Birds of California* by Dawson, it is summarized as "this uncouth Adonis of the oceanfront".

Although its humorous aspect is undeniable, the pelican is not one of nature's jokes but a fine illustration of the old dictum, "Form Follows Function". A brown pelican is a formidable hunter, whose angular frame results from adaptation to its way of life. In such a light, this apparently ill-made knight of the air is seen to be beautiful, eliciting not only smiles but admiration, too.

There is something immensely impressive about brown pelicans in flight. Beyond the thunderous surf of a California beach and low over the water, lines of these deliberate birds heave into view on labouring, eight-foot wings and pass silently into the distance, their great size dwarfing other seabirds. There is about them an inexorable grandeur that always thrills and leaves me awed.

I became acquainted with these cousins of the cormorants and gannets at Point Reyes, north of San Francisco. Always in my mind will they be associated with that time-forgotten and fascinating place, although brown pelicans are more characteristic of the southern regions, the lower California coast and of the strange islands of the Galápagos, where they breed in sprawling colonies. I have known them farther north and have watched them wheeling and diving beyond the bar at Bolinas or as they beat the length of Tomales Bay on their way to some favoured fishing spot. They appear in squadrons and small formations, heavy bombers on silver, black-pinioned wings, searching for their targets. Sighting fish, they brake and bank sharply, peeling away downwind and, like collapsing umbrellas, fold up and plummet. Columns of spray rise as they strike the water.

Capturing prey is one thing, keeping it another. I once watched pelicans fishing off the Eureka fish wharf in California: the great birds flopped and splashed, while around them hovered rapacious Heermann's gulls. After a catch, the pelicans rested briefly on the surface, opening and tipping their bills as they must to drain away the gallons of water in the distended gular pouches. As each pair of long, clapper mandibles opened, the smoke grey gulls darted in with greedy, scarlet beaks to grab and gobble the hard-won fish before the pelican could swallow it.

Pelican colonies are noisy, ramshackle and smelly places. The ground-built nests vary from rudimentary gatherings of twigs and rubbish to more carefully made structures a few inches high, also composed of twigs and rubbish. Importunate young, not beautiful at any stage of growth, scream and gape before the darker, handsomely marked adults, begging for meals. Parents freshly arrived from fishing open wide their pouchy bills and let homely offspring thrust heads, beaks and all, down the proffered gullets to feed. Very young pelicans are given a more completely predigested mixture than the older birds who are able to manage whole or nearly whole fish. They are almost always fish of kinds that people find undesirable. Pelicans eat little else.

It takes up to three years for a brown pelican to mature, and in that time several plumages are worn, although the differences between them are not great. A fully adult bird of either sex in breeding plumage has the chestnut to black neck shown in the painting, as well as yellow feathering on the crown and breast. These parts become white in fall and winter. The young birds of the year are plainly dressed in drab brown with white underparts and do not begin to assume the silver-grey body plumage until sometime in their second year.

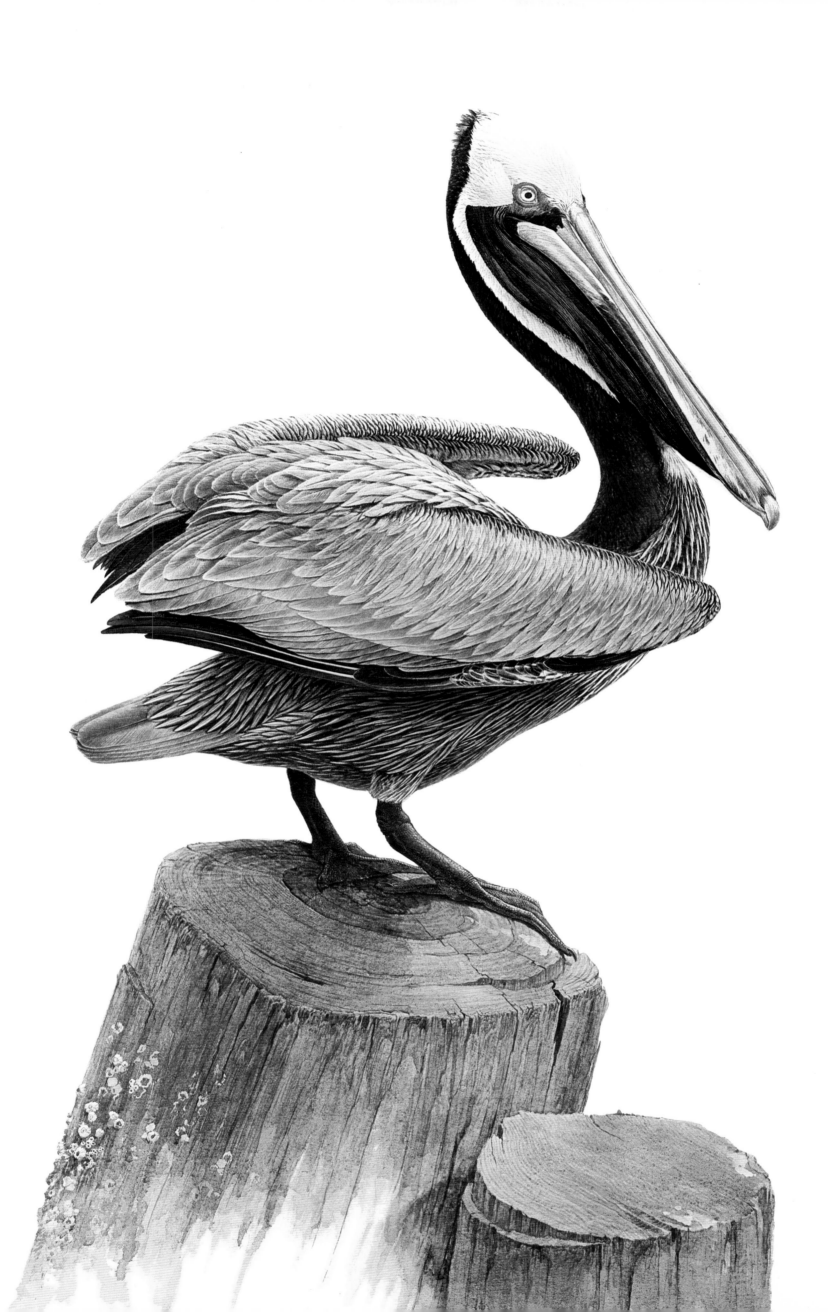

4 *Baird's Cormorant*

Phalocracorax pelagicus resplendens

When travelling the road along the magnificent coastline of the Pacific states, one sees at intervals offshore rocky islets that gleam whitely in sunlight or mist. Precipitous and barren, they long ago were carved or split away from the mainland to stand in stark isolation and to my romantic mind seem like citadels or the fortresses of ancient times. They are the breeding places of countless seabirds, whitewashed seasonal cities of murres and puffins, loud with the cries of gulls that are both marauders and colonists.

Here also, Baird's cormorant, a race of the pelagic cormorant of higher latitudes, nests in large numbers. It is the smallest and most graceful of three species living on the west coast south from British Columbia.

At a distance, cormorants appear quite black but close at hand reveal themselves to be beautiful and far from colourless. In high plumage, the glossy feathers of the head and body are shot with rich greens, blues and violets, in contrast to the bare-skinned face of scarlet. With good reason is this bird named *resplendens,* for it is a very handsome species and becomes more so in spring with the addition of white filamentous neck plumes. Fully mature birds also display white flank patches that, together with the double fore-and-aft crest, proclaim their identity.

In the nesting communities, the species keep each to each. Puffins and murres have different preferences in housing, as do cormorants and guillemots. Murres, little, formally-clad figures, line ledges or stand about on level ground as though waiting for a party to begin, while puffins stand like plumed sentries before their burrows.

Cormorants, their necks upstretched in vigilence, appear as inky verticals against the streaked and whitened rocks. These birds build bulky nests of grass, seaweeds, sticks or moss which may be placed at considerable heights, or near the tide line, and generally on the steepest, most inaccessible slopes. Advantage is taken sometimes of shallow sea caves or grottoes that afford partial protection for nests and young. The number of eggs is usually five to seven and their colour a simple white or greenish white.

Cormorants live almost entirely on fishes, which they pursue to surprising depths. Baird's cormorant dives deeper than most, and the northern form is said to have been netted more than four hundred feet below the surface. They also catch their food near the surface and can be seen hunting in shallow water near shore. With heads and all but their backs submerged, they present a strange appearance as they course back and forth.

A more spectacular method is used in the packed and confused congregations of excited birds that are a familiar sight to all who fish or go boating on the waters of the northwest. The cries and awkward plunges of gulls that have found a herring shoal near the surface attract other birds. Murres come to feed on the outer fringes of the turmoil, and skimming the sea from every direction come cormorants whose reptilian sea-green eyes have marked the sudden activity. The numbers that soon arrive are amazing, and in a short while the water for yards around is churned to froth by the shining, frenzied bodies and flailing wings.

Soon the glinting horde seeks safety in the depths and the water grows smooth as the birds disperse. The cormorants return to their vantage points once again to stand in angular repose with wings spread and drying.

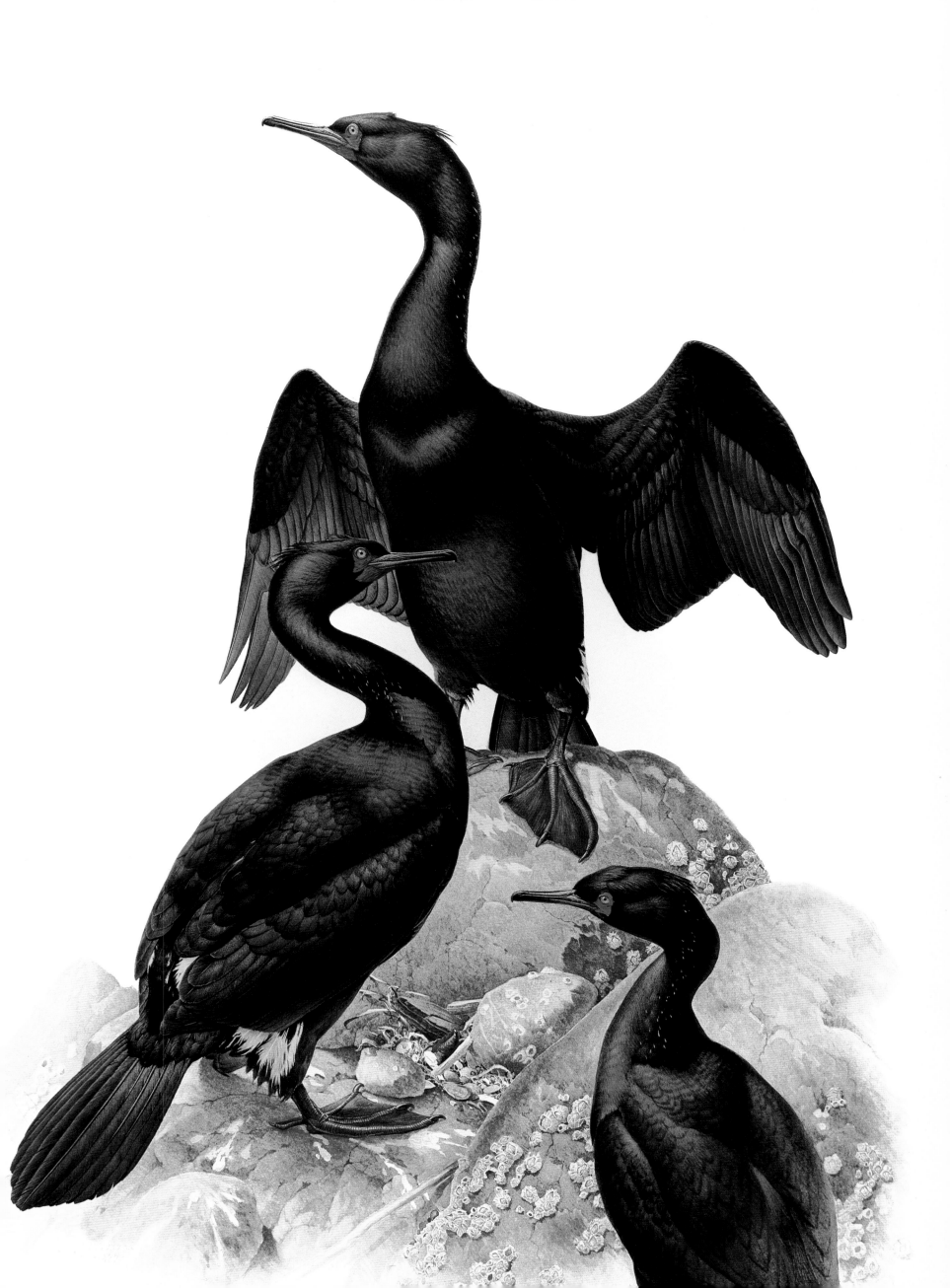

5 *Great Blue Heron*

Ardea herodias

People quite often ask how I think of postures and actions for the birds I paint. My answer is that sometimes these things suggest themselves but frequently they are taken from memory and reflect real encounters with birds in the field. In this way, the heron painting was done; a bird I saw crouching against the force of a biting January wind impressed itself on my mind so much that its image stayed with me for months. When the time came for the picture, my pencil drew it as if from life.

That heron on Vancouver Island was part of an essentially west coast landscape. The rain-filled skies and leaden water, the salt marsh's tattered, faded grass and bleaching driftwood could all have been seen in a hundred places from British Columbia to California. In this northwestern part of America, great blue herons lend mood and atmosphere to the country. They are plentiful here, too, despite the overall depletion of bird life that is apparent everywhere. At times I have come across twenty or thirty of these tall and angular birds stalking gauntly through tide pools or over the muddy sands of an estuary.

Being found mostly in marshes, rivers or at the sea's edge, this species relies heavily on water as the source of its food. Part of this food is fish. Herons most frequently eat coarse species that are of little interest to man, although they have been accused of destroying trout and other game fish. Their taste in other prey is not narrow, however, and all sorts of things from frogs and tadpoles to snakes, small birds and mammals are known to be part of their diet.

Sometimes herons resort to summer meadows to hunt voles and mice and also to catch insects that fly up before them from the grass. With inexhaustible patience they will stand motionless and poised, tension described in every line, as they await their prey. Sooner or later a lightning-fast jab of the bill will transfix some squirming, hapless thing that is shaken quickly and gulped down. Sometimes its size is greater than the bird's ability to swallow, and there is much thumping and hammering to reduce it to edible proportions.

Spring finds herons gathering at certain traditional and long established sites. These are the colonies where, in massive nests of sticks many feet above the ground, they hatch and raise their young. In old, large heronries or "rookeries," as they are usually and inaccurately called, there might be a hundred pairs or more nesting in a small group of trees. Every tree bears its burden of many, and each season new sticks and new linings are added to old structures that in time become very compact and heavy.

Herons breeding in the northwest usually seek stands of conifers well away from any possible disturbance, although recently I saw a settlement in an alder wood. In this part of the herons' extensive range, the colonies contain no admixture of other species. Farther south, however, great blues nest in the company of black-crowned night herons in much noisy confusion.

Each pair of herons may raise and bring to nest-leaving age three or more chicks and these, in all stages of activity, contribute much to the general liveliness. Nestlings, tousled and of homely aspect, clamber reptile-like with wings, bills and feet over worn and whitened branches and among the nests. Some have fallen from their own homes, some merely have gone exploring. Repelled with savage thrusts by strangers and often by their own nest-mates, they not infrequently fall to the ground and perish. The more fortunate stay-at-homes are fed by both parents and thrive on regurgitated food. Later, they are given whole fish, and by the time they are ready to depart they can fend for themselves.

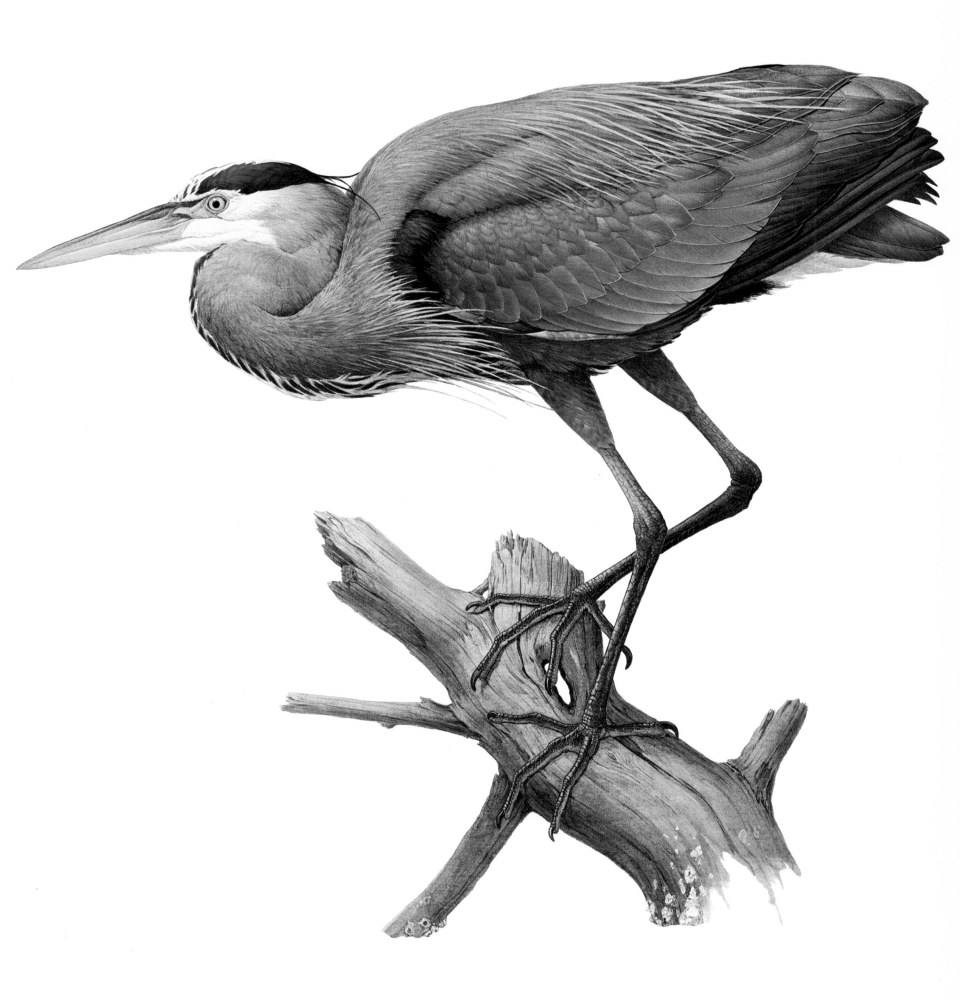

6 *Great Egret*

Casmerodias egretta

The great or American egret or common egret, as it has been known at various times, is one of the most strikingly beautiful of the herons. Its main areas of distribution are in South and Central America, but it is inseparable in our imaginations from the steaming mangrove swamps of the Everglades and the miasmic marshes of the southland generally where it is plentiful.

In the west, inhabiting a less lush and humid environment, this leggy, javelin-billed stalker of frogs and fishes breeds from California to Oregon and lately has been seen with increasing frequency in British Columbia.

As well as being the largest of the egrets, notably bigger than the golden-toed snowy and the immigrant cattle egret, the great egret is also the slimmest and most lightly built. The neck of this bird is extraordinarily long, and as it carefully paces through shallow waters or lifts its broad wings to sail deliberately away, we can see that its body bulk is very meagre.

"Egret", the name by which this and other white species of heron are known, is derived from the long plumes or "aigrettes" that in the breeding season so splendidly adorn their plumage. The story of the nineteenth century plume trade, its persecution and near-annihilation of the white birds and others is well-known and needs no repetition. It was the great egret that suffered most severely and whose image became the symbol of the Audubon Society that was formed to protect it.

I have admired these angular yet graceful birds in the marshes and lagoons of the New Jersey coast and have often seen them feeding in the dark waters of tree-shadowed pools and shallow inlets in California. Great egrets are not as big as the more robust great blue herons that sometimes fish beside them, but their brilliant whiteness makes them seem at least equal in size. When perched against the foliage of a bank of trees, their degree of visibility is high.

I have never been lucky enough to visit their crowded breeding grounds, nor have I seen them in the full nuptial finery which is flaunted during courtship. Much has been written by naturalists in description of the dancing and sparring of the great egrets as they court their mates or contend with rivals at this season. The back and breast plumes that were nearly the cause of their destruction are raised and spread to form misty halos about their bodies as they raise their wings and stretch their necks in threat or greeting.

The nests of this species are built either at a considerable height above the ground on the branches of trees or, if these are not available, on the bent and down-beaten stems of reeds and rushes. They are usually rather ill-made affairs of sticks, shallow and flimsy, yet individual abilities vary and some egrets construct firm and well-lined nests.

In Florida and the southern states, in countries where herons are more numerous than in the west and where spoonbills, ibises and other long-legged birds occur, the egrets nest in company. These communities are loud with the voices of the parent birds and later with the squawks and cries of growing young. They are also malodorous and dirty, for the fish and other things that are fed to the nestlings by regurgitation are often dropped or vomited.

The great egret lays three or four eggs that are incubated by both sexes.

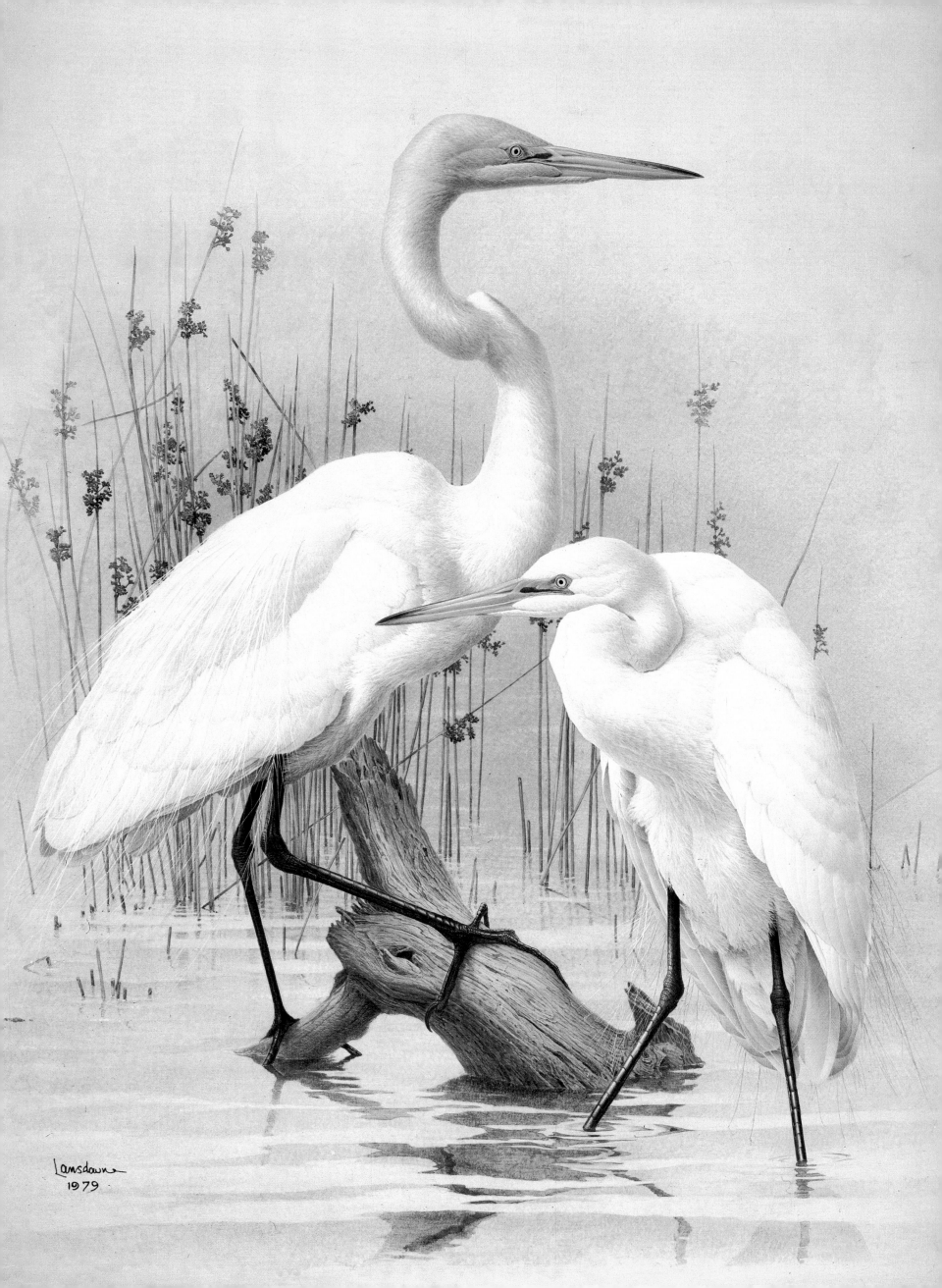

7 *Trumpeter Swan*

Olor buccinator

Most impressive of all waterfowl are the swans. Majestic and much larger than their relatives the ducks and geese, their dignity of bearing and simple beauty set them apart from lesser birds. "Swan" is a word imbued with ages-old connotations of physical grace and elegance. It is not surprising to find that in the myths and legends of many peoples swans are mentioned frequently and often play important and supernatural rôles.

Two species are native to North America, the whistling swan and the larger and much less numerous trumpeter swan, biggest of its family and named for the sonorous bugle notes of its call. When settlers opened the west and wildlife fell to the guns of pioneer men as trees fell to their axes, trumpeters underwent a degree of persecution that quickly became disasterous. Being so large and noticeable, they were shot whenever they were seen. They provided food for the table, at least the young birds did–the old were too tough–while the mature swans, weighing more than thirty pounds, made irresistible targets and splendid trophies.

Before Europeans arrived, trumpeter swans could have been found to some extent over the entire continent from coast to coast, yet the west has always been their true home. Although it seems likely that they were never as plentiful as whistling swans, they may have bred in the region of the Great Lakes and in some of the eastern states. Early mention of what were likely birds of this species was made by Dutch and English colonists, indicating that they were not unfamiliar with the "trompeters", and could distinguish between the two species.

Several things helped to account for the slaughter and drastic decline of these birds, most of them attributable to the greed or ignorance of man whose hands are so often bloody in matters of this kind. Patterns of behaviour exhibited by these swans: their habits of travelling in small parties and family groups and of frequenting certain places, made them more vulnerable to hunters than were the wilder whistling swans that flocked on open water out of range. Such factors, combined with a profitable demand for swan's down, very nearly pushed these birds into the abyss of extinction.

By the end of the nineteenth century they had become very scarce. A decade or two later they were listed in one bird book under the heading "Extirpated Species" and had disappeared entirely from the east coast, the Mississippi Valley and the Gulf States. In Wyoming, Montana and the Canadian west, all places where they had formerly bred, they were practically unknown.

After the Migratory Bird Treaty was signed, persecution of trumpeters abated and although their numbers were down to a very few, almost to vanishing point, the decline was stayed. Careful protection in several refuges has brought the population back to between one and two thousand birds, so that it is again possible to see and understand a little of what naturalists such as Audubon described with such eloquence and admiration.

As snow and cold descend upon their breeding grounds, trumpeter swans undertake a limited migration, rather less extensive than the great southward journeys of their cousins, the whistlers. Trumpeters mainly travel in search of open water and good feeding conditions; while some head westward to the coast, others stay on in the continental interior and endure the low temperatures, provided they can find what they need. For many years a lake in British Columbia has been the winter home of several hundred trumpeter swans. There, magnificent birds in a beautiful setting, they return to be fed by the family of people who have been their guardians for two generations.

On Vancouver Island, trumpeter swans are present every year. They seek the river mouths and feed on the tidal flats where, against the sombre colours and tawny shades of grass, they seem very large and very white.

The nest of this species is a raised mound of vegetation with a grass and down-filled depression wherein the eggs are laid. As many as eight small, greyish-white cygnets may be hatched, although it is usually only three or four that leave with their parents in the fall. A summer's perils and misfortunes account for the rest.

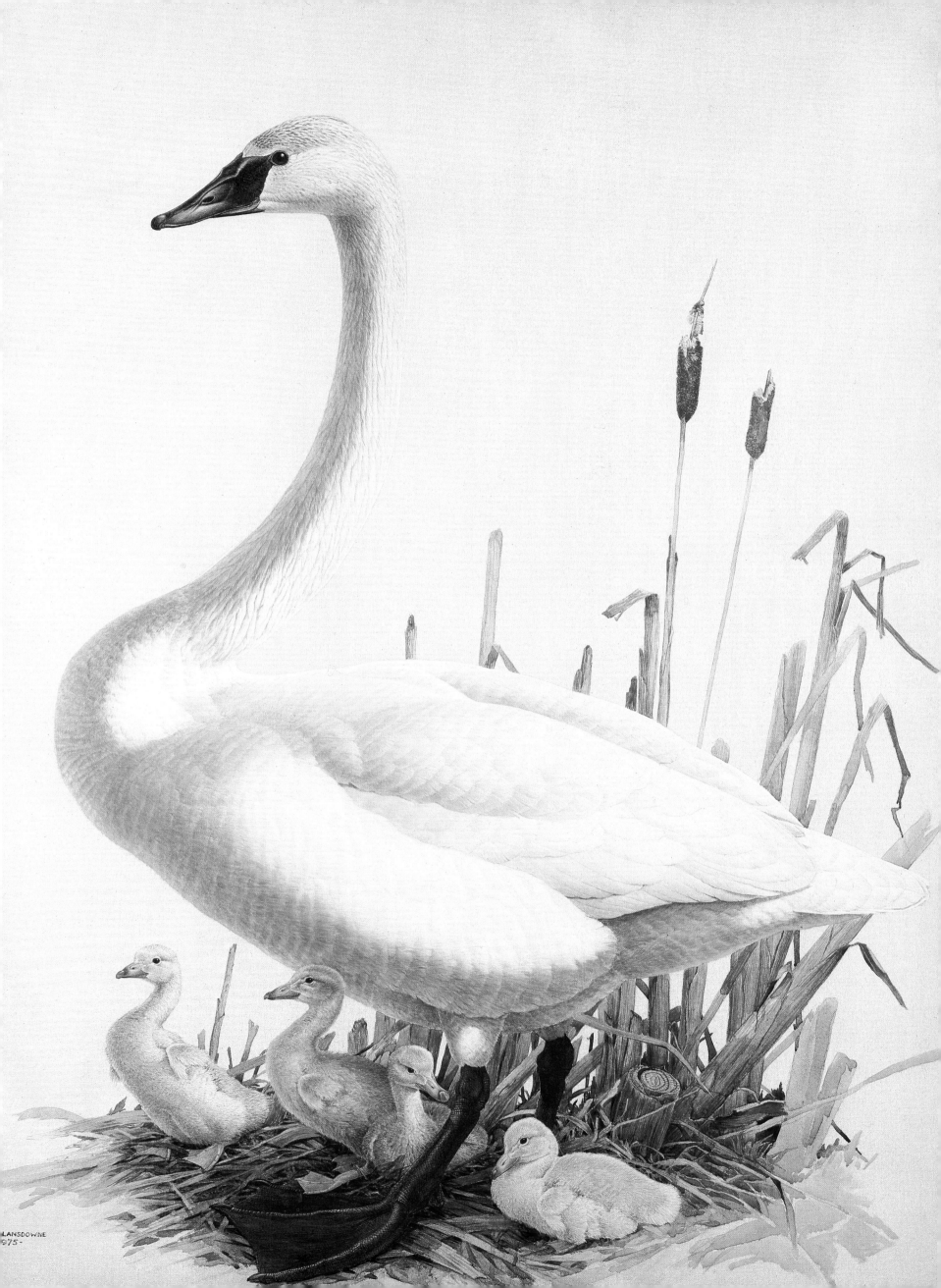

Cackling Goose

Branta canadensis minima

The Canada goose is a wintering or breeding bird in practically every part of America from the treeless barrens above the Arctic Circle to the Gulf of Mexico's humid coast.

It is divided into several well-defined subspecies that occur over a large area and are to be found in many different kinds of habitats. All are recognizable by their "black-stocking" necks and white cheeks as being Canada geese, but in size and relative proportions there are great differences between them. Ornithologists are not agreed on how many races there are, but in his *Waterfowl of the World* Jean Delacour recognizes twelve, from the "giant" Canada goose, weighing as much as seventeen or eighteen pounds, to the diminutive cackling goose, smallest of all at between three and four pounds. These two races of a single species are respectively the largest and the smallest of geese.

Colonial nesting and strong ties within the family help to prevent interbreeding between races, despite there being, in many instances, no geographical barriers to separate populations. These birds mate not merely for a few months but for life. The young of the year remain with their parents throughout the first winter, returning with them in spring to the breeding grounds. In the avian world, where seasonal pairing and a fall dispersion of the young are general rules, this family closeness is an unusual thing.

In a sort of regular progression, Canada geese become larger from north to south and darker from east to west. From these facts it may be deduced that the cackling goose that nests on the western shores of Alaska is not only the smallest but also the darkest of the races. This is so, and in plumage the pale sandy browns of south-eastern birds are replaced in the north-west by saturated shades of tawny and umber overcast with a purplish sheen unique to the race.

The cackler is a pretty little goose, hardly larger than a duck and more delicate in appearance than its rangy, long-necked relatives. It is a toy Canada goose, for miniaturization has changed its proportions and given it a shorter neck and a little bill as well as a more compact body. A consequence of the short neck is a shorter windpipe that produces a higher voice than is found in other subspecies. The notes have been rendered in words as "luk luk," high-pitched and rapidly repeated. As well as this "shrill honking," as Delacour calls it, there is a cackling call which gives the bird its vernacular name.

Migrating birds appear on the northwest coast in fall. The young are not ready to fly until well into August, and it is somewhat later that the first south-bound travellers arrive among us. The records I have are mostly for November in southern British Columbia with a few much later, indicating that some cackling geese settle in for the winter where conditions are right. Most, however, press on toward the great wintering grounds of California, where huge numbers of geese of several species gather on the land of the flat, central valleys. More than one race of Canada goose may be found there, but in general there is no indiscriminate mixing, though they may mingle with other species such as snow geese.

Cackling geese build the slight, down-filled nests typical of their family, choosing spots near water, perhaps on stream banks or among clumps of fragrant grass near ponds. The ganders are belligerent toward rivals during courtship, and later both they and the females display the same quality in defending their nests and young.

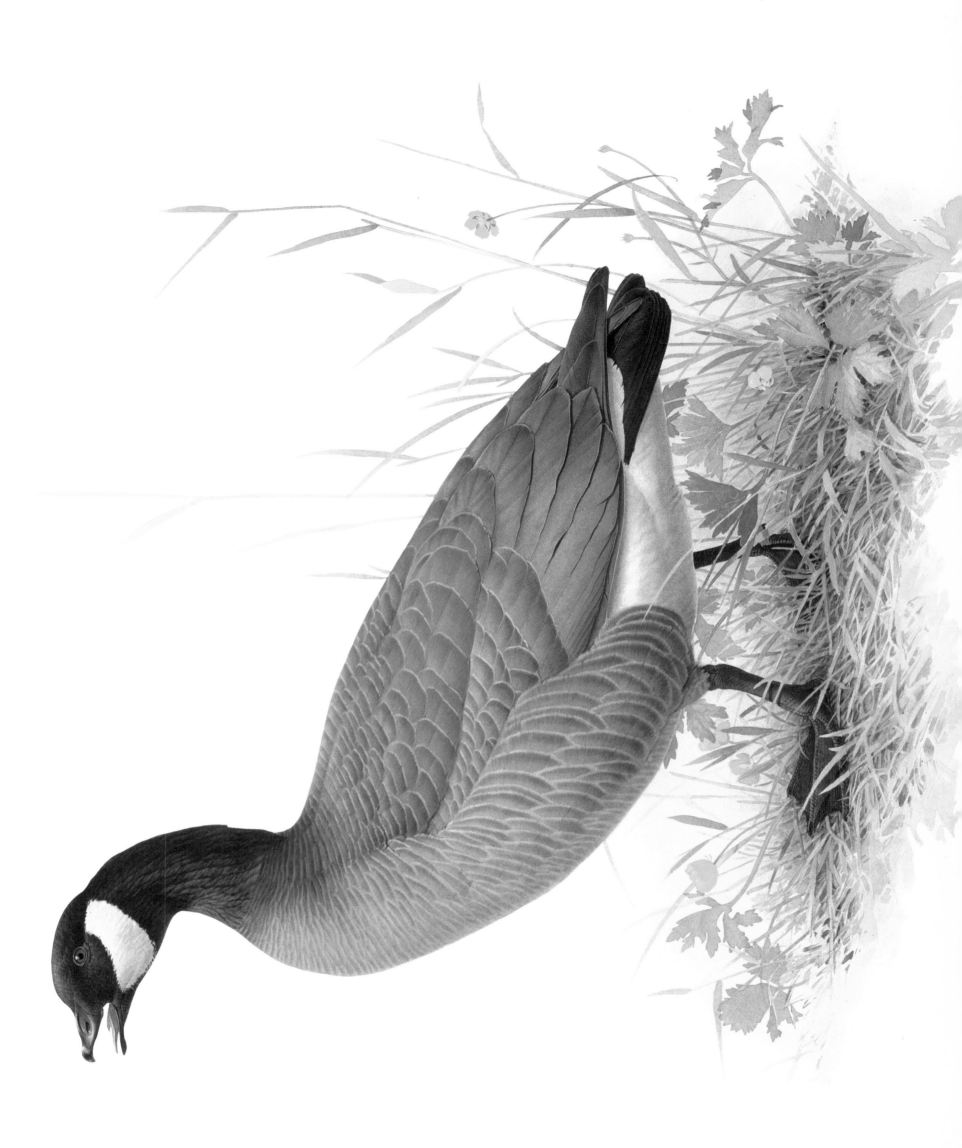

9 Snow Goose

Chen caerulescens

There is nothing so evocative of the wilderness as migrating geese passing overhead. The gabbling voices that come down to us are a wild and eloquent music, and in the passage of the wavering skeins that trace patterns across the skies of fall and spring there is something that stirs the heart of everyone.

Perhaps the most beautiful of the geese on this continent, certainly the most abundant, is the snow goose. Its nesting grounds seldom are visited, for they lie in remote areas of the far north, but the early approach of winter there sends this bird south where, for a few months, it becomes a part of our world. Despite years of sustained wildlife slaughter that accompanied the progress of human settlement, great flocks of snow geese still congregate in favoured places. These gatherings afford us a hint of how it was in the past when multitudes of these waterfowl whitened acres and scores of acres with their closely packed bodies until the land seemed as if covered by snow.

There are two races, as well as a distinct colour phase, of the species. This phase, the so-called "blue goose," was thought to be a separate species; now it is believed to be an alternatively coloured snow goose, an evolutionary "new idea," perhaps, that eventually may make obsolete the older and at present more widely spread white form. Our race is not the big or "greater" one of the Atlantic coast but the more numerous lesser snow goose. It nests over the whole Arctic from eastern Siberia to Baffin Island.

In late August or early September, there comes an end to the brief, intense Arctic summer. Then the geese turn their thoughts toward the south, and after some days of increasing restlessness and gathering together, they rise and leave the northland. They do not return until late the following spring.

Flying in long, curving lines, snow geese on migration follow the ancient flyways used by their species as they beat their way down to distant winter quarters. They travel at high altitudes and often nocturnally, so that we who are bound to the earth can tell of their passing only by their distinctive, high yelps and terrier-like barks.

Those that travel down the Pacific coast may linger here and there along the way and some stay throughout the winter, going no farther. There is a great annual gathering of snow geese at the mouth of the Fraser River, where some thousands find the rich delta land to their liking. Feeding in the fields and around the marshy, shallow bays after their arduous journey from the high latitudes they soon recover lost weight and sleekness.

Many travel on to Louisiana and Texas, the winter homes of the blue phase birds, but most of the white snow geese settle down for the season in the central valleys of California, where their numbers are augmented by flocks of "black-stockinged" Canadas and by the little white Ross' geese, snows in miniature. Together in thousands, forming a vast concourse of garrulous, gabbing waterfowl, they present a magnificent spectacle, worthy of the eyes of Audubon or Wilson.

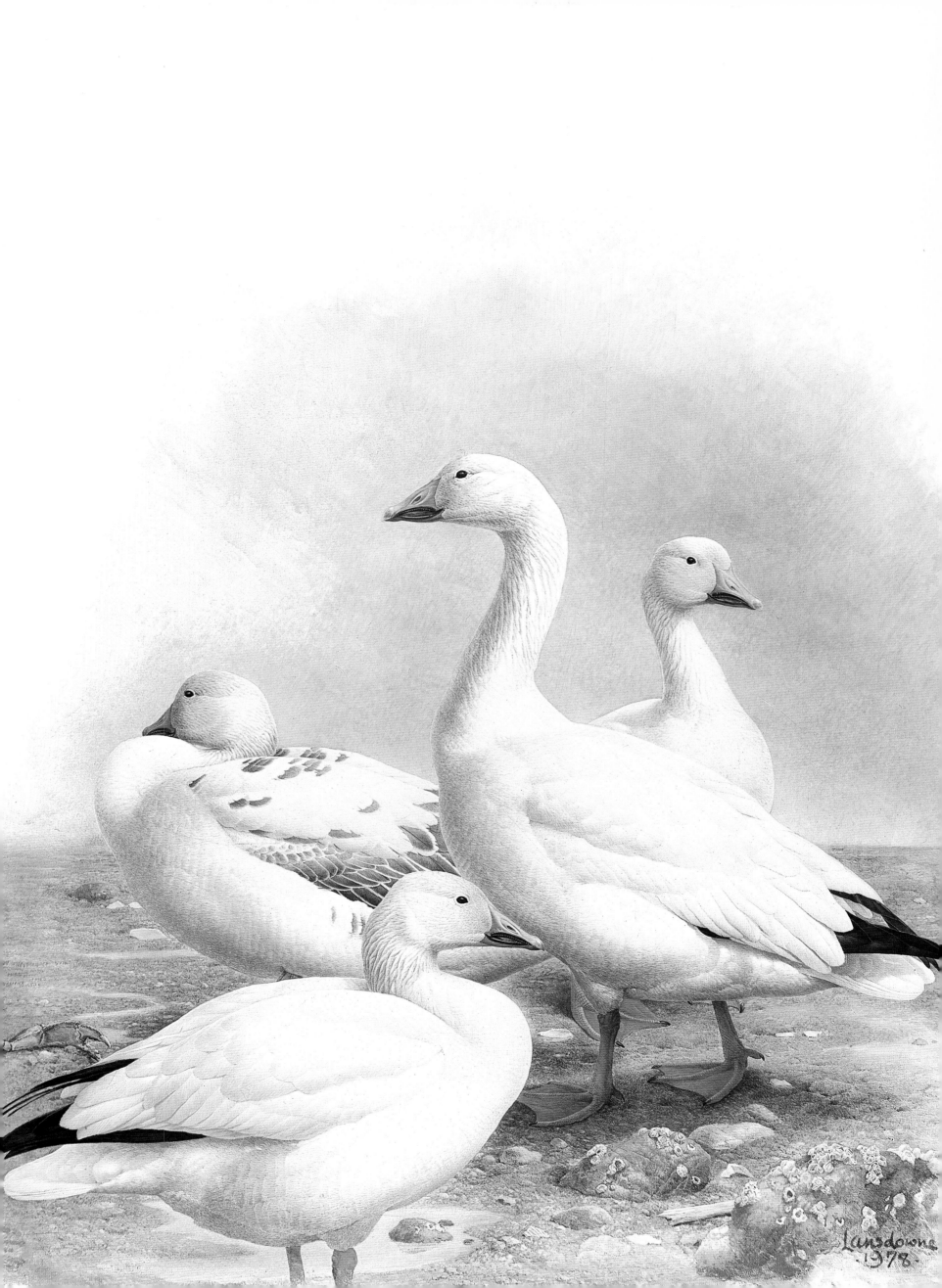

American Wigeon

Anas americana

The beautiful American wigeon is known also as "baldpate," a picturesque name with a homespun quality that I like. In spite of its descriptiveness, this alternative appellation seems to be going out of fashion, and I seldom hear it now. Older bird books recommend its use, claiming "wigeon" is a name too often applied to several species by wildfowlers who cannot identify them with precision.

Whichever it is to you, wigeon or baldpate, it is a duck that makes a handsome and lively addition to our winter birdlife. The approximate northern limit of its winter range is marked by Vancouver Island in the west. It is found also in the southern states, Mexico and north along the Atlantic coast as far as Chesapeake Bay. Wigeon are an abundant species which may be sought along the shore, for in their winter quarters they are birds of salt water as well as of fresh.

Living on a coast, as I do, you cannot forget the sea. Its murmurings and the voices of seabirds–the distant cries of gulls, the shrill "wheeping" of oystercatchers or the trill of turnstones–are carried inland on sharp salt air to mingle with more urban noises. On damp fall evenings that are heavy with the scent of oak leaf fires, I can hear the wheezy whistle of baldpate on the beach.

These are wary ducks that frequently feed at night, probably for the security that darkness offers, although they are always more active at dusk and dawn than in daylight. At any time wigeon enjoy a low tide with barnacled, weed strewn rocks and tide pools. When low water is at night they come to dabble in the sand and converse contentedly; I hear the muted whistle of flight feathers and the sibilant "whew whew whew" as they pass overhead to join their fellows at the water's edge.

Because wigeon are largely vegetarian, aquatic plants make up much of their food. They also relish the tender shoots of grass and will even grub out the roots from soft earth. On a golf course near my home wigeon alight in squadrons to graze like sheep on the fairways. Strangely, though unapproachable here, in city parks they jostle the mallards at the feet of people who come to feed the ducks.

On the coast, wigeon are taken by birds of prey such as bald eagles or, during their periodic invasions, snowy owls. No doubt they have other enemies, the large hawks and horned owls, or perhaps an occasional southward wandering gyrfalcon. Once I came upon a partly plucked drake, ringed by his own feathers, while in a nearby fir sat his killer, a peregrine falcon, one great yellow foot shining in the morning sun as it grasped the branch.

American wigeon breed throughout the western states and provinces and north into Alaska. Mating seems not to occur until they have reached the breeding grounds, at which time prospective pairs indulge in erratic courtship flights. The drakes flash ahead of the females to beguile them with their brightly marked wings and heads. In the fervour of their desire they repeatedly toss their heads, whistling and coasting on set, bowed wings.

Nest building and incubation follow a pattern general among waterfowl. The nests are simple depressions lined with down and grasses, sometimes at a considerable distance from water. Bent describes the setting of some he found, on treeless islands covered in coarse weeds, grass and wild rose tangles. In another place, the female wigeon may build her nest at the base of a tree or under a bush but almost always on high, dry ground.

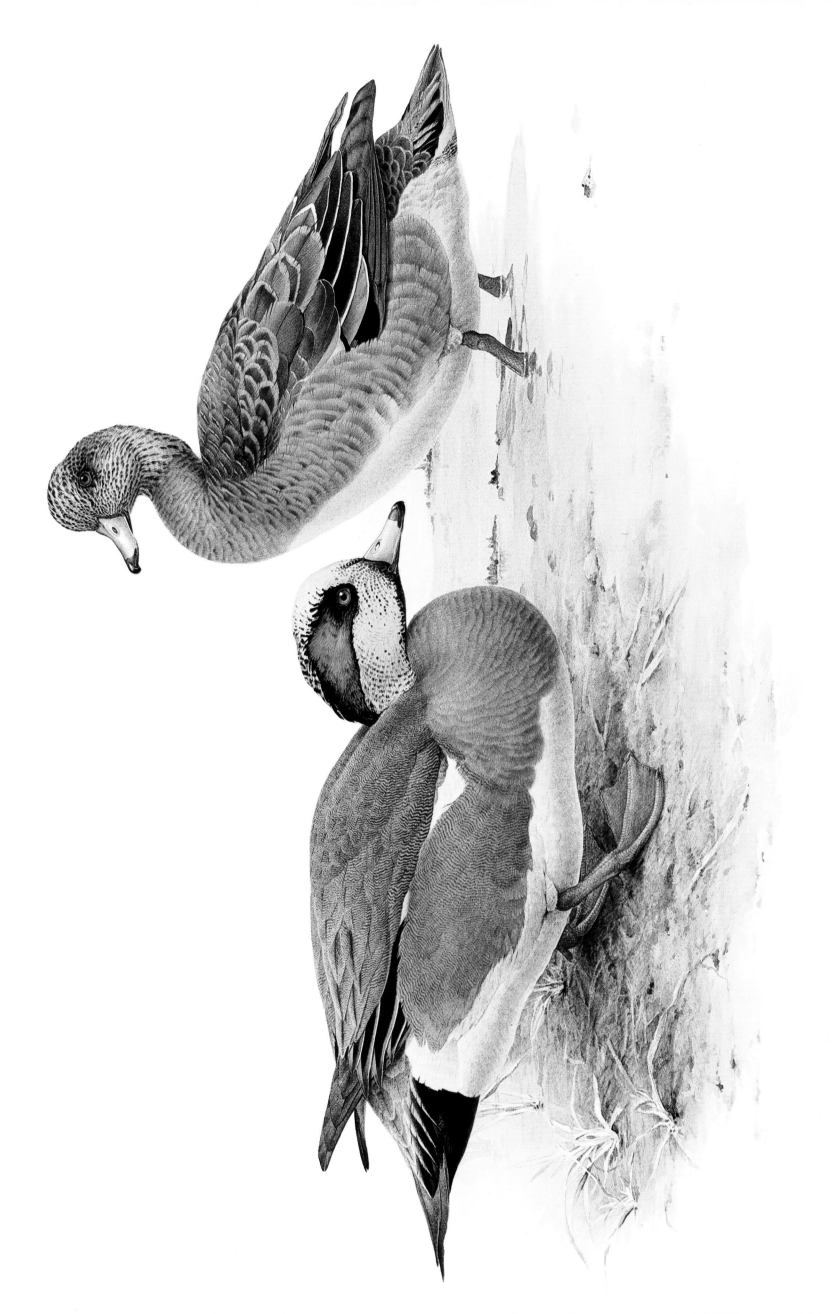

Anas clypeata

When drawing the shovellers, I was fascinated by their bills; the size and shape are so exaggerated. It was a pleasure to follow the lines with my eye and to delineate in pencil the planes and strong curves, for there is a beauty as of fine engineering in things as specialized as these. Close at hand there can be seen along the bills' open edges the tooth-like serrations called lamellae, delicate structures that, like the baleen of whales, allow water to strain away, trapping within the bills whatever is edible.

Of course, at a distance the refinements of a shoveller's feeding apparatus are not evident and the bird appears as a slender duck forever burdened with a bill overlarge and too heavy. It is closely related to the cinnamon and blue-winged teals, and, in fact, species of shoveller living in other parts of the world display the colouring of one or the other of these, while retaining the familiar and characteristic profile. They share, too, with teals their lightness and quickness on the wing. All are slim little ducks, and it is said that a shoveller never grows fat, no matter what its diet, but remains always thin and, for the table, unrewarding.

Whether or not you agree with this, and Audubon, for one, did not, it is a very handsome waterfowl with beauty that deserves a greater degree of appreciation than it enjoys. Hardly another native duck, unless it is the woodduck, can compare with the neat, brightly painted and impeccable drake in his breeding plumage. His mate is undistinguished, it is true, but the females of waterfowl are almost universally unobtrusive in plumage.

The shoveller is a dabbling duck, that is, a non-diving, surface-feeder found on fresh water and making its home on shallow sloughs and backwaters. In marshes, on prairie puddles and lakes over an enormous area of the Great Plains, the western and southern states and parts of the northland, it is among the commonest inhabitants.

The method of feeding is much like that of other dabblers, but the size and development of the shoveller's bill indicate some refinement or at least a greater reliance on animal food. The oozy bottoms of lakes and ponds are rich in nutrients and animal life; there shovellers like to feed, rapidly pumping water through the sieves of their bills. The birds are reported to paddle slowly about with bills submerged, several following one another in a curving line or circle. In this way, each reaps the benefit of the disturbance caused by the bird ahead. When feeding in this way, shovellers are aided in selection by their especially sensitive tongues and palates. In addition to animal food, a great deal of plant matter and vegetation is consumed. This makes up approximately two thirds of the whole food intake.

Their distribution being what it is, shovellers are not seen on the Pacific coast in great numbers, but they are not rare and may be seen in winter, one or two at a time, or in small parties. They seldom venture to the salt water, preferring the type of habitat that is a west coast approximation of their home country. Occasionally, though, I see one feeding along a beach with baldpates and mallards, looking small and self-conscious in this foreign environment.

On the water and during what one writer describes as spirited aerial flights, shovellers in springtime perform the ritual moves of courtship. The twisting pursuits on the wing and the scenes of posturing ardour enacted afloat are like those in which the males of many waterfowl pay suit to the opposite sex, with variations only in technique and procedure.

The nest of this species is made and the eggs laid in June. In form, the nest is typically that of a duck, a depression of slight depth sparely lined with grass and softened by down. Usually, it is concealed among grasses somewhere near water and on damp ground. There may be more than a dozen eggs which hatch after some three weeks of incubation.

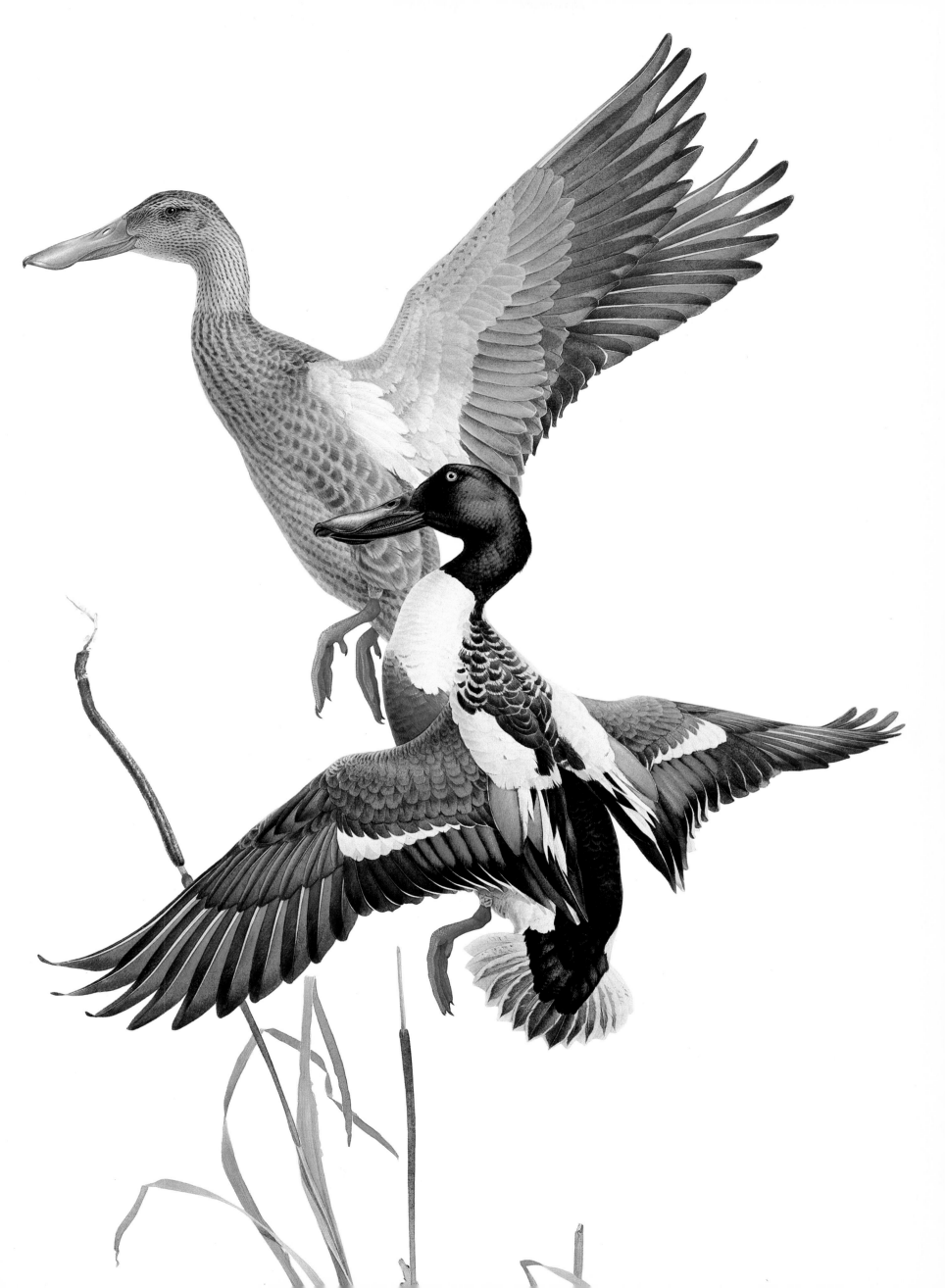

12 *Greater Scaup*

Nyroca marila

A greater scaup may be described aptly as being "black at both ends and white in the middle." This refers to the male, of course, since the female scaup is dark brown with few distinguishing features. In fact, her very uniformity is her best fieldmark.

In winter these "big bluebills," to give them one of their most widely used names, frequent littoral waters of the Pacific where they are among the commonest of the diving ducks. Anyone who has looked seaward in the course of a marine promenade has seen groups of them resting on the water a hundred yards or so offshore, looking rather like decoys. They are in every bay, and at times large numbers gather together in congregations known as rafts. Sometimes, I have seen them in these compact masses waiting out stormy days, "hove to" at a safe distance from the breakers. Yet they are not afraid of rough water and they ride it buoyantly, sliding easily into troughs and diving unconcernedly through the crests of waves. A. C. Bent describes the greater scaup as "a hardy sea duck, unexcelled in its powers of swimming and diving," and this it certainly is. The sturdy form and vigorous contours of this bird speak of strength and robustness, qualities it possesses to a degree. Reinforcing the impression of hardiness are its bold patterns and dense feathering with the glittering, brass-nail eye accentuating the darkness of the head.

The greater scaup resembles the rather smaller lesser scaup, a bird with a pronounced preference for fresh water and with a more southerly distribution, though the two overlap throughout much of their range. In the field the two species, although quite distinct, are difficult to separate and often tax the identification skills of birders. A general rule of thumb is that scaup seen in a marine setting may be presumed to be greater, while those in fresh water are lesser scaup, though this is far from sure.

These are ground nesting ducks. In June, the females construct simple nests of grasses and down in slight depressions within reach–that is, walking distance for ducklings–of water. The eggs, which number between seven and ten, are described as being olive buff. Following a common pattern of behaviour in waterfowl and, for that matter, in many birds, the males quickly abandon domesticity and dull care to their mates. With others of their sex they pass an idle, masculine summer while undergoing the moult.

The food of this duck is more largely vegetable than that of some diving ducks such as scoters. Scaup eat many different plants, including that favourite of the brant geese, eelgrass. Their animal food consists of shellfish, crustaceans and insects, although, of course, what is eaten depends very much on the time and the season. Birds in a seacoast environment consume a different bill of fare from those on inland breeding grounds.

Partly because of the swiftness and strength of greater scaup in the air they have always been one of the most popular waterfowl with east coast sportsmen. They are late to leave the north, lingering until driven out by the approach of bad weather, when they come rocketing south on whistling wings with winter at their backs.

13 *Oldsquaw Duck*

Clangula hyemalis

Among the familiar and most pleasing marine sounds I know is the lilting, five-syllable cry of the oldsquaw. It can be heard from the cold days of November until March and April when this little duck leaves us for the summer. Watchers ashore, even knowledgeable ones, seldom are aware of oldsquaws except as disembodied voices blowing in from the sea, for they feed just far enough out to be undiscernable without binoculars. The cries of birds are difficult to translate into words that convey anything helpful and that of the oldsquaw, so unducklike, is no easier than most. However, "south south southerly," with an accented, rising inflection on the last syllable is a close approximation. This call and its frequent utterance have given rise to many colloquial names such as "caccawee", "kla-how-ya", and "old wife". A more prosaic but descriptive name is long-tailed duck, by which it is known in England.

Oldsquaws are noisy and talkative, their behaviour and actions giving an impression of cheeriness and gaiety that strikes all who watch them or write about them. They are also elegant and distinctive, and no other waterfowl resembles them in either voice or appearance. They are unusual, also, in having two annual plumages, summer and winter. With but one other exception, the ruddy duck, all of the northern hemisphere ducks have single full plumages and briefly worn eclipse plumages that are assumed during the short time they are flightless.

The drake oldsquaw in winter, shown in the painting, is largely white and is so unlike any other that identification is a simple matter. The female at the same time wears a corresponding, but less attractive and curiously piebald plumage.

A spring moult, completed in May, produces a summer plumage of chocolate and rusty brown. In this dress the garrulous and now eager and ardent birds travel in swiftly flying groups to the shores of innumerable lakes and ponds on the subarctic tundra. The drakes are the first to arrive, preceding the females and timing their appearance in the north to coincide with the June break-up of the ice. Now the males are particularly voluble; with mates to be courted and won, little clusters of excitedly calling suitors collect around each female. With their long tails held stiffly, they bob and posture before her, each striving to out-bow his rivals and capture her attention.

For oldsquaws rough seas and boisterous weather hold no terror. They are among the last waterfowl to leave the north in the fall, and when they do, they do not seek warm southern waters but remain along the rim of the north Pacific, braving storms and gales. They seldom are found south of the Washington coast.

They feed on crustaceans, fish and molluscs, as do most of the diving ducks that share their habitat. Such a diet makes them undesirable birds for the table, though their swift flight is a temptation to skill-testing sportsmen.

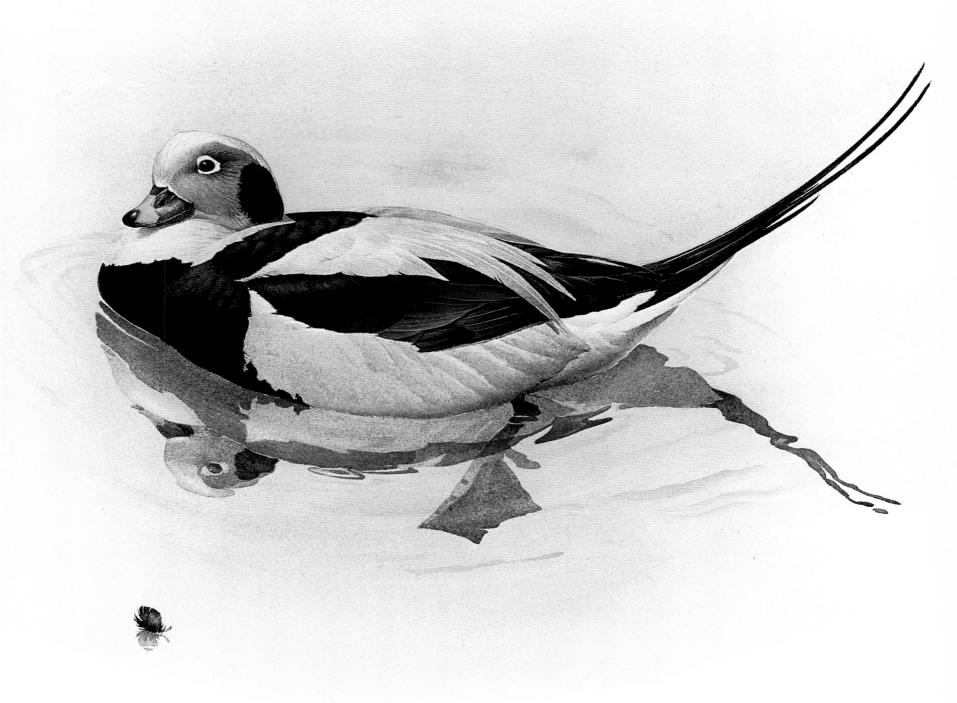

White-winged Scoter

Melanitta deglandi

One of three big, black ducks called scoters that winter on the Pacific coast is the white-winged scoter. It is the largest of them and, if not the handsomest, is at least the most plentiful.

A heavy bodied, ponderous waterfowl that gives an accurate impression of strength and hardiness, the white-winged scoter is found in all but the breeding season anywhere between the Aleutian Islands and Baja California. It does not normally mass together in large flocks but is found in little groups in the bays and inlets of the coast, usually in the company of surf scoters and other diving ducks.

A ready clue to its preference in food may be found by noting the type of habitat favoured by this bird. Shallow, tidal water which covers extensive beds of shellfish draws white-winged scoters in quantity, and there the powerful ducks dive for and tear from their moorings the strongly-clinging molluscs, swallowing them whole. Mussels are greatly favoured, as are scallops, small oysters and clams, all creatures with shells apparently stout enough to defy the digestive ability of any bird. To a scoter they are as nothing, and the muscular gizzard of this duck crushes what would require a hammer blow in other circumstances.

White-winged scoters are familiar and very common birds around the southern end of Vancouver Island, and I think of them always in connection with a certain stretch of shoreline sixty or seventy miles north of Victoria. Here the highway parallels the water for some miles almost at sea level and passes numerous little commercial oyster beds. The slope of the beach is gentle, and the strand is periodically punctuated by glistening mounds of shells that have accumulated over the years. In addition to oysters there

are mussels, and hundreds of scoters feed in the clear, shallow water. Not only white-wings are here, closer to shore than one can see them elsewhere, but the brightly marked and bizarrely beautiful surf scoters and the orange-knobbed, all black common scoter that is practically unknown a few miles south.

Though scoters are spoken of as black, this is, of course, an example of blatant male chauvinism, because only the drakes are black, while the females of all species are dressed in shades of brown.

While on spring and autumn migrations, scoters generally follow the lines and eccentricities of the coast. Half a mile or a mile offshore their dark skeins may be seen beating heavily along near the water. Many seabirds pass by at these times, usually too far out to be visible to the shorebound observer; but the wavering, inky lines of the scoters travel closer. As the flocks pass through the straits near my house, alternately appearing and vanishing against the mountain background, they transmit some of the excitement of their primaeval, astonishing undertaking.

The strangely formed, lumpy bills of all scoters give them a clumsy and homely look. Though more regular and less garishly coloured than that of the surf scoter, the bill of the white-winged scoter is strange enough. Of three races of this species that between them embrace the northern hemisphere, the American subspecies stands midway between the others in order of bumpy profiles.

Unlike the ducks that breed on the open tundra or raise their families in marshes, white-winged scoters nest in more wooded areas of the north and lay their pink-tinted eggs under bushes near lakes.

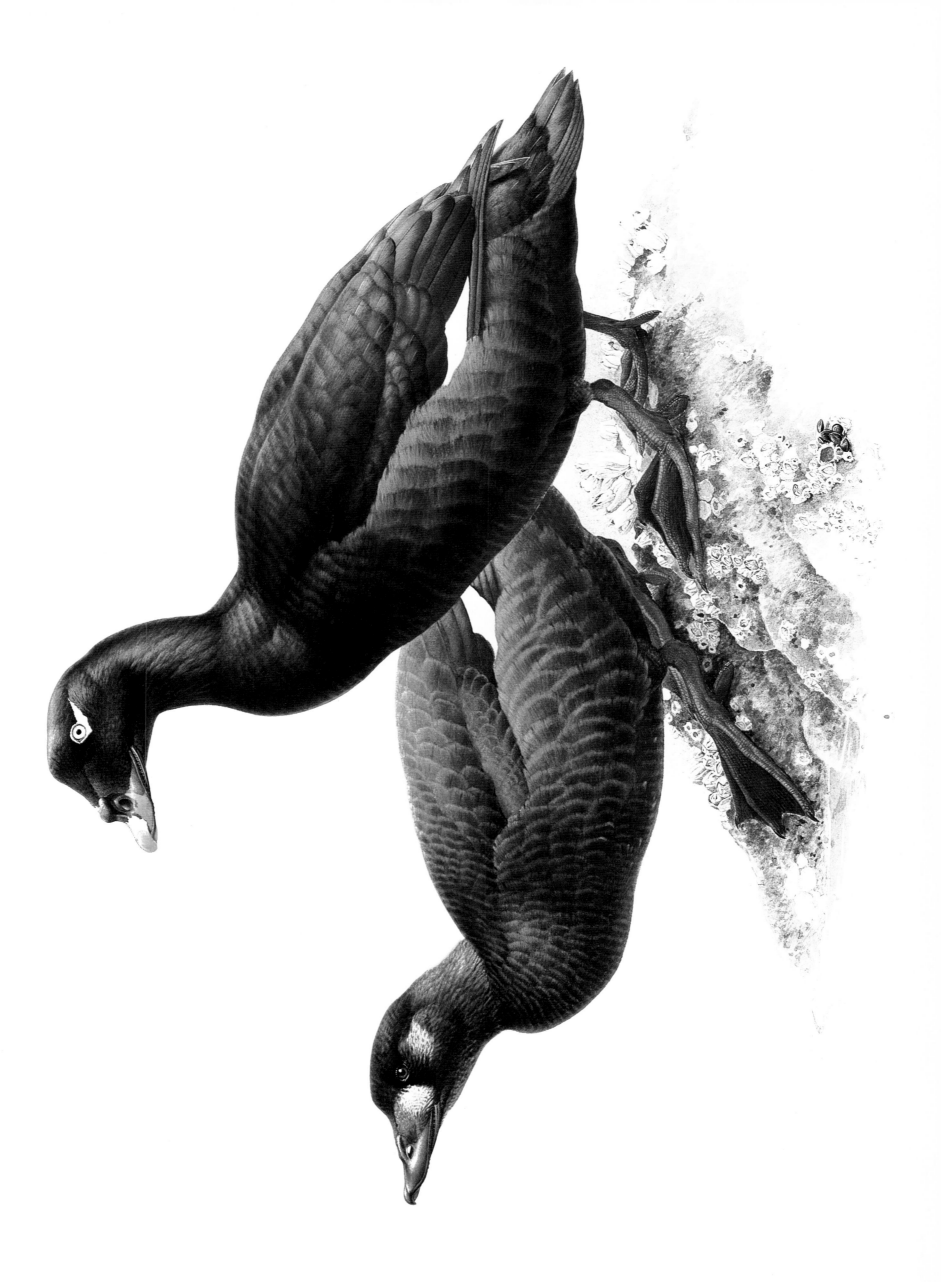

Ruddy Duck

Oxyura jamaicensis

The ruddy duck is one of an extraordinary tribe of waterfowl known as stiff-tails. There are only nine species; in their peculiarities they resemble one another but are notably different from other ducks.

Their physical traits and behaviour set the ruddy ducks apart, and in many ways they seem closer to or at least parallel with the grebes. There is between these two groups a shared ability not only to dive quickly but to sink silently beneath the water's surface. There is the same inability to walk well, so that on dry land they must progress by means of sliding on their bellies.

The dense plumage of ruddy ducks and the silvery sheen to the white of their underparts also are like those found in the grebes. These and other unusual anatomical features serve to point up the apartness of these strange little creatures.

With his snub-nosed, belligerent profile and glowing colours, the ruddy drake is an engaging and delightful bird to see and never more so than when indulging in the elaborate courtship of his species. Then he is at his electric best, all tension and ardour, with head drawn back stiffly spread and sharply angled tail. Employing one of his unique physical attributes, inflatable air sacs, he puffs out the loose skin of his thick, short neck, simultaneously uttering a series of squeaky grunts and hiccups.

The object of his performance is as demure in colouring as the drake is bright, a brownish duck as spike-tailed and bigheaded as her mate, with a dark horizontal line bisecting the creamy plumage of her cheek. In marshy sloughs of the Great Plains and elsewhere

in northern North America, she and her sisters build nests that are floating and well attached to the reeds that surround them. Raised some inches above the level of the water, they are described as being domed and basketlike, although less complex structures are made at times. Usually, a ramp of reeds slopes from the nesting platform to the water so that, grebe-like once again, the incubating bird may slide away when leaving.

In this neat abode is laid a clutch of ten or more eggs that are astonishingly large for the size of the mother. White, thick-shelled and rough, they are greater in size than the eggs of much larger species. The young that hatch from them are correspondingly big and strong and able to dive proficiently and care for themselves. Their feet are large, and it is said that when half-grown they become "sullen and ferocious."

The males of many ducks desert their families in summer, but male ruddy ducks are said to be conscientious fathers, assisting in the care of their infant broods. They do not, however, take any part in incubating the eggs.

Ruddy ducks have or have not an eclipse plumage, depending on your viewpoint. In *The Waterfowl of the World*, Jean Delacour describes it, while A. C. Bent's *Life Histories of North American Birds* says quite clearly that there is none. The difference lies in interpreting the plumage that is assumed in late summer and which could be considered a prolonged eclipse, as it is worn until the following spring. During this period, the males wear a drab dress not unlike that of the females.

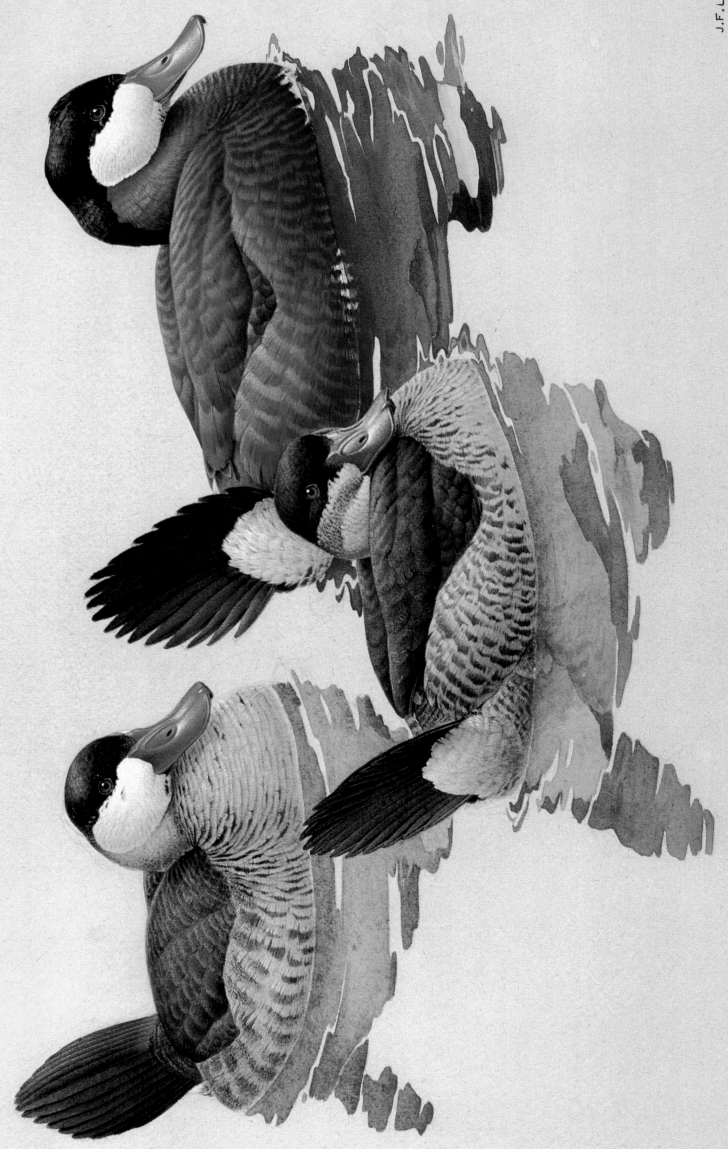

Common Merganser

Mergus merganser

Mergansers are fish-eating ducks belonging to a small subfamily of a few species. They are chiefly characterized by narrow, unducklike bills equipped with toothy serrations along the edges.

The common or American merganser is the largest species and is known sometimes as sawbill and also by its British name, goosander. All the mergansers are crested, some strikingly, but in this species only the female is noticeably so. The male, though spectacularly marked, has simply a slight lengthening of the head feathers, giving no more than a fullness to the nape of the neck. This does not detract from his handsome appearance and is more than balanced by the lovely peachy pink suffusion to the plumage of belly and breast. This pink is an evanescent shade that fades quickly in death, but in a living drake it is an admirable foil to the glossy green head and brilliant red bill.

A glance at the painting shows that the female is quite as handsome as her mate, though in a less showy way. She resembles the female red-breasted merganser, but her greater size and richer colours are usually enough to set the two apart from one another.

Although it seems an unlikely habit, mergansers are among the waterfowl that nest in holes. They often choose hollows in trees. That is their preference; of course, they cannot excavate their own but must take advantage of natural cavities or those dug by large woodpeckers. Such holes are not always to be found and mergansers may nest on the ground. Incubating birds have been found under bushes, in hollow logs, in caves and frequently in crevices or crannies among rocks and large boulders.

When nests are built in places like these, leaving them presents no particular difficulty to the ducklings. A day or so after hatching, they heed the entreaties of their mother who then leads them to the nearest water.

However, those hatched in trees, fifteen or thirty feet from the ground and sometimes much higher, must clamber to the edge of their nesting cavities and leap. With blind faith in the urgent calling of their mother, they tumble out, peeping their obedience. They are so light that the fall does not hurt them, and one after the other they quickly pick themselves up and patter away. These downy young are prettily marked in black and white and are able to swim, dive and feed themselves almost at once.

The mergansers are all primarily freshwater birds, but they do not entirely disdain the sea coast. The common merganser is most frequently met with on lakes and the clear running waters of swift rivers, where it is able to hunt the fish that form the greatest part of its diet. This species, as are the others, is very fast and adept in underwater pursuit, employing both wings and feet. Large fish of seven to ten inches are eagerly seized and forced head first down the expandable gullets. Sometimes, too big to fit, they protrude for a time from the bills. The narrow "sawbills," with their toothlike, backward pointing serrations, are an apparent aid in the gripping of slippery prey.

These birds often can be seen in beautiful flotillas. On a calm morning the sight of a dozen or two cruising serenely on the milky surface of a lake or harbour is unforgettable. They also fish in packs, rushing upon their panic-stricken prey in line abreast, darting and seizing. They progress much as starlings do when feeding in a field, the rear ranks flying over the foremost hunters in a repeating pattern of voracious pursuit.

Common mergansers are hardy birds, widely distributed. In America, they breed all across the northern part of the continent and winter south in California and states of the same latitude. Winter weather does not alarm them, and they are among the first waterfowl to move north in the spring migration, crowding the edges of retreating cold and fishing unconcernedly in frigid water amid the breaking ice.

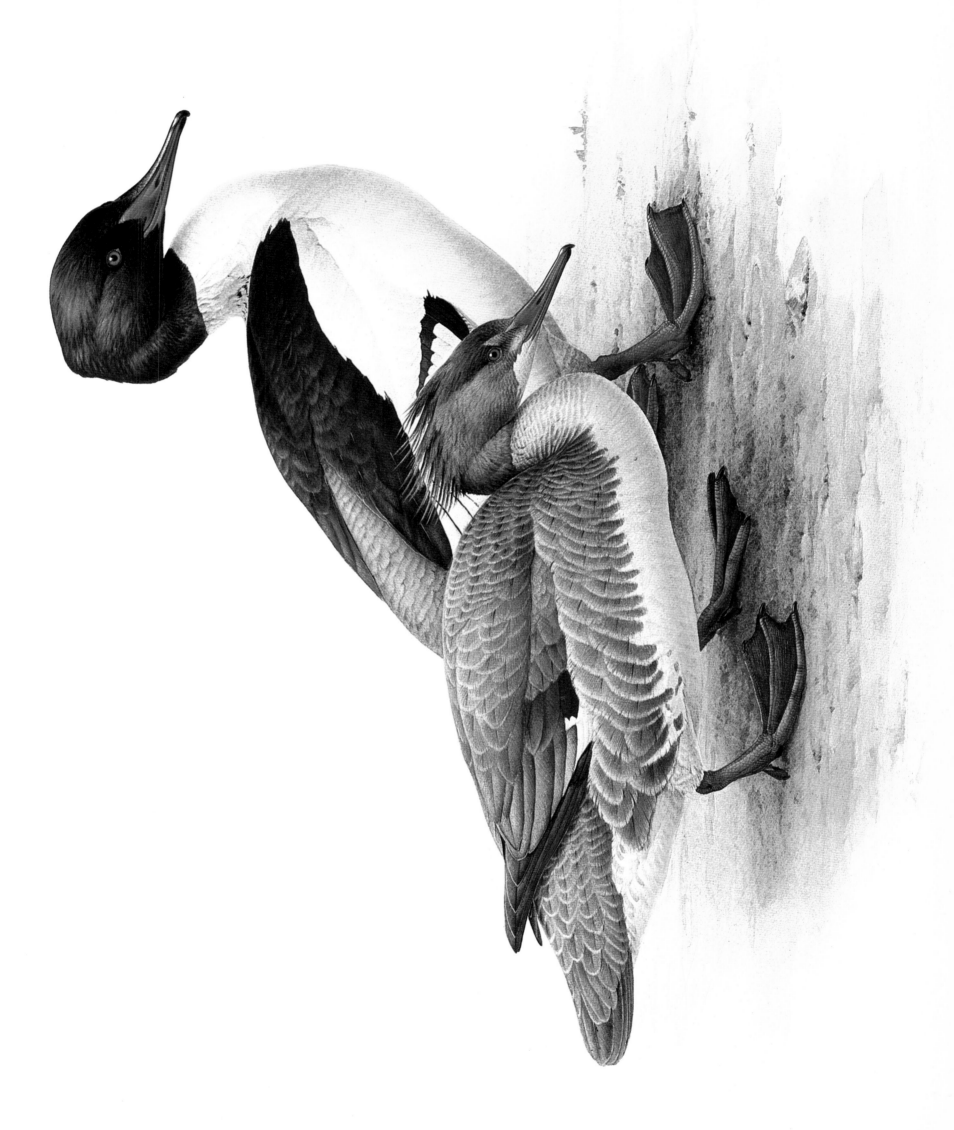

California Red-shouldered Hawk

Buteo lineatus elegans

On a bank of a northern California river that runs past Point Reyes Station, I first made the acquaintance of this handsome hawk, in Latin so aptly named *elegans*. Sitting quietly, hoping for the return of an osprey that earlier had been hunting the stretch of water before me, I looked up to meet the dark-eyed stare of a pale, medium-sized raptor.

I did not at first recognize it as it stood, yellow feet apart, gripping the branch of an overhanging willow. The plumage of breast and belly was warm terracotta, contrasting with the chequered pattern of the wings and the creamy, lightly marked head; I longed to paint it. Now I have done so, although I could not capture its beauty as I saw it in a setting of California's faded yellows and dusty greens.

It was, of course, a California red-shouldered hawk, the pale western race of a woodland bird familiar to easterners. Formerly, this race was known as the red-bellied hawk but is so no longer: bird naming is a fickle business, and now a respectable ornithologist would not be caught with the obsolete "red-bellied" on his tongue.

Preference in habitat remains generally the same in all subspecies of this bird of prey, and true to its kind the Pacific representative is a creature of watercourses, streams and the shores of lakes and may be found in groves of willows, sycamores and such trees as share its liking for damp places. The bird that I encountered beside the river at Point Reyes was very much at home in the old, waterside willows with the background of marshes, meadows and densely wooded ridges.

In California, the species also has a liking for the tall, wonderfully fragrant eucalyptus trees that in raffish, aromatic dignity line roads and form groves. In these stands of blue gums, the hawks are said to make their nests, using the tangled, peeling strips of bark in their construction.

The nest of the red-shouldered hawk is placed near water and is usually fifty feet, sometimes more, above the ground. In the crotch of a tree or on a limb beside the trunk, it is built of sticks, with a lining of shredded bark and continually replenished green leaves. Not uncommonly, a pair will have one or two spare nests in reserve that may be used in emergencies or occupied in different seasons.

Throughout its life, the red-shouldered hawk is an inoffensive and useful bird that does little to bring upon itself the censure of mankind. Its prey consists of small creatures: frogs, reptiles and insects, as well as ground squirrels and other little rodents. Particularly when feeding its brood of young, it must account for many injurious things. Birds are taken, too, but happily they do not seem at most times to be of major importance in the diet.

This race of the red-shouldered hawk is found from southern British Columbia to Mexico and may be looked for in suitable valleys between the coast range and the ocean.

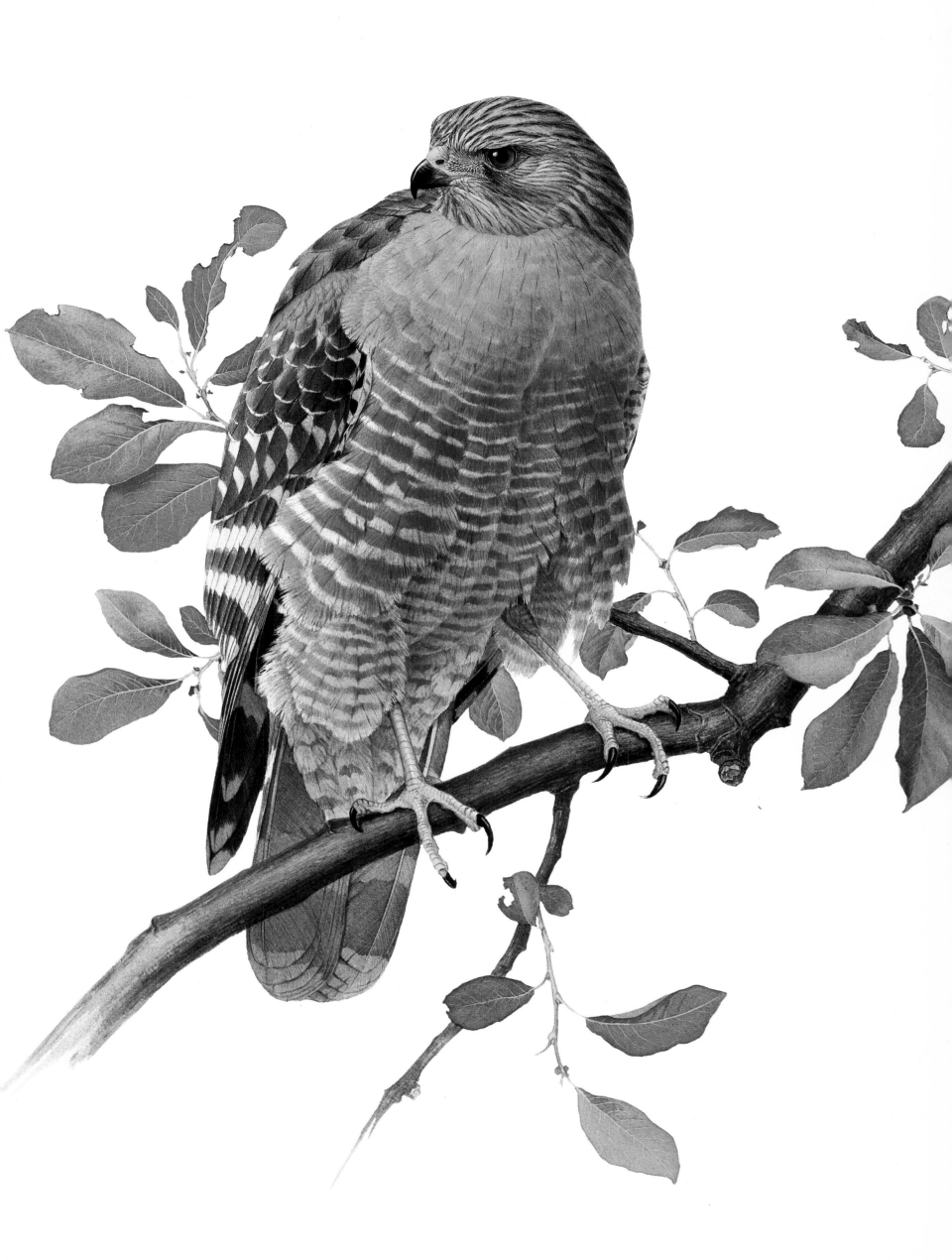

Golden Eagle

Aquila chrysaetos

The most thrilling and splendid of our birds of prey must certainly be the golden eagle. Its soaring flight and the wind-whistling rush of its stoop make an indelible impression upon the minds of those who witness them; the very words "eagle" and "golden" conjure up pictures of nobility and magnificence. Reality does not entirely dispel these preconceptions, because in its strength, boldness and beauty this great hunter of the air exemplifies our idea of a "king of birds".

The golden eagle, so called for the cape of lanceolate, "golden" feathers on the napes of adult birds, is found in the mountains and on the steppes and plains of both Asia and Europe as well as in North America. It has the respect of the human inhabitants of this vast area, for it is not a bird to be taken lightly, being strong enough and sufficiently audacious to attack and kill large animals. This eagle once was and perhaps in remote parts of the east still is flown from the wrist against gazelle, bustards, foxes and wolves.

More usual prey are smaller mammals and birds, and it is probable that whatever creatures are most numerous in a particular eagle's territory are the most frequently killed. In the American west, animals such as jackrabbits and ground squirrels form the staple food source, and in alpine country the hoary marmot, grizzled and weighing as much as thirty pounds, is taken by eagles. There are many accounts in the literature of the golden eagle to indicate that even deer and other game of comparable size are not immune to attack, despite the fact that they may be too heavy to lift. When driven into narrow defiles or deep snow by the heavily beating wings of their assailants, they succumb to the fearful talons and tearing beaks. The fawns of white-tailed deer in America, roe and red deer in Europe, furnish many a meal for eaglets in the nest.

Birds are taken in direct pursuit and are either grasped in the air or struck to the ground. Few are swift enough on the wing to avoid

and survive an eagle's onslaught; in its death-dealing stoop an eagle may reach a speed of more than a hundred miles an hour.

The nests of golden eagles are large, repeatedly used structures that are added to over the years until they become very big and heavy. They are built of stout sticks and lined with soft greenery to make pleasant aerial nurseries for the young that spend several weeks in them.

Although there is a preference shown for rocky ledges and inaccessible cliff faces as nesting sites, many nests or eyries are built in trees. Eagles customarily have two nests which they use in alternate breeding seasons and may choose to raise their young in a tree one year and on a rock the next.

In a typical clutch there are two eggs, but not always do both eaglets that hatch from them attain nest-leaving age. Females of all raptors are considerably larger than males and this is particularly true of golden eagles. Should one of each sex hatch, the smaller bird may have a bad time. Mercilessly bullied and attacked by the other occupant of the nest, it may be pushed overboard or even killed outright in what has been called "ritual fratricide". At best, it will have only second-class food, the leavings of the stronger fledgling.

On the Pacific coast, golden eagles are not numerous and to see one is a thing unusual enough to be memorable. Nevertheless, they regularly slip down to the valleys to the west of the coast range and are seen sometimes feeding on fish with bald eagles in the Skagit Valley of Washington. In the San Juan Islands off the Washington and British Columbia coasts, there is a concentration of them, probably due to the abundance of rabbits that serve as a ready food supply. There golden eagles are said to breed and it is possible to see several of these wonderful, great-winged birds in a day.

Falco columbarius suckleyi

The old words for birds of prey, used for centuries in England, distinguish between families as well as between species. The terminology of hawking or falconry, still used, is even more exact and in it the sexes, states of training and origins of the birds are precisely defined.

Our forefathers in North America neglected these old names and had the habit of calling all hunting birds that were not owls or eagles, hawks. To differentiate families, as well as to emphasize the relationship between our native species and those of the Old World, we are taking once more to the use of the more accurate and interesting names of old. With the use of these, birds that were known to earlier generations as duck hawk, sparrow hawk and pigeon hawk become again peregrine, kestrel and merlin, each appellation with a rich and romantic history attached to it.

The black merlin is generally considered to be one of several races of the merlin or pigeon hawk, a small, audacious falcon that occurs across the continent. The family to which it belongs, the falcons, are dark-eyed with pointed wings and are not true hawks. They dive or "stoop" on their prey, striking it from the sky with a single blow. As this indicates, they are primarily hunters of feathered quarry, and the merlin particularly is almost exclusively a bird killer.

The darkest and in some ways the most beautiful race, the black merlin seems a perfect example of the colour saturation that happens in the plumage of birds living in the humid atmosphere of the northwestern coast. All shades are darkened; the light slaty blue of interior birds becomes deep indigo to black. Barring on the tail is reduced to dots and the streaking of the underparts is heavier. Even the yellow skin surrounding the eyes, on the cere and feet is darkened in this subspecies to a golden orange.

This describes the male. His mate, darker than her sisters elsewhere, is brown rather than blue. She is also much larger, as are the females of other raptorial birds.

The black race has been something of a puzzle to ornithologists. Even though it is found on the coast and breeds in some parts, it nests as well in the drier interior, where the rules of coloration should produce only pale birds.

It is fairly common on the coasts of British Columbia and Washington in fall migration and in winter but is largely absent during the rest of the year. From September to March, if one sees a small dark bird of prey, very quick, with pointed wings, it is almost certainly a black merlin. It is sometimes seen harrying a flock of sandpipers over a tide flat or flicking along a fir-hung shoreline. In size it resembles its small, more delicately made cousin, the kestrel, but in build and potential menace this species is more like the great gyrfalcon. It will take or attempt anything up to the size of a pigeon, and so fast is it on the wing that it pursues and catches swifts.

Merlins are voluble and noisy in spring and will fly out to a considerable distance from their nest to meet and repel intruders, thus advertising with their circling flights and shrill chatter what they would conceal. The nesting sites show wide differences in taste. A sheltered hollow under a bush may be selected or a rock or ledge. More commonly, the nest will be built in a tree but here is further diversity; a hole in the trunk, the hollow of a broken stub or a horizontal limb are all possible places. Quite frequently, the four or five young merlins are raised in a second-hand abode that in an earlier year held a brood of crows.

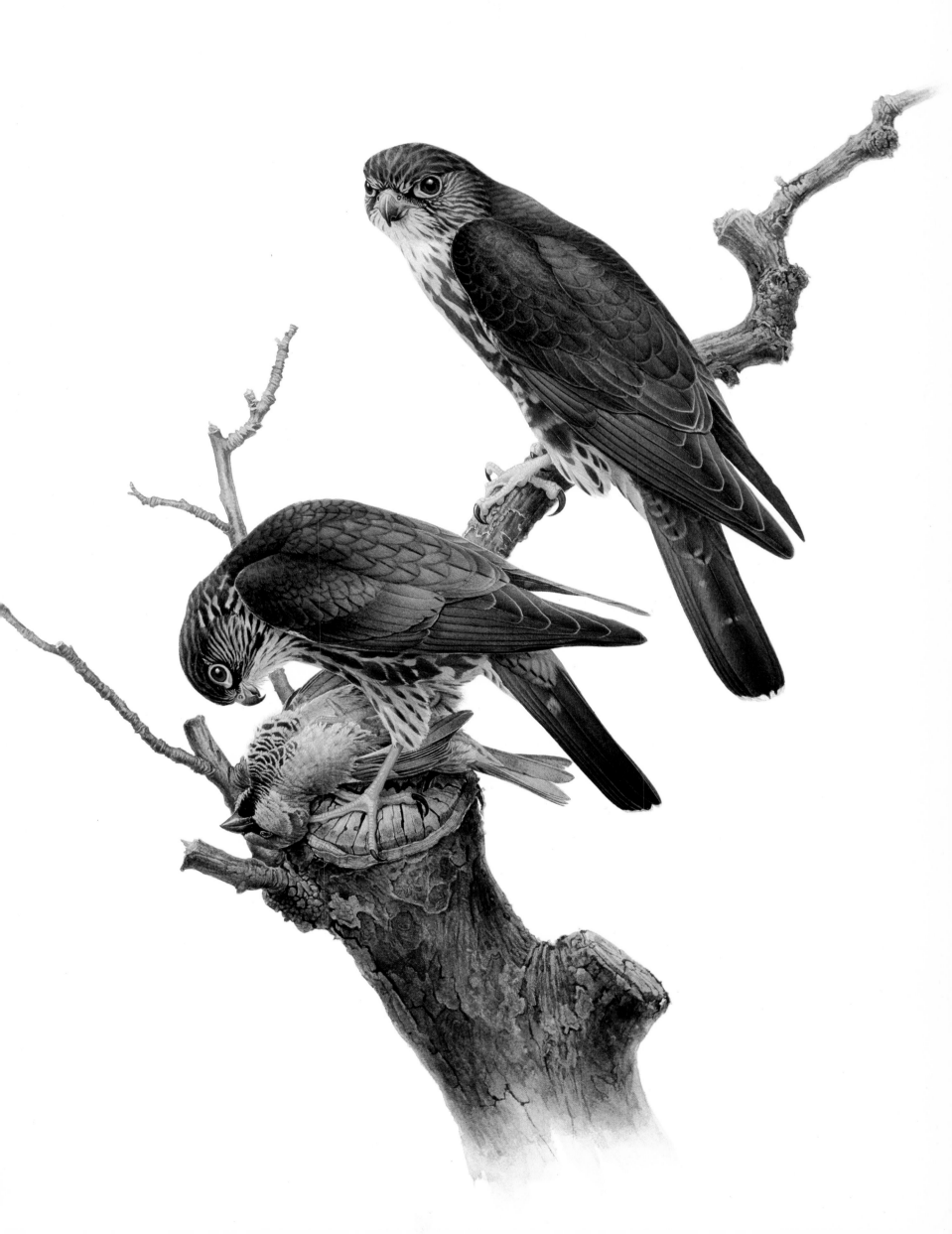

Porzana carolina

Rails are shy birds, more often heard than seen. The family includes some bolder species, such as the coots and gallinules or moorhens and even a few that prefer dry land, but most of its members are secretive denizens of marshes and damp meadows.

Of several that occur in America, none is more typical of its family or more widely distributed than the plump little sora, sometimes called the Carolina rail. It is found in practically every part of this continent, as well as in Central America and the West Indies.

It is a true bird of marshes and sloughs, seldom found, except during migration, away from wet places. Rails are mindful of their privacy, and even though the sora is a shade less retiring than some of its relatives, it is not seen often. For every one that comes stepping cautiously into view, there are sure to be several in concealment. Their world is a closed-in one of green and tawny reeds and rushes; in it they stay hidden and only their voices betray them. Indeed, when the whistles and cackles that are heard so often in a marsh are recognized as the calls of the sora, it may be realized how widespread this species is.

Sora rails swim and dive readily and proficiently. Also, with their long wide-spreading toes they are able to walk on floating vegetation that would otherwise not support them. Flattened bodies, "as thin as a rail," allow them to pass easily between the close vertical growth of the marshes.

Though preferring to steal away on foot, this species is sometimes flushed from its hiding place. When this happens, a round-winged, floppy bird is seen rising awkwardly with dangling legs, only to drop back again at a short distance. On migration, however, its flight is strong and sustained, but perhaps not especially swift.

As do many birds, the sora migrates by night, and twice I have been brought birds, both young in a lovely first autumn plumage, killed by hitting powerlines in the dark. They were picked up in the heart of the suburbs, where no rail would be expected. Many birds that we would not think to see must pass over and through our gardens when we are abed.

The nest of the sora is a marsh bird's nest: a bowl or rush basket raised a few inches above water level. At times it is placed in among the stems and leaves of the thickest stands of rushes; at others it is in more open situations, attached to the nearby plants.

It contains an astonishing number of eggs, usually ten or twelve and occasionally as many as a dozen and a half. To incubate them successfully, the little hen rail must arrange them in a double layer, otherwise she could not hope to cover so great a number.

Perhaps because of this, the eggs are incubated more or less as laid. This means that instead of having all the chicks hatch within a short time of one another, and so be of almost uniform age, they hatch over a considerable period. A brood of baby soras will contain downy young all of different ages, and the eldest may be well grown before the last makes its appearance. The chicks are very quick to leave the nest, clambering out and away as soon as they are dry. They swim and dive with skill and feed themselves with no assistance from their parents.

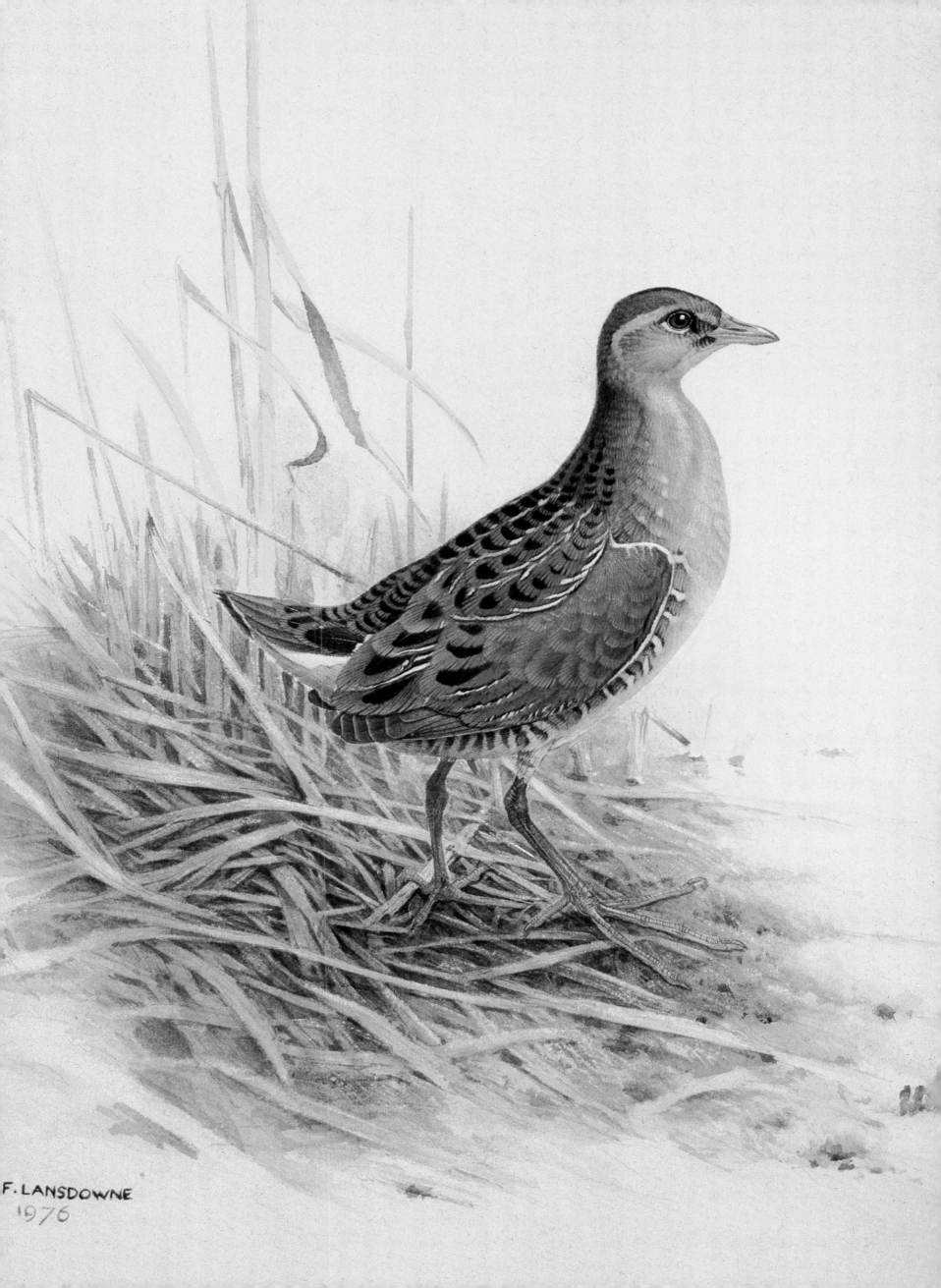

F. LANSDOWNE
1976

American Golden Plover

Pluvialis dominica

The golden plover is not a bird that comes to us in great numbers, but it is beautiful and remarkable enough, despite its comparative scarcity, to warrant a place in this volume.

These gentle, long distance travellers with the melodious whistle regularly appear among the hosts of shorebirds that make a twice-annual passage along the Pacific coast. They are seen every year, but there are never many. When these handsome plovers are in their black, white and gold breeding plumage of spring, there are few to be seen. Rather more seem to appear in fall, altered now in appearance and wearing an unobtrusive autumn dress. They may be looked for in open places, on golf courses and ploughed or stubbly fields, where they feed in the characteristic run, stop, run way of plovers. They frequent the rocky shore also, though less commonly than their larger, paler relatives, the black-bellied plovers, whom they resemble. The golden plovers' lesser size and warmer coloration are usually enough to make their identity known.

The main route of migration for the American golden plover lies along the Atlantic coast and thousands take this path going to and from their breeding grounds. Birds of great abundance before the appalling, witless slaughter of nineteenth century market hunting, golden plovers once passed over the eastern parts of the continent in tremendous numbers. During the day, for they fly mostly at night, they would cover acres of land at points along the way as they rested between stages. Easily, greedily killed, the flocks of plovers grew smaller; with protection they have increased again, but neither this nor any of the species that came so near to extermination around the end of the last century has ever recovered its primaeval abundance.

A secondary flyway passes over the middle of the continent, with the birds crossing the prairies and the Great Plains west of the Mississippi. A trickle of migrants chooses the Pacific coast route and provides a chance for us to see one of the world's great travellers.

The winter home of the golden plovers is an immense distance from their tundra nesting grounds, and with astonishing endurance and strength these small birds travel each autumn to the pampas of Argentina. Here, under the Southern Cross, they enjoy a second summer and in spring return to the north.

A migration which in magnitude and navigational wonder is even more captivating to the human imagination is performed by the Pacific or Asiatic race of the golden plover, a smaller, brighter bird that nests in eastern Siberia and Alaska and which occasionally has been taken on our coast. It has a great wintering range that includes India, China, Australia, New Zealand, Hawaii and the other islands of Polynesia. Following unseen tracks over thousands of miles of ocean and using forms of navigation we do not understand, this bird makes its appointed landfalls with remarkable accuracy.

It was a golden plover that our ship encountered when my family crossed the Pacific from Hong Kong to Canada in May of 1948. It joined us for a time, I cannot remember now for how long, perhaps an hour or two, perhaps longer, flying alongside the starboard railing. It made a great impression on me, and I found it even more interesting, or at least more romantic, than the black-footed albatrosses that planed over the grey waves or the little black petrels that I glimpsed from a porthole.

In their exposed, quite unconcealed tundra or moorland nests, golden plovers lay four buffy coloured eggs, heavily blotched with brown. The incubation time is about four weeks, and the young are active and able as soon as they have dried.

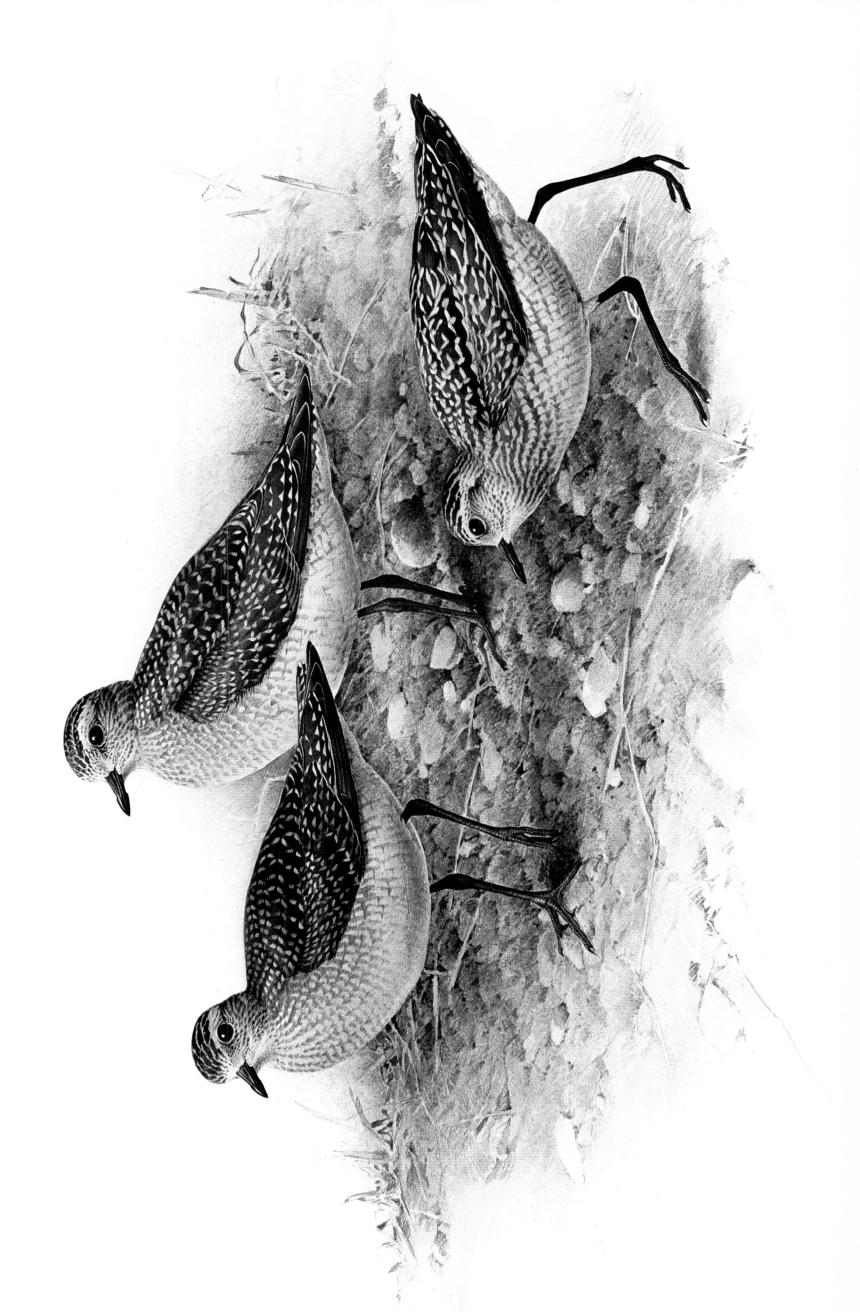

Surf Bird

Aphriza virgata

Surf birds are greyish, inconspicuous shorebirds that blend with their surroundings. They bear a superficial resemblance to turnstones and also to some of the dark-plumaged, rock-loving sandpipers.

They may be overlooked on this account, but, in fact, are worth a little attention for they are interesting birds that have an unusual aspect to their life history. Arriving on the shores of British Columbia and the adjacent state of Washington with the early migrants of July, surf birds spread south in the ensuing weeks; their winter range extends along the whole Pacific length of the North and South American coasts to the Straits of Magellan. Well named, they are most at home on rocky, spray-washed shores where ocean breakers crash and seethe. This kind of habitat they share with few other waders, as the majority of sandpipers prefer the smooth expanse of tidal sand or the rich mud of marshlands. Oystercatchers, Aleutian sandpipers and the stubby, pottering black turnstones are the surf birds' companions, and it is with turnstones that they are most easily confused. A careful look, however, will show that surf birds are the possessors of yellow legs, white rumps and, in winter, paler, more speckled plumage.

The nesting place of the surf bird was unknown to ornithologists until less than sixty years ago and when discovered in 1921 was as surprising as it had been mysterious. In a departure from the usual habits of shorebirds, many of which nest near water or on the tundra, surf birds at the commencement of the breeding season fly inland to the mountains of central Alaska, making a journey of several hundred miles to nest at high elevations in country frequented by mountain sheep. For the weeks of summer they are to be found at altitudes above four thousand feet, in the roughest of rocky alpine terrain, where the tallest plant is only an inch or two high.

The nest is nothing, merely a scrape or natural depression that will hold the four well-camouflaged eggs. Incubating birds sit tight and do not fly from danger until the last moment. Then, in startling bursts they will "explode" in the intruders' faces. Much of the care and incubation of the eggs is undertaken by the male.

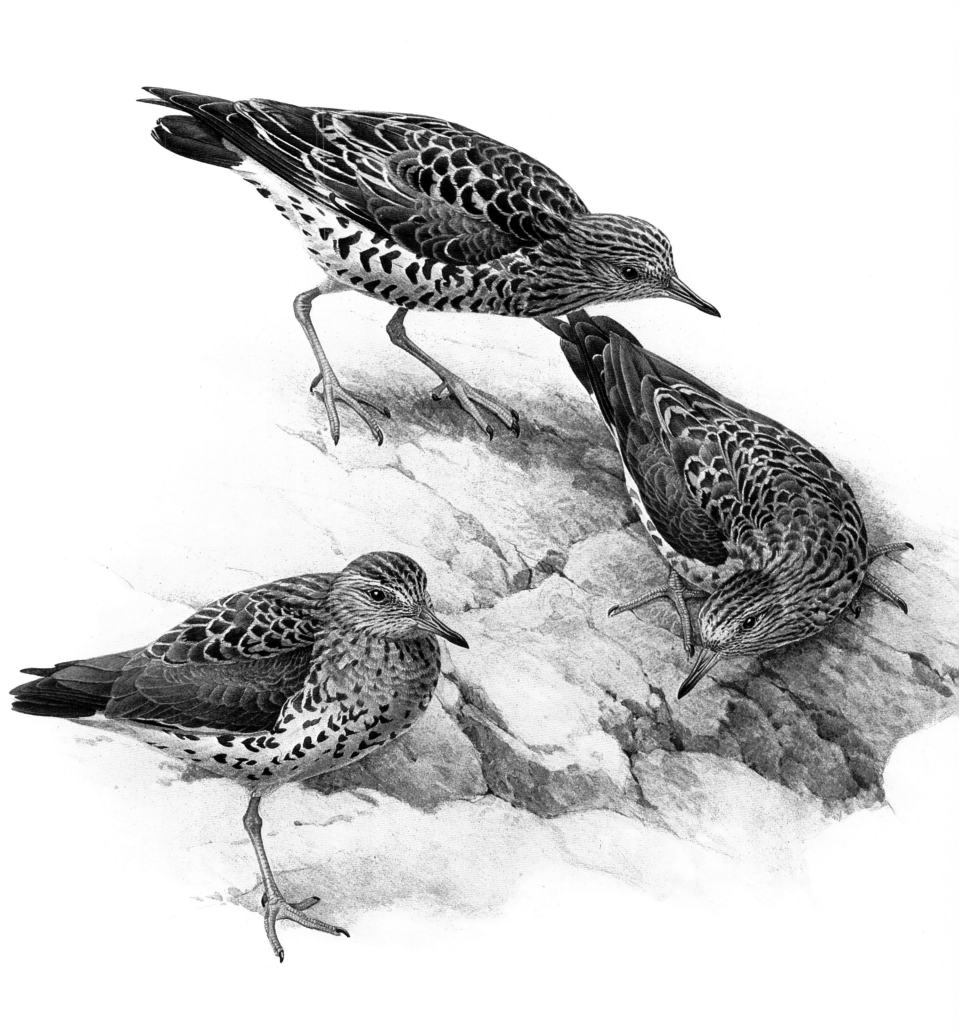

Calidris mauri

In the short summers of the tundra barrens, many shorebirds woo prospective mates, win them, make nests and raise broods of active little downy young. Their whole cycle of reproduction, from courtship to the fully grown juveniles that result, takes only a few weeks, because at the approach of the early northern autumn young birds and old alike must undertake a long journey to winter quarters.

The route followed by most species breeding in Alaska and the western Arctic lies along the Pacific. Thousands of waders, from big, sickle-billed whimbrels and teetering yellowlegs to the finch-sized sandpipers, pour south along this flyway, many bound for the distant coasts of South America.

The first shorebird migrants appear in mid-July, and by late August and the beginning of September the trickle of birds becomes a stream. Outnumbering the other small species on the beaches and mudflats of the northwest is the western sandpiper, an unobtrusive shorebird that looks very like several others.

Some birders scamp sandpiper identification, because even in the best conditions, it is difficult. Due to a near resemblance to the semipalmated sandpiper in particular, the western is often overlooked or simply dismissed as "one of the peeps". However, it is a completely distinct and attractive bird that is especially interesting because of its unusual pattern of distribution.

Leaving the north in late summer, it travels along the Pacific coast, as stated. Although while nesting it is confined to a fairly small part of northwestern Alaska, in winter it ranges over a great area and is found on our southern and Atlantic coasts as well as on that of northern South America. Western sandpipers are some of the most familiar birds of the beaches, travelling in flocks or resting and feeding on the wet sands, and their habit of flying in close formation is characteristic of them and of the other little waders. With pointed wings sharply angled, they jink and twist as one bird, white underparts flashing and vanishing as they alternately present to view bellies and backs.

Having spent the winter months thousands of miles from its breeding grounds, this sandpiper returns in spring by the same paths by which it left in fall. The main wave brings the little migrants north in April and May, and it is late in May when the last birds arrive at their destination, the upland tundra of Alaska.

Naturalists who have observed western sandpipers at this time of year write of their pretty ways and gentleness. While in the ecstasy of courtship, the males display to their future wives in a charming way that lifts them from the anonymity of the winter months. In terrestrial display, they strut with drooping wings and elevated, fanned tails; when unable to express their feelings in this way, they rise aloft in quivering flight song.

Western sandpipers nest in scattered colonies, concealing their nests beneath tufts of grass in the drier places. Usually there are four eggs, protectively coloured and incubated by both parents.

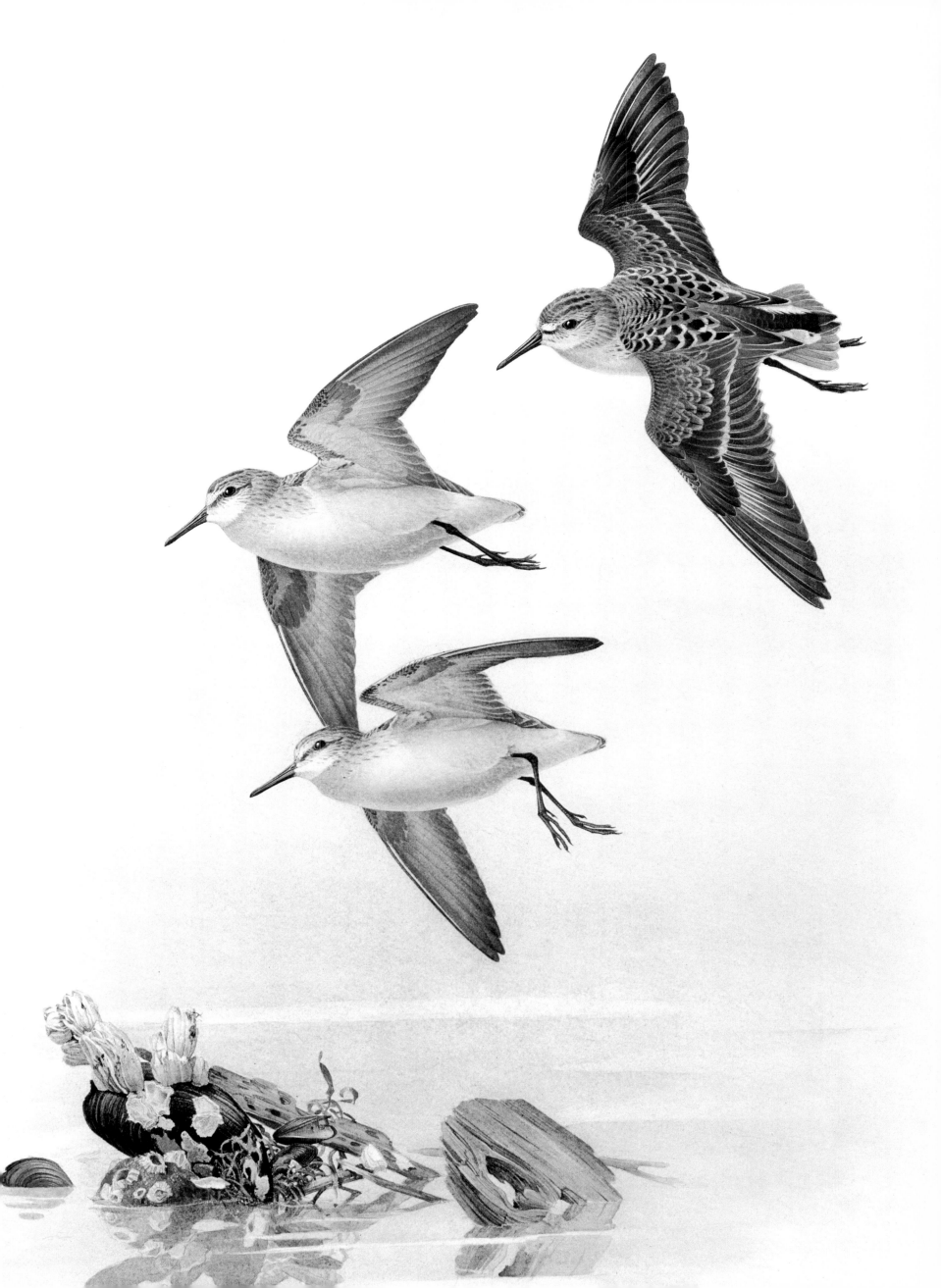

American Avocet

Recurvirostra americana

Nobody would contest the avocet's claim to being one of our brightest and showiest waders. To me, its bold, pied markings and cinnamon foreparts place it among the most beautiful. Its body is set on slaty blue legs of impossible length and delicacy. Its slender lines are given an almost feminine distinction by the upward curve of the rapier bill.

A bird of wide distribution over the west, south and central parts of North America during different times of the year, the avocet is an easily seen bird. It does not conceal itself in places inaccessible to human view, and its favourite haunts are the borders of alkali and salt lakes, the shallow edges of ponds, marshes and meadows, where the water is only a few inches deep. Often, avocets can be seen feeding within a few feet of a highway as in the vicinity of Marysville in California. Here, from Interstate 5, the main north-south highway, I have watched them wielding their uniquely shaped bills through the flooded rice fields.

Their method of feeding is to walk or run briskly through the shallows, heads down and bills submerged and moving from side to side. As the upcurved, partly open mandibles rake the muddy bottom in a scythe-like motion, they seize anything edible. It is not uncommon to see groups of avocets, sometimes dozens strong, advancing in lines abreast, each bird sweeping the water before it as it feeds. In deeper water, they thrust both heads and necks under

to reach the bottom and when necessary, swim easily and well.

The avocet's food is more than half animal and includes all sorts of marsh and water insects. The remainder of their diet is made up of plant seeds.

They are said to be rather tame birds at most times and may be approached with little trouble. When nesting, however, they become wary and vociferous, greeting a visitor with great noise and shows of distress. Their displaying becomes more frantic the closer the intruder's approach, and to deceive and decoy him they employ the old broken wing trick so well known in the kildeer.

These birds breed in small colonies, building their nests of grass and sticks, not far from the edge of water. The nests are not complicated structures, merely shallow cups with perhaps the addition of a few feathers and bits of weed to the basic materials. They hold clutches of three or four eggs that are buffy or isabelline in colour overlain with speckles and splotches of a darker shade. They are liable to be inundated by occasional sudden floods, and when such an event threatens, the parents are galvanized into frenzied action. Dashing hither and yon, they gather and thrust into the framework of the nests anything that will serve to build it up above the rising level of water. They often successfully save their eggs in this manner and may raise the height of the nest by several inches.

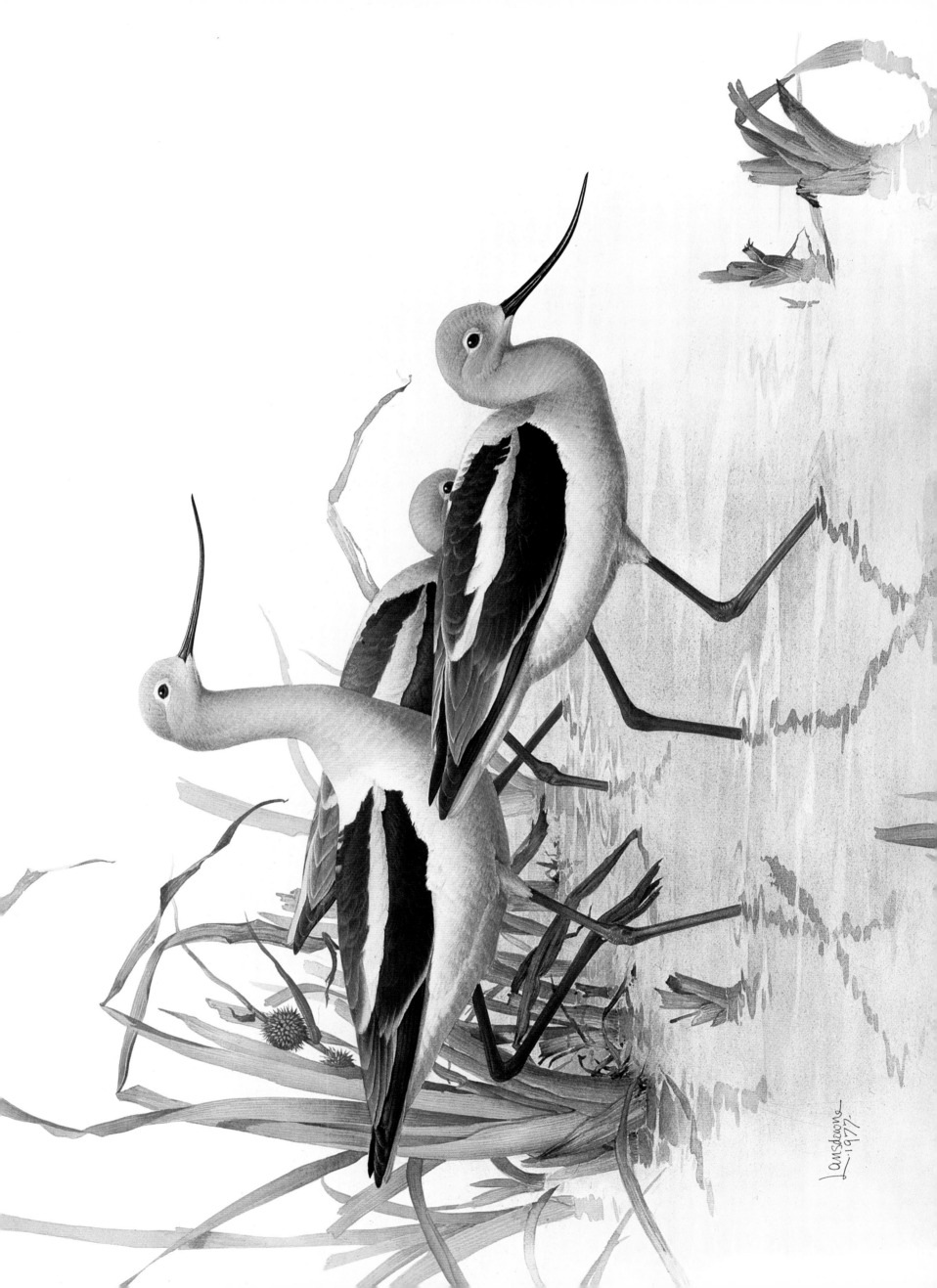

Black-necked Stilt

Himantopus mexicanus

As their name so graphically conveys, stilts represent the ultimate in spindly shanks among our shorebirds. Longer than an avocet's and proportionately longer than those of any birds except flamingos, the extraordinary legs of these waders give them a tippy, somewhat uncertain look as they stalk the shallows of their home,

Stilts are nearly world-wide in distribution, and all five geographical forms bear the startling black and white plumage, with only minor variations in pattern. Our black-necked stilt, the American bird, occurs throughout the southern parts of the United States, to Central and South America, and is found even on the islands of the Galápagos Archipelago. In winter, it retreats to the southern portions of its range.

This is a bird of fresh water, with a liking for ponds, lakes and, above all, for marshes. It is not really an inhabitant of the coast, though it may be found there occasionally or not too far away. I have seen stilts feeding in the company of their equally elegant cousins, avocets, just outside Oceanside in California, and they may be found north as far as southern Oregon. They are said to breed at Klamath and Malheur Lakes in that state.

The habits of the black-necked stilt are quite like those of the avocet, but the almost straight bill precludes the curious feeding method of that bird. When moving delicately through shallow water and particularly when ashore, the stilt keeps its legs bent at a considerable angle so it may reach the surface or ground with its bill. This problem of being too tall would be appreciated by the giraffe, though the solutions each has found are different.

More than ninety-eight per cent of the stilt's food is of animal origin and consists mostly of the insects and aquatic larvae that are so abundant in marshy places. It also consumes small molluscs, crustaceans and some fish, while the negligible amounts of plant matter eaten are mostly seeds.

Nesting in marshes, in much the same way as avocets, stilts run the same risk of finding their eggs awash when the water level rises. They are as diligent as their cousins in an emergency, as many people will know who saw the *National Geographic Magazine* article about them some time ago. It contained remarkable photographs of these birds in such a crisis and of their desperately shoving anything handy under their eggs to raise them to safety.

Baby stilts take some hours to master the art of standing and walking successfully; even though their bodies may be ready enough, their legs are wobbly. It is at least a day before they are really active, and even then they prefer to rest on the flat of their tarsi rather than at their full height.

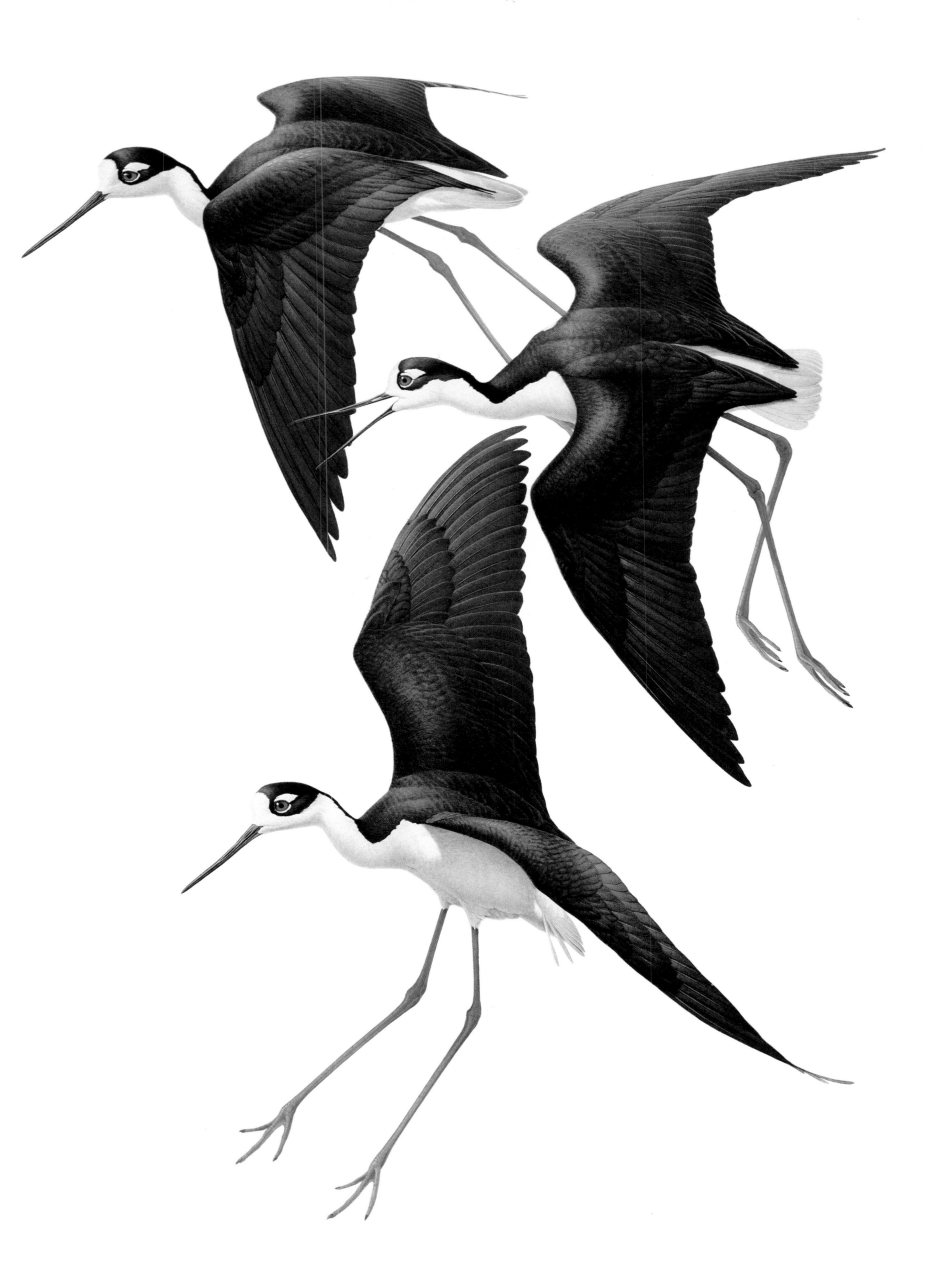

Northern Phalarope

Lobipes lobatus

What pleasing birds are the diminutive northern phalaropes. Like little, seagoing sandpipers, they forsake the land during much of the year and wander in great flocks, the ocean companions of shearwaters, gannets and penguins. In their sea life, they frequent patches of weed or drifting flotsam and may be seen wheeling and twisting, shorebird-like, in erratic flight over the water before alighting to feed.

There are three species only of these strange birds, all breeding in the polar and subarctic regions of the world. The northern phalarope, smallest of the three, has the widest distribution and in fall crosses the Equator and is found off the coasts of western South America, Africa, Arabia and around the Asian coasts of the Pacific.

The special adaptations to its peculiar way of life include partly-webbed or, as they usually are described, "lobed" toes, as well as especially thick plumage which has an underlying layer of dense down. This gives added insulation against cold and increased buoyancy. Anyone watching these birds will see that they ride the waves as lightly as corks.

Phalaropes feed by picking tiny creatures from the water's surface. They do not often dive–their buoyant bodies make it difficult–though they sometimes tip tail-up in the manner of ducks. These birds have evolved a unique way of feeding that never fails to delight the observer: paddling their feet, they pirouette in rapid circles, dabbing at the water from side to side with their slender bills as they spin. To see a whole flock thus daintily engaged is charming, and it is thought that this twirling behaviour roils the water and brings edible things within reach. R. M. Lockley, in his book, *Ocean Wanderers,* says that two-thirds of the individual birds spin to the right.

In spring, northern phalaropes journey north along both shores of North America and also through the interior. Their destination is the tundra land of the Arctic where they will breed beside ponds and marshy sloughs.

It is just before and during nesting that phalaropes display their family's most unusual characteristic, the reversal of normal sexual attributes and behaviour. In all species, the females are more brightly coloured than the males and have a more active rôle in courtship. They indulge in prolonged and seemingly fierce battles over chosen mates and lead the dull-plumaged husbands truly henpecked lives.

When the clutch of four creamy, speckled eggs is laid in a body-formed depression in the grass of a damp meadow, the female's work is virtually over. It is the male who undertakes the greater share, if not all, of the incubation and he alone develops a brood patch. Later, again with little or no help from his mate, he cares for the young until they are grown and independent.

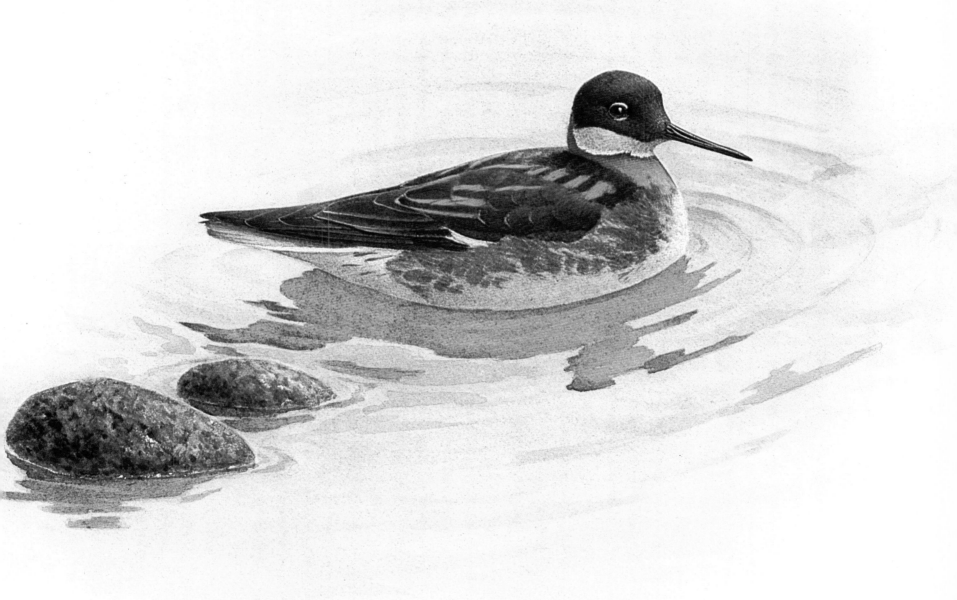

Parasitic Jaeger

Stercorarius parasiticus

When the fine, late summer weather envelops the northwest it brings the first of the migrants from the north. Sea and sky become a single smooth blue fabric, and though fog may lie offshore and chill the air, it seldom spoils the pleasure of being on the water, surrounded by the cries of seabirds. Marbled murrelets now can be seen with their stolid young, loons and the first grebes appear and, as early as July, the shorebirds begin to trickle southward.

With September and October comes the van of the tern migration that begins in August, and among the slender-winged sea swallows travel their dark companions, the jaegers.

Sinister attendants of common terns and other fishing birds, the jaegers are gull-like birds with evil habits. Only one of the rapacious four species, the parasitic jaeger or Arctic skua, as it is known in Britain, is liable to be seen with any frequency on the west coast and only during a few weeks as it passes to its southern wintering grounds.

The parasitic jaeger can be confused with the smaller, long-tailed jaeger that occasionally finds its way here from its more usual haunts elsewhere. Making uncertainty of identification greater is the presence of immature birds that may have tails of variable length and the fact that jaegers have light and dark phases. This means that there may be dark adults or pale juveniles.

Whatever its species or colouring may be, a jaeger as such is unmistakeable as it dashes into the midst of a group of terns, scattering them in shrieking disorder. Singling out a bird, the jaeger pursues it, twist for twist, with relentless persistence. Unable to elude its tormentor, the harried and frightened tern drops or disgorges its fish which is then snatched up by the victorious jaeger.

The parasitic jaeger is a circumpolar, high Arctic breeder, raising its chicks on the tundra among the nests of the birds it persecutes. At other times merely an aerial pirate, it becomes during the nesting season a true predator, raking the landscape in search of eggs and young left unattended. It also takes small mammals and does not disdain beached or floating carrion in the form of whales or fish.

The courtship and nesting of parasitic jaegers is conducted in the manner of the gulls. The male bird chooses the site for the nest and displays to the female with ritualized gestures that include the flashing of the white patches at the base of the primaries. The eggs are laid in a grass-lined depression, and the young, a few hours after they hatch, are active and out of the nest.

Immature jaegers do not return to the breeding grounds for a year or two after their initial departure. Instead, they remain at sea, hectoring the gannets and boobies of more southerly waters. Even when present once again among breeding birds, they remain for a time unattached, clubbing together to pass the summer in an idle fashion.

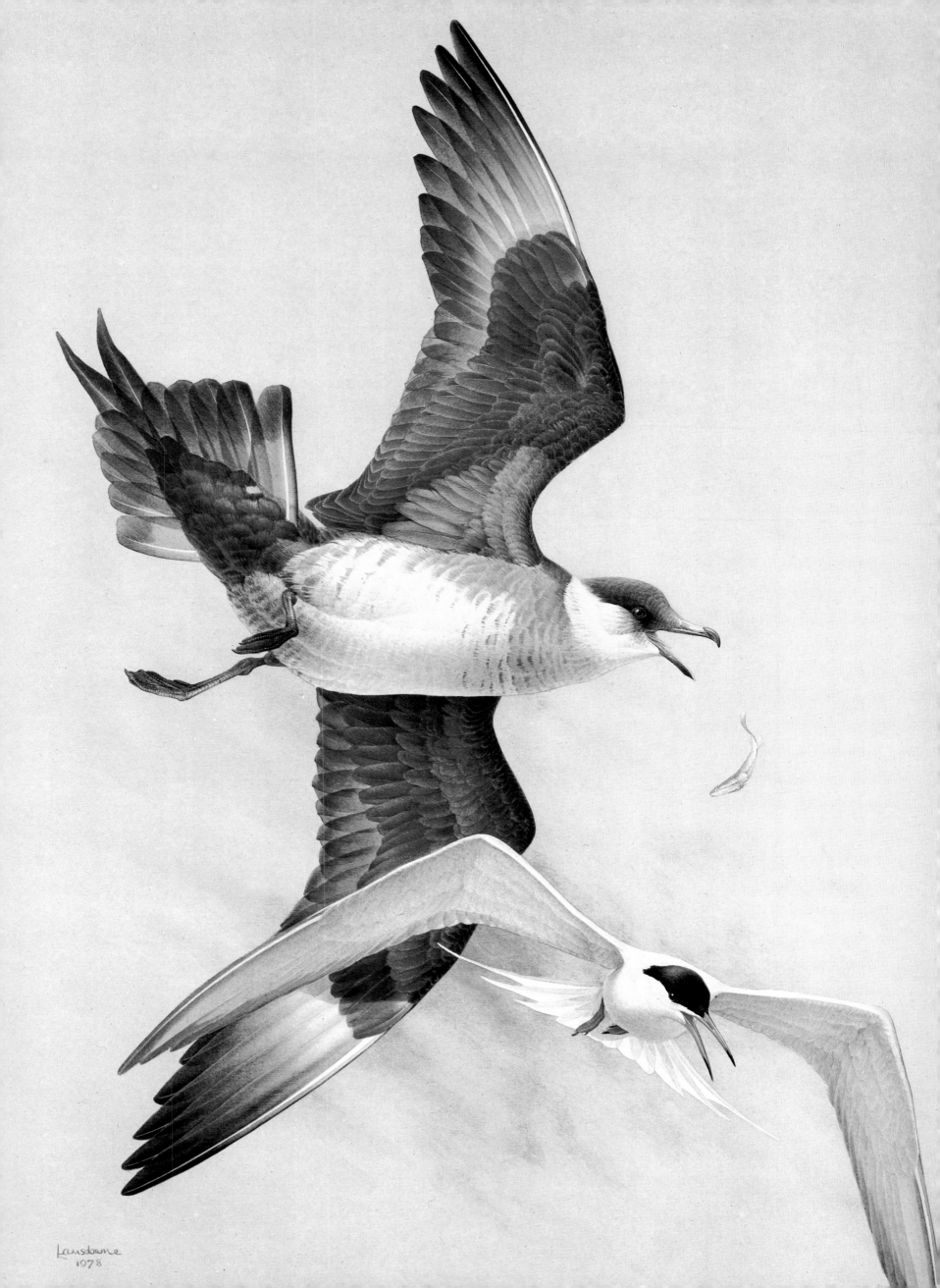

Western Gull

Larus occidentalis

The coast of Washington is the meeting and intermingling point of two large and nearly-related gulls. From this general area to the North Pacific and the Bering Sea, where it encounters the paler glaucous gull, the glaucous-winged gull is the common species. From Puget Sound south it is gradually replaced by the handsome western gull, almost as large as its light-mantled relative, but with wings and back of deep charcoal.

The pristine beaches of Oregon and California nestle into the craggy coastline like gems in a rough-cut setting, and here the western gulls are supreme, everywhere in effortless flight along the cliffs or resting on the sands at low water. The contrasts of their plumage are striking and at first something of a novelty to one used to the glaucous-wing's misty grey and white. Young western gulls of one or two years pepper the assemblies of adults, and these, especially birds of the year, are extremely dark, almost black and very conspicuous. It is a full three years from the time of hatching before any gull reaches maturity of plumage, though with each successive moult it becomes lighter.

Most kinds of gulls—the kittiwakes are the exceptions—are not to be found in pelagic waters; they are birds that remain within a few miles of shore and, except for a few species, seldom go far inland.

Because of this inherent family preference for coast life, gulls, the western among them, have come much in contact with man. At one time attracted on a large scale by the bloody refuse of the whaling and fishing industries, they quickly learned the advantages of human company. Now with the tremendous proliferation of waste that attends our civilization, gulls find a limitless source of food that has enabled their numbers to increase and their ranges to expand beyond the confines of prehistoric days. They are as omnivorous as goats, useful scavengers, that perform a valuable service in their ceaseless patrolling of the tideline and seaside towns.

Their behaviour during the nesting season is less creditable, for their presence in seabird colonies has a potential for great destruction. Breeding side by side with murres, cormorants, puffins and, farther south, with brown pelicans, western gulls exact a heavy toll of the eggs and young of their neighbours. Like the jaegers, they are real and deadly predators at this time of year. Should the other birds of the communities be flushed from their nests by thoughtless human intruders, the gulls will destroy in minutes the temporarily unattended production of a season.

The eggs and young of their own species are not molested, though they lie unconcealed with only their cryptic colouring to protect them. Bulky and well-made structures of grass or weeds, the nests are situated on grassy slopes, on rocks or in crannies. The young gulls remain a few days in the nest and then leave it to wander about over an increasingly wide area. Both parents incubate the eggs and guard their offspring.

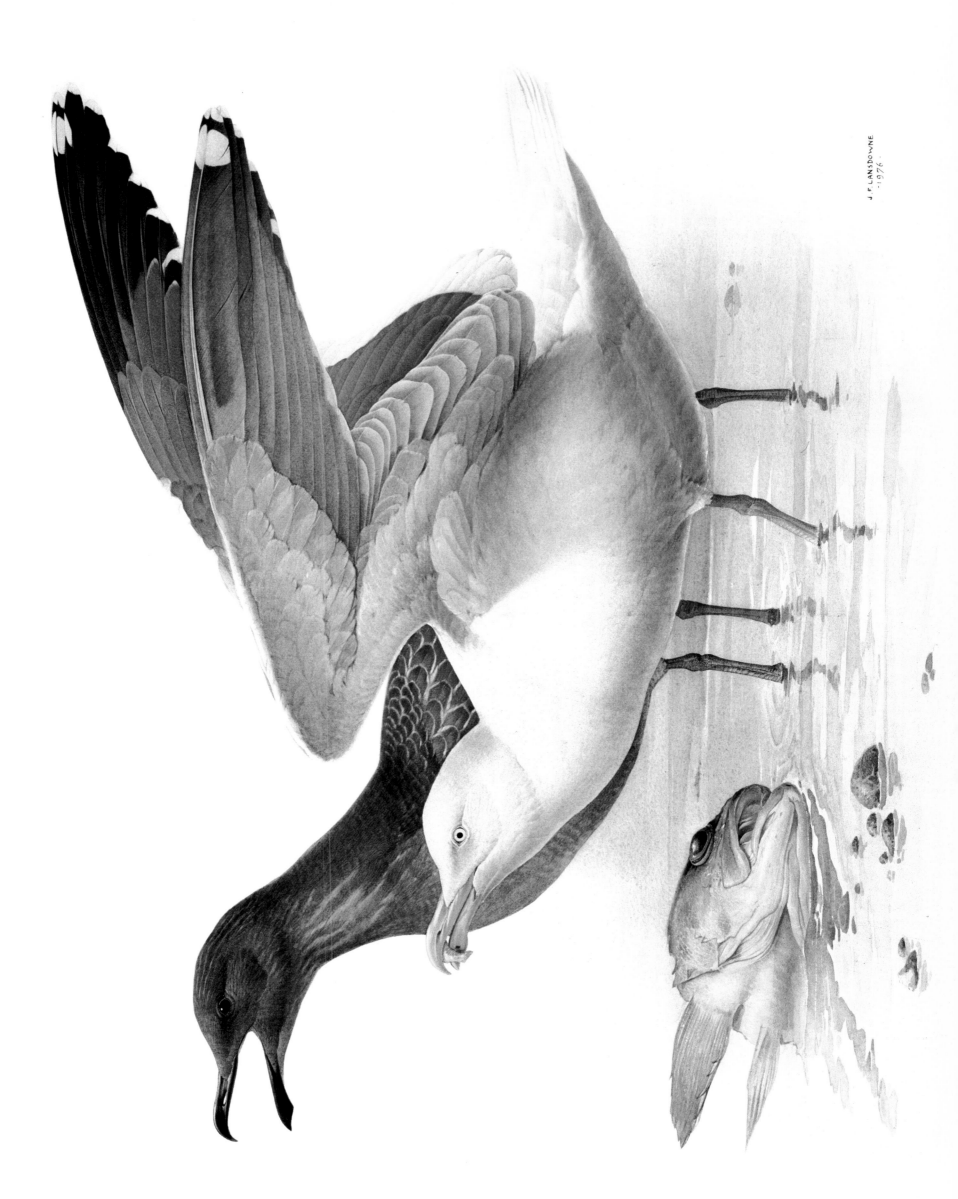

J.F. LANSDOWNE
·1976·

Heermann's Gull

Larus heermanni

The most distinctive gull of the Pacific coast, Heermann's of the smoky plumage and scarlet bill is only a visitor to the northwest. Exotic in appearance–no other of our gulls looks in the least like it–this bird is southern in origin and comes north in fall from breeding colonies on the arid, sun-bleached Mexican coast.

As its colouring is unusual among members of its family, so its habits are somewhat out of the ordinary. It spends much more time offshore than is the case with most gulls and may be found on the great beds of kelp that lie along the edge of the ocean at a little distance from the land. There, Heermann's gulls hover and dip in search of fish and other edible things just below the surface or in the tangled weed.

I have an early memory of them seen in this characteristic way off Vancouver Island one raw November afternoon. Grey skies with darker birds beating up into the wind and then wheeling back across the kelp that rose and fell to the rhythm of the Pacific swell. All was leaden, with only the bills to give points of colour.

They belong, however, in a sunnier land, and on the coast of California in summer, when their earlier, southern breeding season has ended, they are very common. They are beautiful birds in full plumage, rather lighter in build and leggier than the western gulls that are their frequent companions. Only the very dark young birds in their first plumage might be confused with another species, the young western gull. Adults are unmistakeable.

Though a large part of their food consists of fish, Heermann's gulls are also scavengers and thieves. Around the Monterey Peninsula they stand about picnic spots and lookouts in the cold-eyed, slightly disreputable manner of gulls everywhere, sidling forward at a half-run with partly open wings at the sight of discarded food or refuse.

They are a sore trial to the brown pelicans. Not only going into their very pouches to rob them of their catch, but on the Mexican breeding grounds they share, eating the eggs and bullying and bothering the young until, in confusion and fear, they regurgitate their food.

Heermann's gull builds a firm, well-constructed nest, as a rule, reportedly superior to that of the western gull. Eggs are laid sometime in March, ashy or pale buffy grey eggs that, spotted and irregularly marked with darker colour, hatch about a month later. Though the first winter plumage is so very black, the downy birds are pale, to harmonize with their early surroundings.

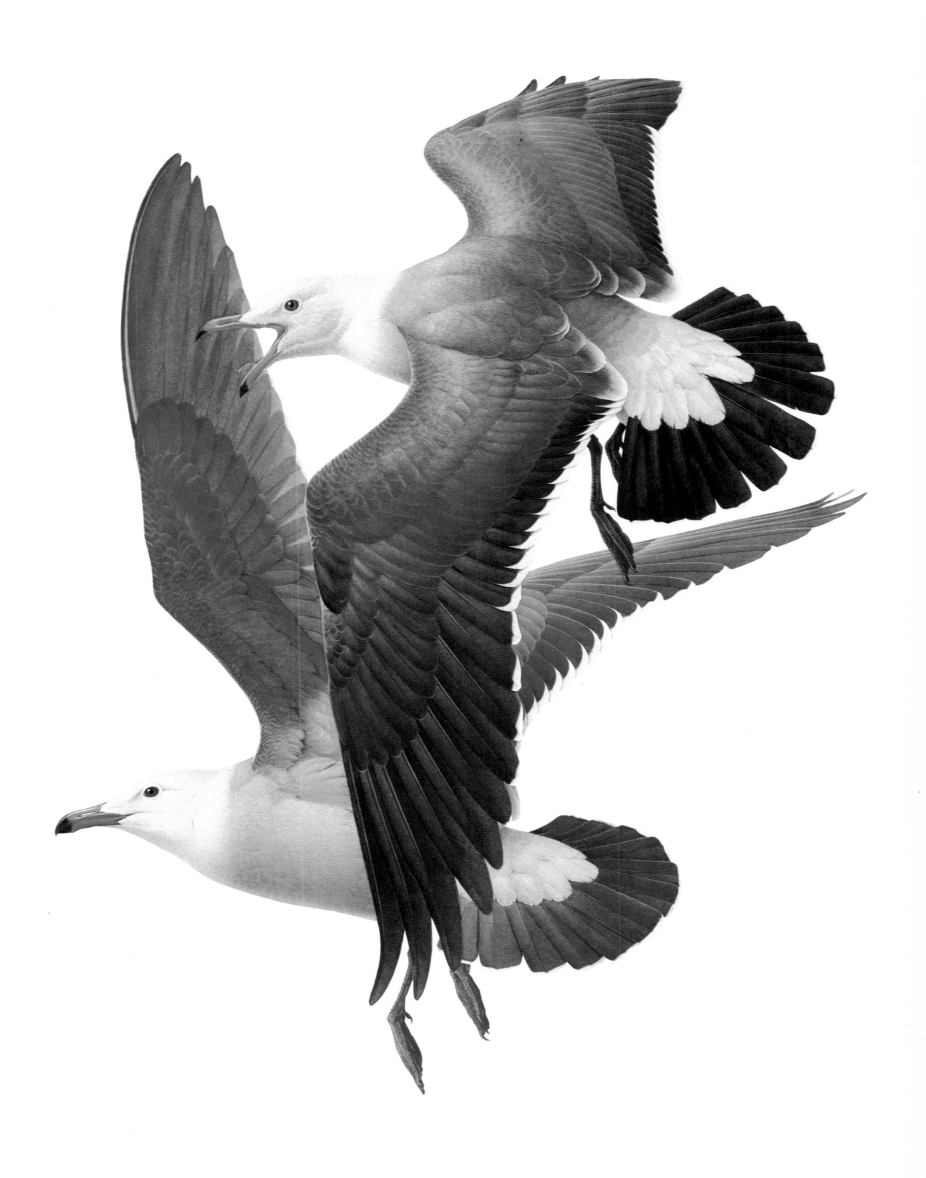

Screech Owl

Otus asio

The screech owl is probably the best known small North American member of the family. It is found in almost all parts of the United States and Canada, and to people living in country districts the tremulous quaver of its voice is still a familiar sound of the night. Sadly, in more populous places it is becoming unusual.

One of the most intriguing facts about the screech owl is that it comes in a choice of colours: grey or bright rufous or a less conspicuous brown. In the eastern parts of the continent where this dichromatism is at its most pronounced, the more common plumage is bright orange-brown with an alternative form in pale grey. Our birds of the west are darker and have less contrasting grey and brown phases. The screech owl I have painted was a bird from Vancouver Island and is shown among the branches of my studio plum tree, about to devour one of the pigeon house mice.

There are areas in which one or other of the colour phases predominates, but these overlap, and birds do not mate exclusively with others of their own colour. Mixed marriages may produce owlets of either plumage.

As in snow geese, the two phases are thought to represent an evolutionary stage on the way to the separation of one species into two.

The screech owl is almost entirely nocturnal in habits, spending the day quietly concealed near the trunk of a tree and seldom being seen abroad during the hours of brightness. One may sometimes use a cavity in a tree and, becoming attached to it, will roost there daily, head and shoulders visible to the outside world. Close to my home there is one such roost in a Garry oak that for years intermittently held a sleeping owl. The owl was exactly the colour of the oak bark, and when it sat filling the entrance, both owl and doorway became invisible.

At dusk the screech owl becomes alert and active. Now the liquid eyes are no longer slitted in repose but wide with dilated pupils, the appearance of the whole bird is in complete contrast to that of a few hours earlier. It may utter some un-owlish notes, and I remember one evening hearing a loud, almost chicken-like cackling that I could not at first identify. This odd sound came from a lively screech owl that had alighted on a clothesline pole, on the first stage of its nightly hunt.

Screech owls are the scourge of small mammals and birds, and although not large are ferocious and formidable. Mice and other rodents are the staples, but other creatures, greater and lesser, are taken as opportunity affords or hunger dictates. At one end of the list are beetles, moths and other insects, while at the other are pigeons, grouse and chickens. A pair of screech owls will wreak terrible destruction among a small bird population and are unwelcome visitors to a bird sanctuary.

The musical notes of this bird are not difficult to imitate and with a little harmless deception one may easily call the callers. Some years ago screech owls could be heard in the suburbs of Victoria, and I would amuse myself on summer evenings by answering them. In the near-dark of a grove of trees I once drew an inquisitive owl to within a few feet of my face.

Screech owls nest in natural cavities or occasionally the excavations made by flickers. Secluded, well-wooded sites are generally chosen and little or no effort is made to line the hollow with nesting material. The eggs, three or four in number, are simply laid on the floor of the cavity. Parental duties are at first divided by sex, with the female bearing the burden of incubation, while her mate brings food to sustain her during the long hours.

The nestlings are fed small pieces of meat or regurgitated food by both parents until they are several days old, when whole creatures are offered to them. During these first days they are sad-looking sights, shivering and without covering. In about two weeks a thick, greyish down appears, and with eyes now open and blinking, they are at their most engaging, huddling together in their tree nursery.

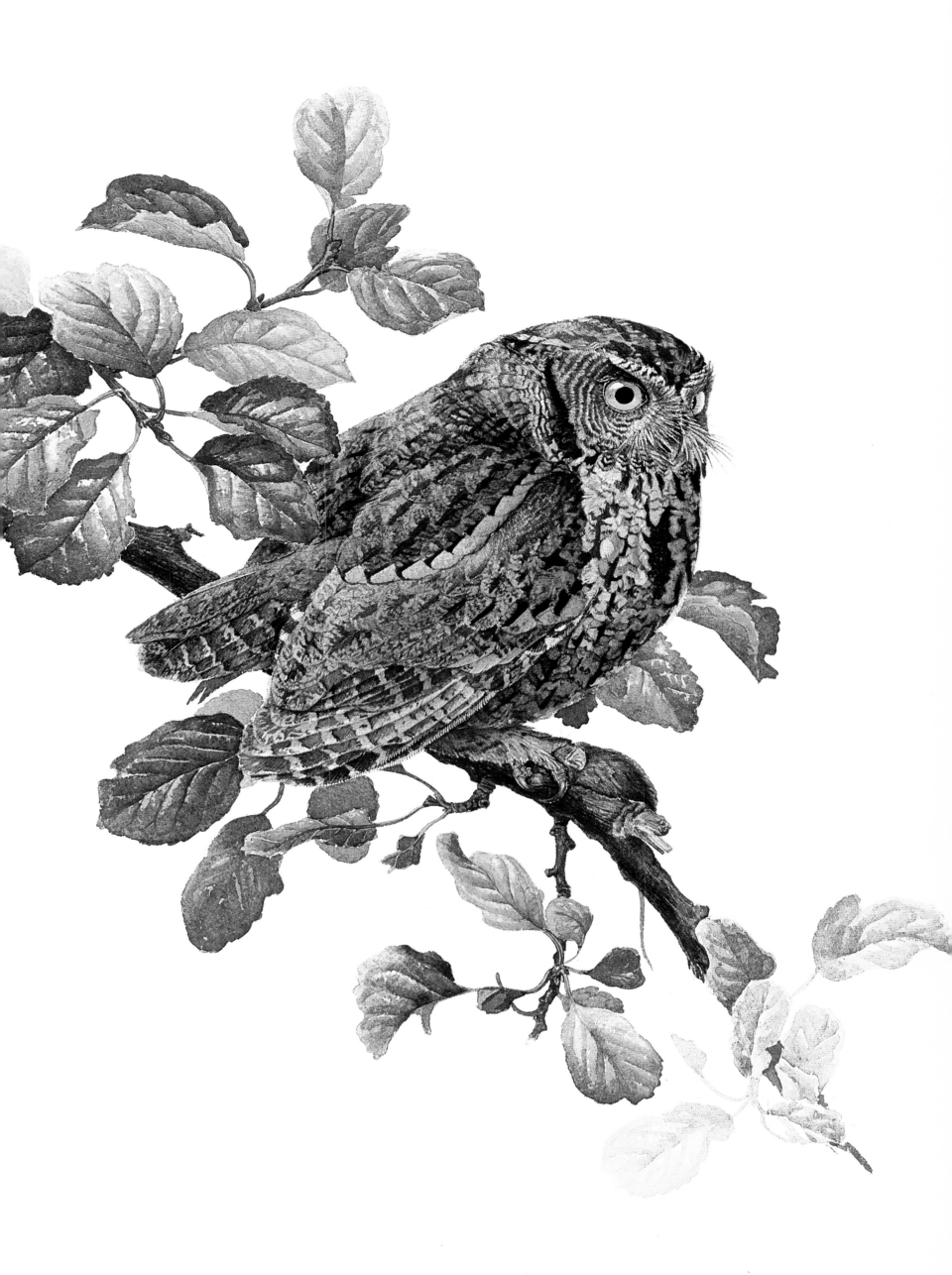

Great Horned Owl

Bubo virginianus

With a wingspan of between four and five feet and a taloned grip capable of killing a skunk or a Canada goose, the great horned owl may well be called a tiger among birds. No exaggeration or slander is this; it is a ferocious, dangerous bird of prey, the terror of the darkness. The horned owl is a bringer of swift, silent death and its penetrating hoot, likened by J. A. Munro to "a savage chieftain's tom-tom beating," is a sound to chill the hearts of every creature abroad in the night.

This magnificent species is one of our largest owls, comparable to the snowy owl of the tundra and far more powerful than the great gray. It is a dweller in forested or well-wooded country from the fog-enshrouded shores of the west to the Maritimes and from the Arctic to Costa Rica. So widespread a bird as this, with a range so climatically and geographically diverse, is likely to vary in the colour of its plumage from place to place. Thus, in the great horned owl we find birds differing markedly in shade; Arctic owls of the treeline's northernmost limit are almost completely white, while darkest of all is the race we encounter on the coast from northern California to British Columbia.

The great horned owl has immensely acute hearing, so delicate that it is able to detect and exactly locate the smallest squeak or rustle. Moreover, its sight is keen by either night or day. Owls' eyes function well in minimum light due to the great dilation of which the pupils are capable. In spite of these huge and marvellous eyes, it may be that horned owls primarily locate and pin down their prey by ear, as barn owls are able to do.

These factors make the species well-fitted to a largely though not entirely nocturnal life, and between the shadowed hours of nightfall and dawn no small or medium-sized mammal and no roosting bird is safe if a horned owl is in the vicinity. Many times of a winter morning the floor of a wood holds the silent evidence of some night forager's end: the "angel wings" imprint of pinions in the snow, a little blood and a few feathers or bits of fur. A horned owl has killed here.

In the past particularly, this owl has been the deadly foe of poultrymen, though where rabbits abound or other natural prey is available, they are preferred to chickens or turkeys. Rodents may constitute the greater part of a horned owl's food but nothing is disdained, provided it is conquerable and for this bird most things are. When confronted by a surfeit of prey, as in a chicken run, the owls will often kill many, eating only the brains of their victims.

Nesting is begun very early in the year, in February or even earlier, when snow lies on the branches and the temperature is well below freezing. Eggs and young are brooded carefully in this weather, and the incubating bird may at times be covered by a white blanket while she sits. The nest itself is almost invariably the abandoned home of another large species such as a red-tailed hawk. The new occupants may add a few sticks and twigs, but the main structure is the work of previous owners. It is usually high, fifty or more feet from the ground, in a secluded position in the deepest part of the forest.

The two young owlets, round yellow eyes blinking through the dark facial discs of their pale down, are slow in growing, and it is nearly two months after hatching before they leave the nest. Even then, it is only to clamber about. An additional month or more is needed before they are able to fly.

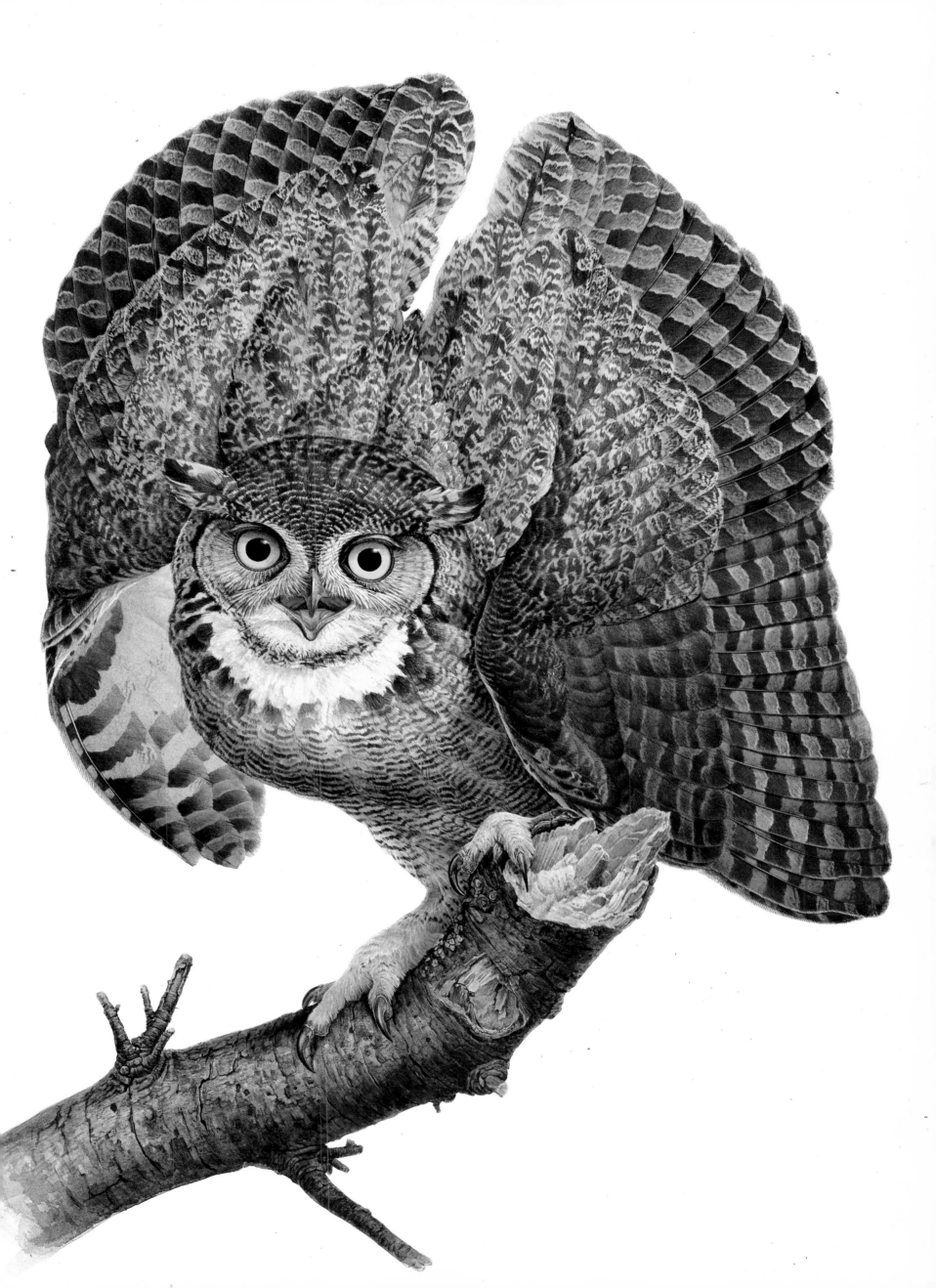

Anna's Hummingbird

Calypte anna

In our minds, this lovely species has always been associated particularly with California; it both breeds and winters in that far western state. However, it has lately become of more than usual interest in the Pacific northwest, because of its recent northward surge. Where the only species of hummingbird to occur was the fiery little rufous hummingbird, the appearance of the Anna's with the pinkly iridescent gorget and forehead has been something of a phenomenon. As sightings became more frequent, it was apparent that they were not cases of mere accidental straggling but an extension of the range of Anna's hummingbird into latitudes where it had been previously unknown as a regular visitor.

On southern Vancouver Island these early pioneers of the 1960s, mostly males, stayed throughout the winters and so were especially noticeable at a time when our gardens were forsaken by those summer soldiers, the rufous hummers. More recently, birds of both sexes have stayed through the summer and have been seen courting and carrying nesting material, though no nest has been discovered.

The northward movement of Anna's hummingbird is interesting but not unique among birds that, due to one factor or another, may alter their ranges quite rapidly. Several examples come to mind, among the most dramatic being the meteoric thrust of the cattle egret from across the Atlantic to South America, the southern United States and north to Canada. On the Pacific coast the housefinch, bushtit and cowbird are all new adventurers to Vancouver Island, while the Bullock's or northern oriole has travelled there from the dry interior.

Anna's is one of the larger hummingbirds, though still a very small bird, and its dark green body and rose-tinted ruff make it fairly easy to identify. As are most other species, it is territorial and the males will spend much of their time on favourite perches from where they are able to overlook their "claims". They are given to strenuous and immediate defence of their territories, streaking out to intercept intruders even if these should be species much larger than the hummingbirds themselves. Crawford H. Greenewalt says in his beautiful and freshly written book, *Hummingbirds,* that he believes "all hummingbirds to have a touch of the Irish in them", and goes on to observe that their "aerial jousts" with other males and other birds may be as much for fun as for anything.

This species sings a song audible to human ears, though it is a squeaky one and not loud. More impressive is the visual part of the courtship in which the male displays before the quietly resting female. In a performance somewhat reminiscent of the rufous hummingbird's, Anna's hummingbird towers until he is all but lost in the bright sky and then dives straight down at great speed. Recovering himself just before disaster, he utters a loud "chirp" and curves up to a point just before and above the object of his desire. There he hovers in a horizontal position, head down and singing. Apparently while still at this angle to the ground, he ascends once more, in what is surely an astonishing feat of aeronautical ability.

The male bird takes no part in nest construction, nor has he any part or interest in the domestic duties that are the result of his flamboyant behaviour. His mate alone gathers the plant down, spider's web and lichen to form the sturdy and exquisite cup, and it is she who broods and raises their two tiny offspring.

These, when first hatched, are black-skinned and unprepossessing, nothing is visible of feathers except a slight suggestion of down on the dorsal tracts; the swollen-looking eyes are tightly sealed. However, in a few days a complete transformation takes place and the young become miniatures of their mother. In about three weeks, they have grown too large for their diminutive home, whereupon they leave.

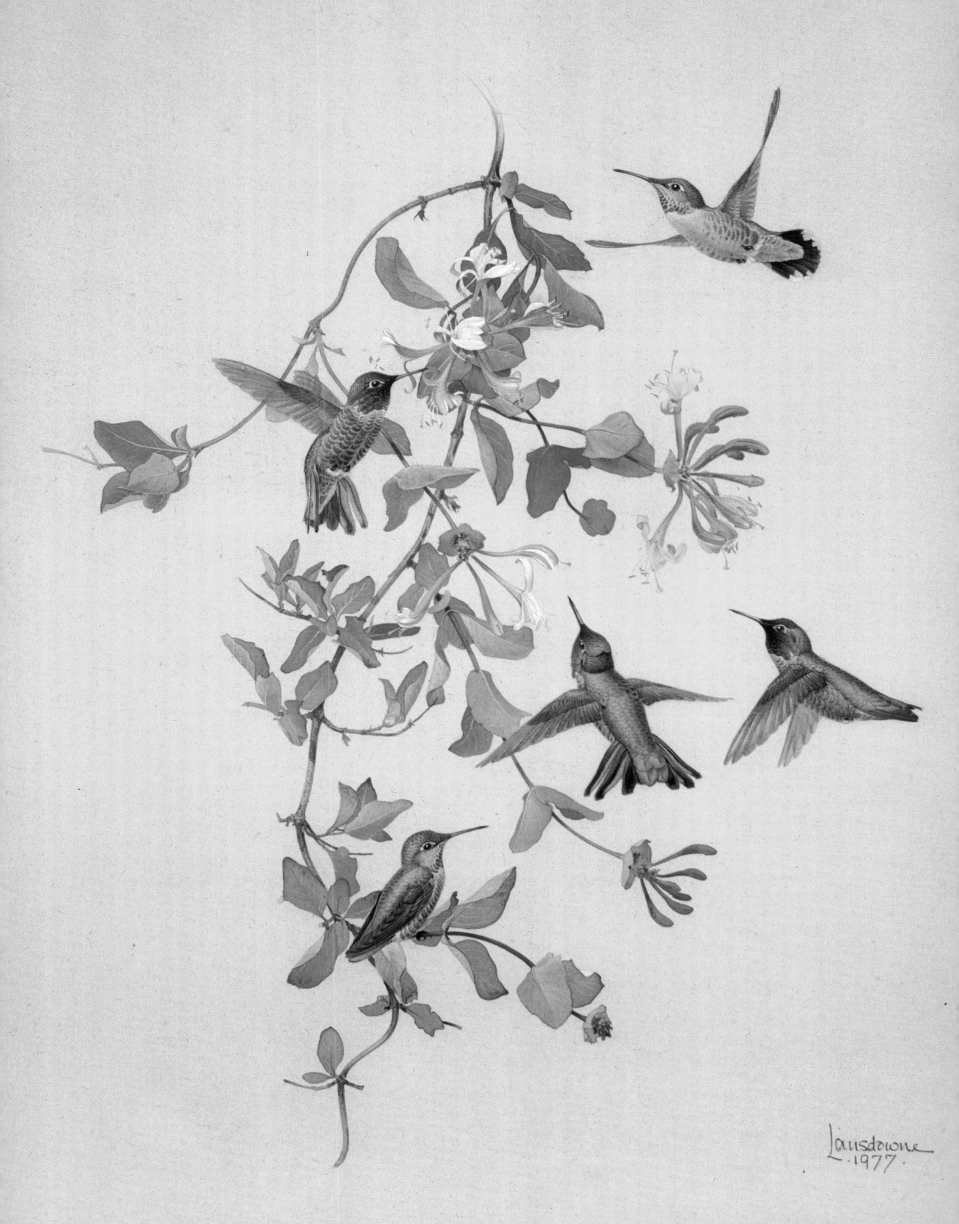

Lansdowne
1977

Black Phoebe

Sayornis nigricans

The Americas are the home of an extensive family known as the tyrant flycatchers. A few species have bright colours or unusual ornamentation, but most are quietly dressed, small to medium-sized birds. Their family name gives a ready clue to both their habits and their nature.

The flycatchers have large heads and the wide-gaping, bristly bills that are particularly helpful in the snaring of small, airborne insects. They furnish an interesting example of parallel development, for in general appearance they are like the Old World flycatchers, birds that have similar habits but to which they are not closely related.

The black phoebe, a flycatcher with an unusually quiet and gentle disposition, is found from Argentina to northern California. If it lacks the belligerence of its relatives, it is a typical flycatcher in other ways, spending much of its time on a well-situated perch from which it sallies out to catch passing insects.

Easterners will find in the black phoebe's demeanour and appearance much to remind them of their own, familiar eastern phoebe, a brownish bird whose two-syllable call has given the phoebe group its name. These species share many characteristics, among them a liking for proximity to water, and both may be looked for along the banks of streams, by ponds and in damp places generally. They seem to find the company of man to their liking and black phoebes are often seen in the vicinity of farm outbuildings, where insects are likely to be numerous.

Phoebes do not seek high, commanding positions as do the quarrelsome kingbirds and noisy olive-sided flycatchers but stay unobtrusively near the ground. A fence post suits them or a low-hanging limb in the shadow of the tree canopy yet with a clear view of the surroundings. The black phoebe is a common bird in some California towns by the coast, and it often plies its trade among suburban trees, flitting down to snap moths and other winged creatures from the lawns.

In the community of Inverness that clings to the shore of Tomales Bay, a black phoebe provided me with an attractive picture: a dusky, alert little flycatcher perched atop a stake to which had been affixed several glittering abalone shells, each larger than the bird.

Phoebes return to the same nesting sites year after year, and once a spot has found favour in their eyes it will continue to harbour a pair of these flycatchers every season. They build a nest somewhat in the manner of barn swallows, firmly gluing a mud cup to the surface of a wall or, as in earlier days, to a rock face in a ravine or crevice. A place is chosen that provides a sheltering overhang, and one of the most usual places to find a nest of this bird is under a bridge, where a beam provides all the requirements of water, shelter and vertical surface for the nest. Both sexes take part in construction of the nest and in incubating the young.

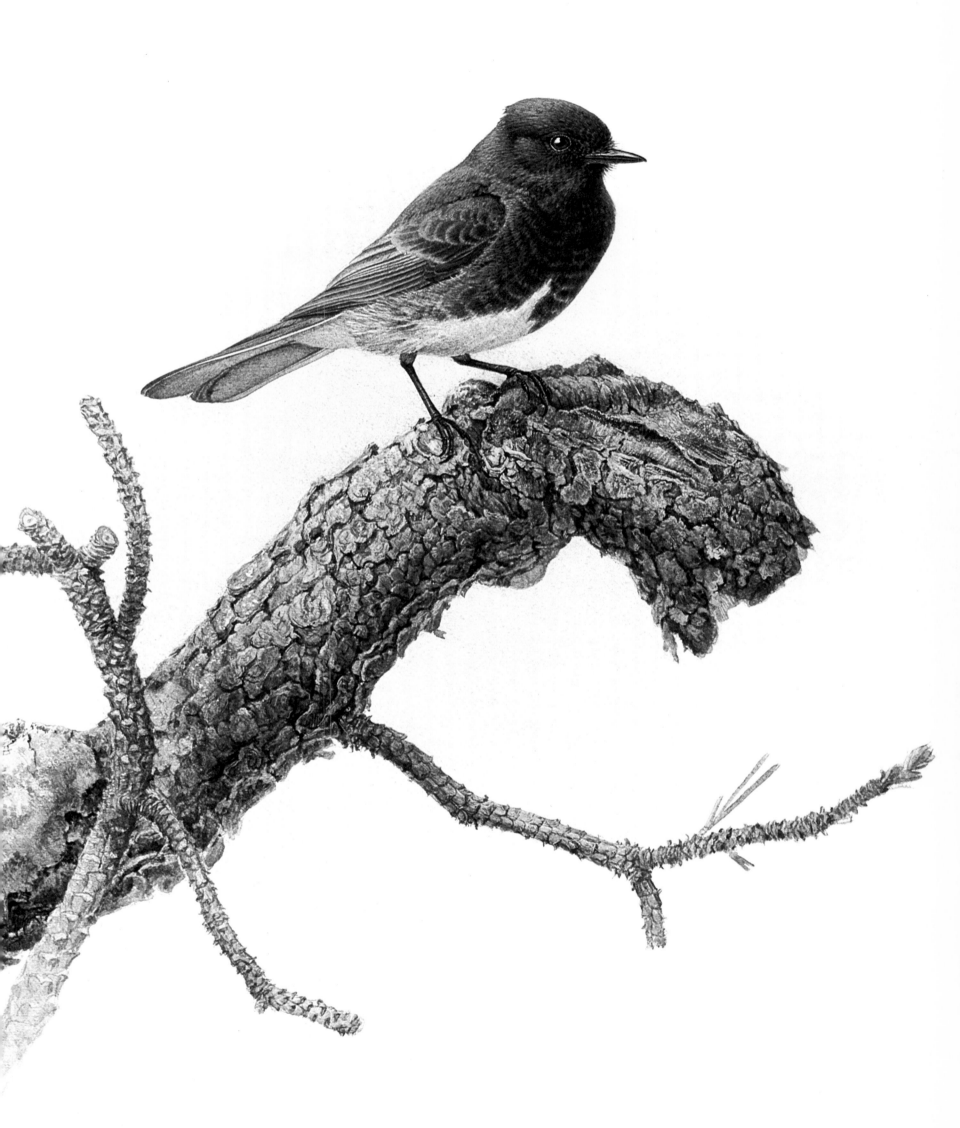

34 Scrub Jay

Aphelocoma coerulescens

On the hillsides and canyons of California, one of the most prominent birds is the blue and fawn scrub jay. A round-winged, loose-plumaged bird without a crest, it fills much the same ecological position in the oak and pine country of the far west as the blue jay does in the hardwoods of the east. It is California's local small-time predator, busybody and general nuisance.

The scrub jay appears on the coast in Washington, but not for some distance to the south is it seen frequently. In northern California, it becomes conspicuous, and its harsh chatter, instantly recognizable as that of a jay, is a common sound that everywhere intrudes upon one's consciousness.

All jays have a bad and unfortunately well-deserved reputation for nest-robbing. Scrub jays are as guilty of this grievous practice as any, and in spring and early summer they are very destructive of eggs and nestlings. Their sharp eyes peer and pry into every bush, missing very little. They themselves, so obtrusive and careless of concealment during the rest of the year, are silent and furtive when they have young. It is as if their own behaviour toward others has taught them an appreciation of discretion.

People find the weakness for nest-wrecking a repellent aspect of the family character. Certainly, to witness an act of thievery is distressing, especially if helpless nestlings are carried off, but this sort of robbery is only one part of an otherwise beautiful and very interesting species. Jays have opportunistic natures and the liveliness of mind common to all the crows, magpies and ravens. They are fun to watch, for they can put two and two together quite quickly, and are good at solving the problems of their daily lives.

Because eggs are a seasonal delicacy, they do not constitute the whole of a scrub jay's diet or even the major part of it. Insects of many kinds are eaten and also miscellaneous other animals when chance arises. The plant kingdom provides the jay with very important food, acorns and oak mast, as well as with berries, seeds and fruit. With their propensity for caching and burying acorns, scrub jays contribute to the renewing of the oak forests.

Scrub jays conceal their nests well in brush or trees, at varying heights from the ground and usually near water. The nests are described as being nicely made of fine roots and grass, constructed without mud and built on a base or platform of sticks and twigs. Four to six eggs are laid, and these may vary considerably in colouring from clutch to clutch. Some shade of pale green is most common, but eggs of pale cream occur and so, more rarely, do greenish eggs that are speckled and blotched with reddish brown.

The nestling jays, once they have passed the blind and naked early stage, assume a plumage not unlike that of their parents, only duller and greyer.

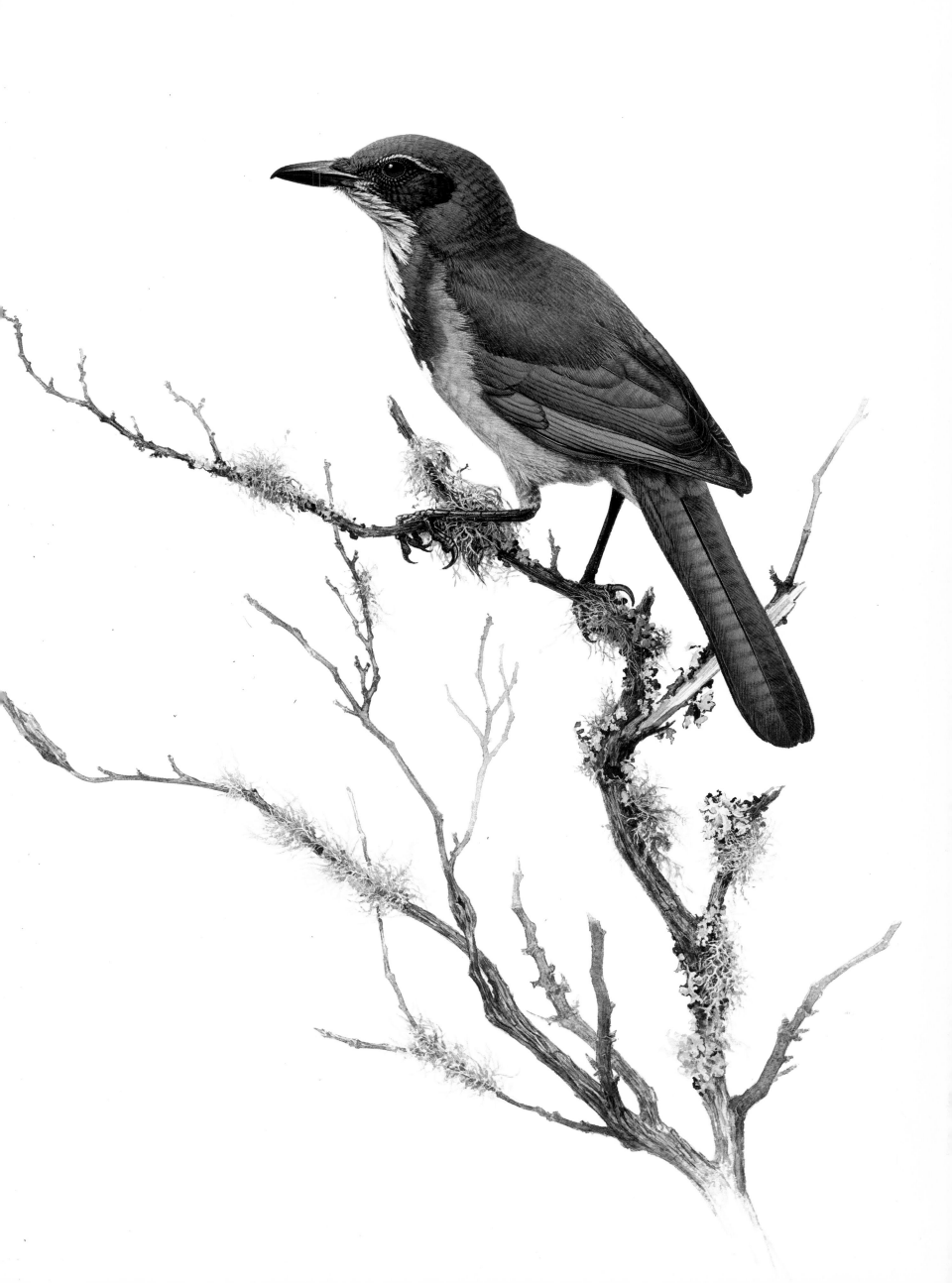

Northwest Crow

Corvus caurinus

Few people have a kind word to say about crows. Their reputation is so dark and of such ancient standing that no words in their favour can eradicate from our ancestral memory the prejudice against them. In popular imagination, they remain as black-hearted as they are black of plumage, and yet, although the hand of every man is against them, crows thrive and have even increased their numbers.

Crows of one species or another are native to almost all temperate parts of America and Europe and to many other parts of the world. Their habits are, in general, very alike but there are slight differences. For example, the carrion crow of Europe is comparatively solitary, while our birds forage and live together in a more communal style, more as rooks do in the Old World.

The crows of the Pacific northwest have troubled the minds of ornithologists, because in some ways they differ from the birds found elsewhere on the continent. Higher-voiced, smaller and with lives more closely bound to the seashore, they resemble the fish crows of the Atlantic and have at different times been classified as a full species and as a race. Whatever its official status of the moment, the northwest crow inhabits the coast from Alaska to Puget Sound in Washington. It is commonly seen on beaches and tidal flats, as well as on agricultural land where crows usually congregate.

Along the shore, the crows feed extensively on shellfish and have developed a characteristic way of breaking the shells. Carrying the clams or mussels in their bills, they fly up and drop them on the rocks. This they do repeatedly until the shells are sufficiently fractured. Gulls do this, too, and I sometimes wonder whether one species taught the other or whether they learned independently.

As can be seen, the pictured bird is young and not long out of the nest; it still has the greyish blue iris of babyhood, although it is able to fly. There is little difference in plumage between adults and young, only a dusty dullness to the feathers and a moth-eaten appearance in the juvenile birds. The legs of these first autumn birds are of a leaden grey but in maturity become as black as anthracite.

In fall, the suburbs of the northwest are noisy with the raucous, gargling cries of crow nestlings. This species builds in trees and bushes everywhere among the houses and is too plentiful to suit most people. Before raising their own young, the crows are a great scourge to the robins who lose most of their first broods to them. Later, busy with the feeding of their own young, they leave the robins alone but are in turn preyed upon by raccoons.

I like crows, but I am in the minority, I know. There is much to admire in their intelligence and in the order and complexity of their lives as well as in their beauty. Despite being without accenting colour or relieving pattern, their plumage is most beautiful. Dense and smooth, jet with a high, almost lavender lustre, it seems lacquered, to all appearances a perfect fibreglass shell. In the hand it is soft and rich as watered silk. Both the strong, hard bill and the glittering eye have their own quality of brightness.

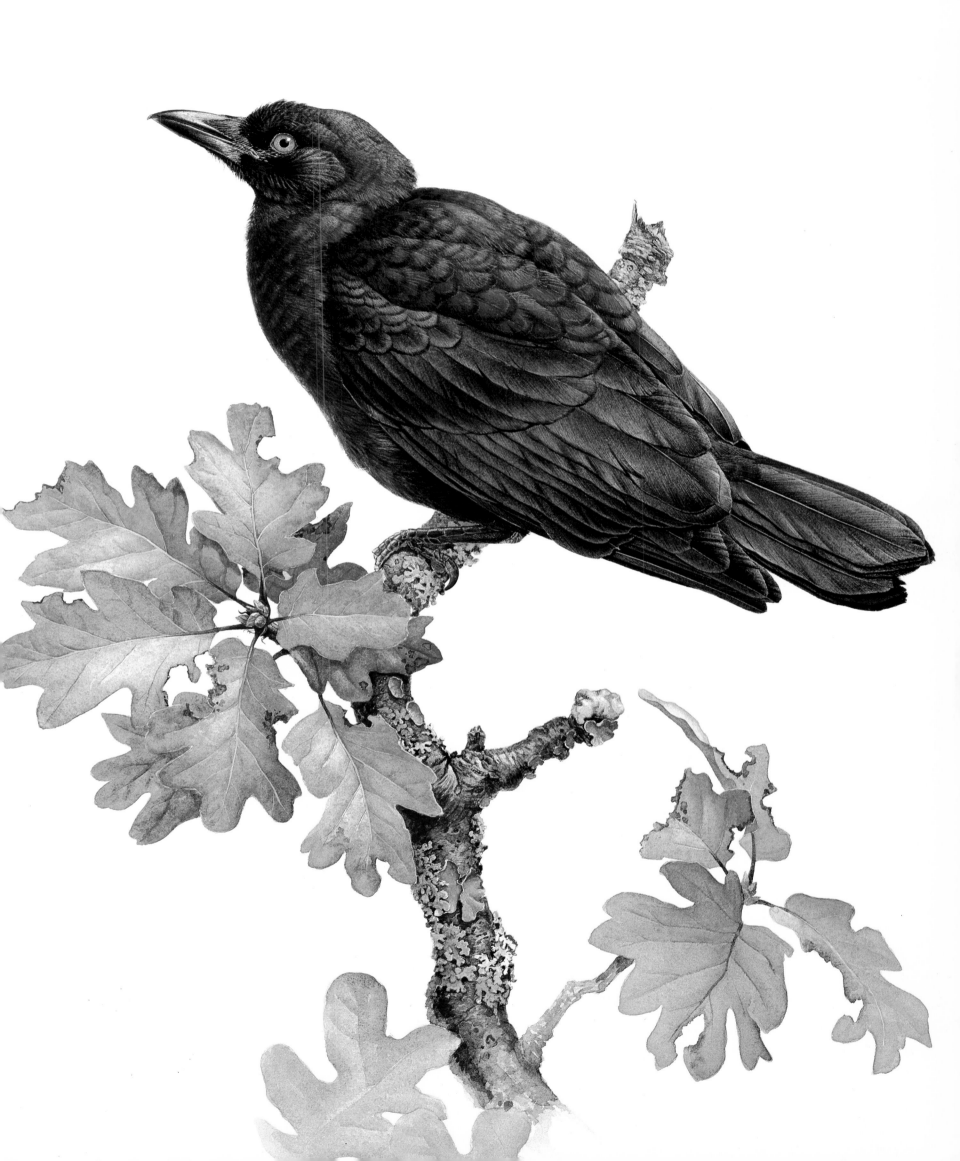

 Bushtit

Psaltriparus minimus

In the last twenty years or so my home country of Vancouver Island has seen the arrival of a diminutive invader, the bushtit. The southern mainland of British Columbia marks the former northern extent of its range, but in one of those sudden thrusts to which some species are given, the bushtit has advanced its frontier northwestward. Elsewhere, it occurs over the whole coast of North America west and, in some places, east of the Rocky Mountains and south to Guatemala.

No one who sees these tiny relatives of the chickadees hastening in a flock through the countryside, upside down, right way up, busy and meticulous in their search for insects, can fail to be charmed by them. The sight was unknown to me when I was younger and before I had visited the states south of British Columbia, but, happily for those of us who take pleasure in such things, bushtits are now familiar and established here.

They are among our smallest birds, little larger than hummingbirds, although their balancing tails give them greater length. So minute are the bodies, so slender the legs, that kinglets seem sturdy in comparison and chickadees clumsy. One must be very near these brown-capped, mouse-grey birds to see the pale iris of the male or to distinguish it from the dark eye of the female. Bushtits are not forest dwellers but are to be found in the shrubbery and hedgerows of more open country where bushes and small trees alternate with clearings and spaces. They travel in active, vocal flocks of twenty to fifty and seem to prefer their own company to that of others. They will not be found enjoying the breezy companionship of the bands of small species that vagabond through the woods in fall and winter.

The ceaselessly uttered, trilling call notes of bushtits can be heard long before the "cloud" of little birds reaches the listener, surrounds him and passes from view. By means of these notes members of a group keep in touch. If one should stray or lag behind, it will climb in agitation to some vantage point and from there send out a louder call until answered by some of the main party. In their progress, they glean quantities of small and often injurious insects: aphids, leafhoppers and scale insects, as well as the larvae and cocoons of damaging moths.

Early in the year the large groups of bushtits begin to separate into smaller parties. By spring these have resolved themselves into pairs for the breeding season. Bushtits build curious and beautiful nests quite unmistakeable and unlike those of any western bird. Using the softest and most delicate of basic materials, plant down, lichens, moss and spider web, they weave an enclosed, pendular structure of seven to ten inches in length. After the initial, anchoring ring has been lashed to a set of twigs, both male and female bushtit work downward, adding and pushing and tucking, building from the inside. Other materials at hand are incorporated; some nests may have string or rootlets or fir needles woven in, while others display grey lichens, or a covering of yellow green moss. Hung in clumps of leaves and blending well, they often escape notice.

The entrance, at the side near the top of the nest, leads to a steeply inclined passage at the end of which is the enlarged and reinforced nesting chamber. One nest which I have beside me has this compartment thickly walled with plant down and a few breast feathers of a robin.

In this small, snug nursery five to seven eggs are laid and here the nestlings spend their first days. After leaving the nest, the young are fed by their parents for eight or ten days, until proficient enough to forage for themselves.

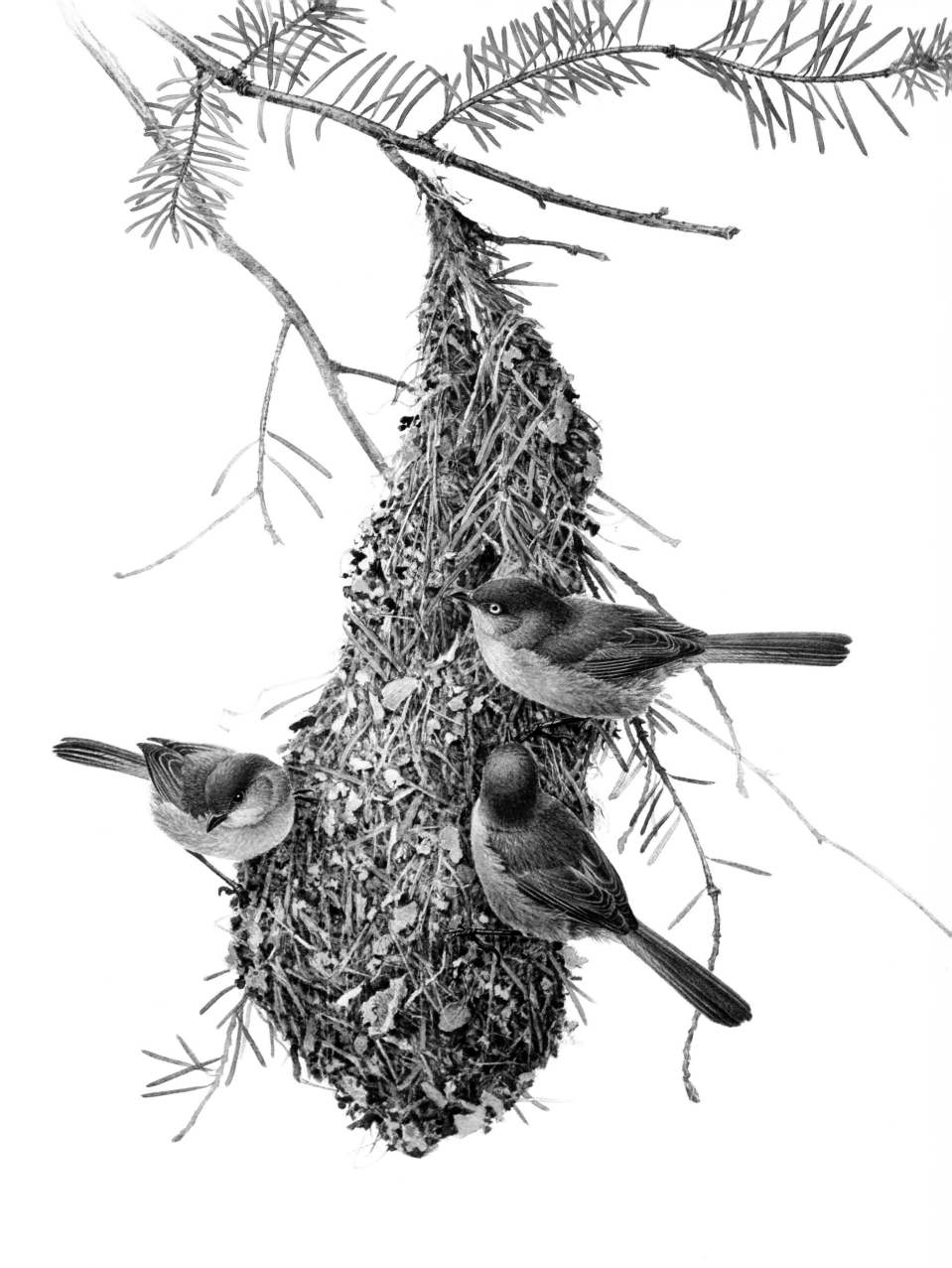

Chamaea fasciata

My experience with the wren-tit, that elusive and unique inhabitant of our west coast, is limited to a single encounter. It is not well-known to most people, and its way of keeping to tangled and obscuring undergrowth make it a bird more often heard than seen.

The wren-tit is restricted to the western edge of North America between Oregon and Baja California. In the northern part of its narrow range, the area dealt with in this volume, it inhabits sheltered valleys and dense, wind-clipped slopes above the sea. There it is very difficult to glimpse, both by nature of the terrain it favours and because of its predilection for concealment.

It is not an easy bird to place in relation to others, for it shares the outward attributes of some species and yet is unlike any. The wren-tit's stout little bill brings to mind those of the chickadees, while in its colouring, its scolding and the angle of the long tail one sees the wrens.

"Wren-tit", its put-together name, is compounded of those of two unrelated families and shows the dilemma of taxonomists when attempting to trace the wren-tit's origin. Unable to assign it a place in any established family, they have put it by itself.

These birds seldom show themselves in the open and could be described as skulkers. They keep low, within a few feet of the ground, and from the security of thick cover berate with harsh notes any intruder into their tangled kingdom. They have what A. C. Bent describes as a "loud-ringing call", and for the mischief-making scrub jays they reserve a special degree of vituperation and hostility.

The wren-tit is not a migratory species, and individual birds, like villagers of former days, do not venture far from their places of birth. Mature birds establish territories and maintain them more or less throughout the year, although defence of the boundaries against other wren-tits is more vigorous during the breeding season. Once settled, they keep within an area of a few acres.

Insects and fruit are eaten by wren-tits. Ants and small species of wasps, beetles, all sorts of bugs, caterpillars and, without doubt, many other tiny creatures contribute their share toward the food of these birds. Low-growing bushes, such as snowberries and huckleberries, give their products in season. These small fruits and berries are held to a perch with one foot while being eaten, in the familiar way of jays or chickadees that will anchor peanuts and other things before pecking at them.

A rather charming account of wren-tits roosting together is given in Bent's life history of this species. The pairs are said to spend the nights side by side, their feathers fluffed and intermingled, so close that they seem a single bird.

The nest of the wren-tit may usually be found at a height of eighteen inches or two feet. It is a deep, strongly-made cup of spiders' web and strips of bark; in a lining of softer strips and grass the four pale, blue-green eggs are laid.

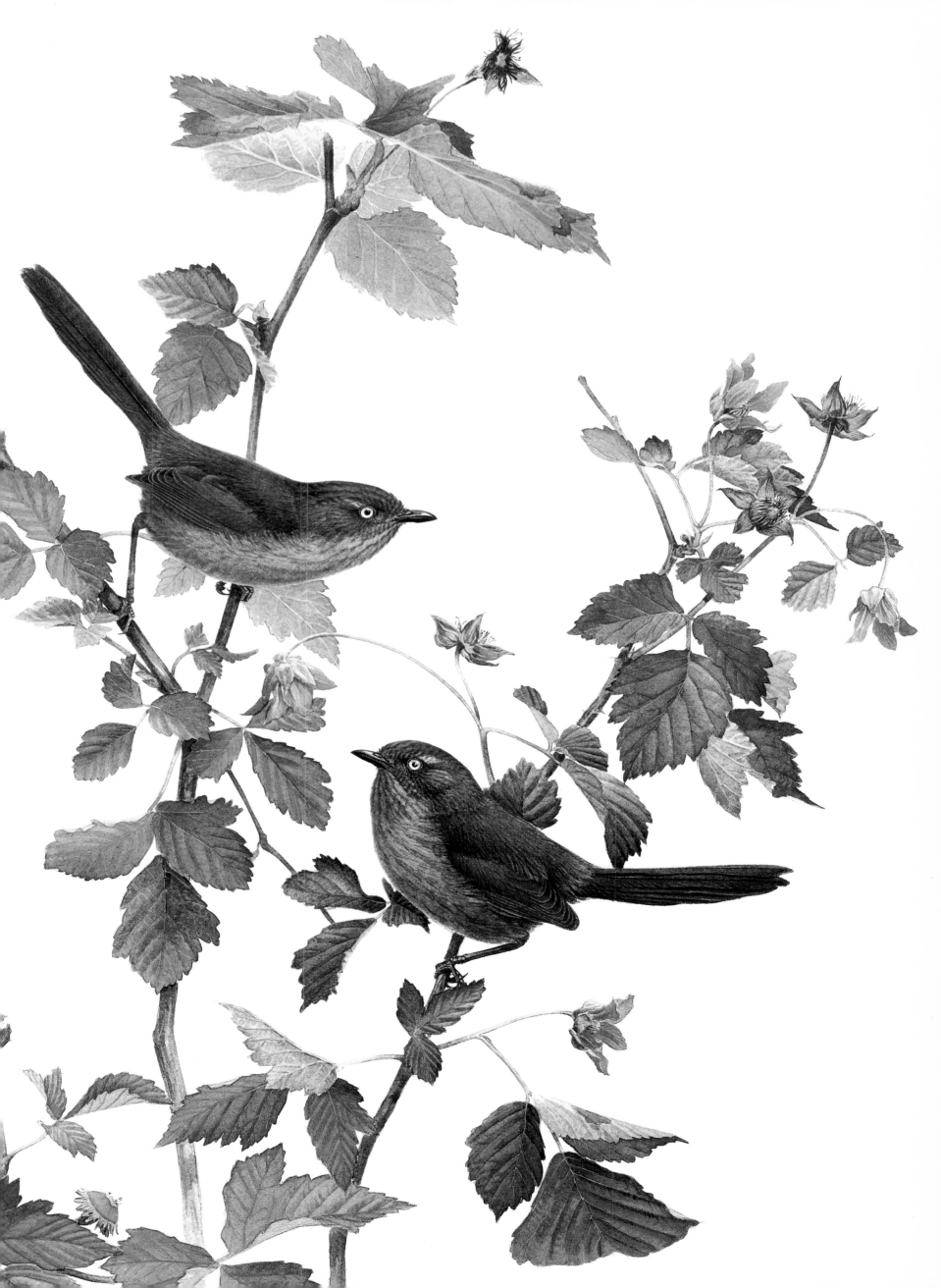

Troglodytes troglodytes

The tiny winter wren is almost the smallest bird living in the vast American forest, yet it possesses a voice of astonishing magnitude. Pouring out its song in the green remoteness of the deepest woods, it fills the stillness with a torrent of rippling notes as pure as silver.

At home on the forest floor, the winter wren keeps to dense undergrowth and to mossy shadows among great decaying windfalls, a Lilliputian in a land of giants. It prefers not to show itself, and a subdued "tchick" of interest and inquiry is usually the only indication that one is near. However, a little patience will often be rewarded by a glimpse, for winter wrens are inquisitive. A dark, stub-tailed mite will be seen lurking mouse-like within a foot or two of the ground or whirring away on minute wings to the next cover.

For all its apparent physical fragility, this species is surprisingly hardy. In demonstration of this is the fact of its breeding on the most inhospitable shores of the Aleutian and Pribilof Islands. Moreover, it is the only member of its originally tropical family to nest above the Arctic Circle. From North America, perhaps across the old land bridge of the Bering Sea, this dynamic and indomitable bird travelled, eventually to colonise the whole of Europe. It is the one single wren to be found outside the Americas.

In our west, winter wrens inhabit the humid rain forest and all the timbered regions of the coast south to California. With the mildness of climate they are largely resident, though probably those spending the summer at high altitudes make their way down to the warm valleys in fall. That a migration of sorts takes place in the northwest is indicated by the presence there for a week or two in late fall of winter wrens in town gardens, from which at other times they are absent.

The winter wren builds a nest not unlike an old-fashioned baking oven in shape. Large for the size of its owner, the nest is covered with moss and has a small entrance hole leading to the feather-lined interior. Quite frequently it is placed in among the upturned roots of a fallen tree and always is in a crevice or hollow of some kind, close to the damp ground and often near water.

In the characteristic way of more than one related species, the male winter wren may build several false nests which, if nothing else, serve to confuse the searcher. One nest alone is occupied, and in that four to seven eggs are laid.

Hardy they may be but in the coldest weather winter wrens suffer and many perish, as in the bitter winter in Europe a few years ago. There are many pretty accounts of wrens roosting together in numbers when the temperature falls below acceptable limits. A. C. Bent records a nesting box dormitory that sheltered thirty-one wrens, and I have read of fifty-two being counted as they left a similar box after a warm night of communal roosting.

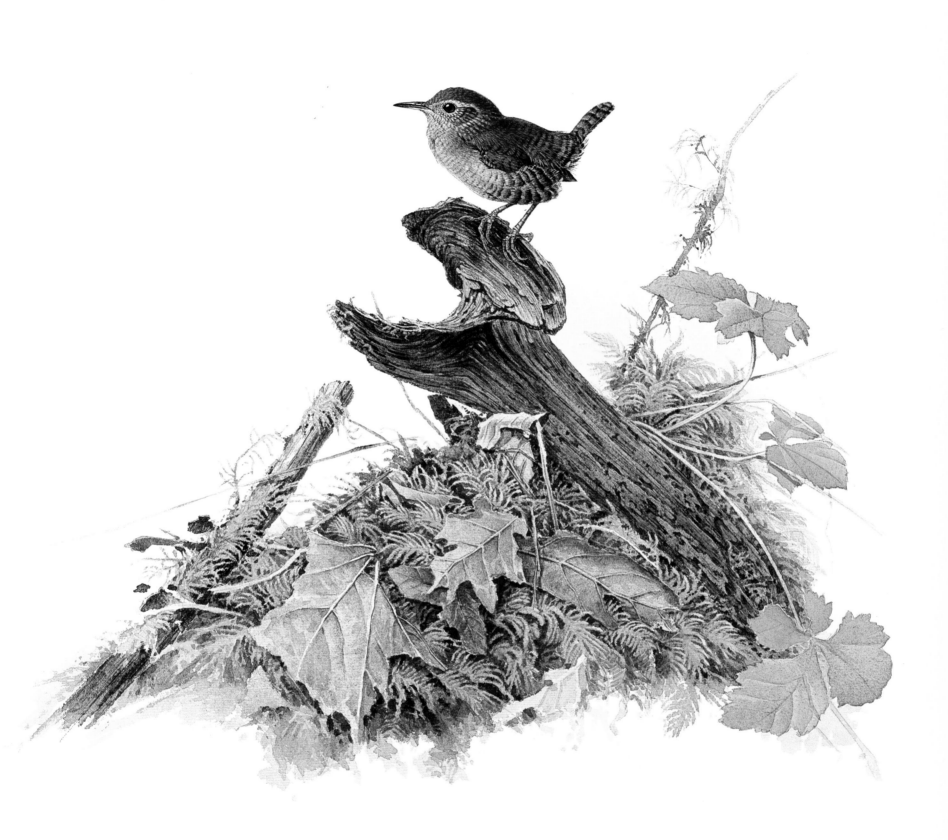

Long-billed Marsh Wren

Telmatodytes palustris

One of my haunts is a wedge of brackish marsh at the head of Cowichan Bay on Vancouver Island. Across it runs a causeway road, under which the water gurgles at the tide's change; on either side of the blackberry-tangled embankment bulrushes and other wetland plants grow thickly. Herons stalk over the glinting flats half a mile away, and an occasional eagle or raven plays overhead in the air currents that glance upward from the steep slope of Mount Tzouhalem, bordering one side.

At any time it is a lovely place to be, fresh-scented and exciting, a meeting ground where gulls and waders mingle with birds of less marine tastes. In spring rails call; the air then is filled by the discordant, beautiful voices of red-winged blackbirds and the emphatic song of the yellowthroat. Pale autumn brings the sibilance of waxwings to the thorn trees, the tinkling notes of passing goldfinches and the last swallows, flying high.

Marsh wrens live here, for it fulfills all their requirements. In summer, I can be fairly sure of being treated to a good scolding from one of these birds, delivered from a clump of reeds or from low in the willows and marsh marigolds that fringe the wettest parts.

Long-billed marsh wrens are found in marshlands throughout North America. The rapid, buzzing song is given all year but most often the singer is unseen, for in spite of his officious chatter, he is shy. A glimpse is all he will permit, and it shows a tautly active, vibrant little creature, the colour of last year's vegetation, with his tail sharply cocked in curiosity and indignation.

Before the green spears of new growth push through the sodden wreckage of the previous season's luxuriance, one sees balls of vegetation caught among the tattered, blown seedheads; the abandoned nests of wrens. Standing two or three feet above the water, they are roughly spherical and are anchored between several surrounding stems. These nests are constructed of about four discernable layers, with the form-giving outer one being of the coarsest material: long, often wet, strips of leaves and stems. When the "roughing-in" is done, the builders work from the inside, applying successively finer layers of damp vegetation. Finally, feathers and cat-tail down are brought for the lining. There is a side entrance with a projecting sill that is thought to prevent spilling of the eggs in wind or rough weather.

For every nest in use there may be several dummies built, not by the female but by the busy, polygamous male. They are not carried beyond the first stage of outer walls, and the reason for them is not clear. Perhaps they simply represent an over-abundance of energy.

The eggs of the long-billed marsh wren are an unusual shade of dark brown, described as "snuff" or "powdered cooking chocolate". Three to six are laid, and they hatch after a twelve day period. On a diet of small insects, fed to them at first in regurgitated form, the tiny, naked hatchlings double their weight daily and leave the nest in less than two weeks.

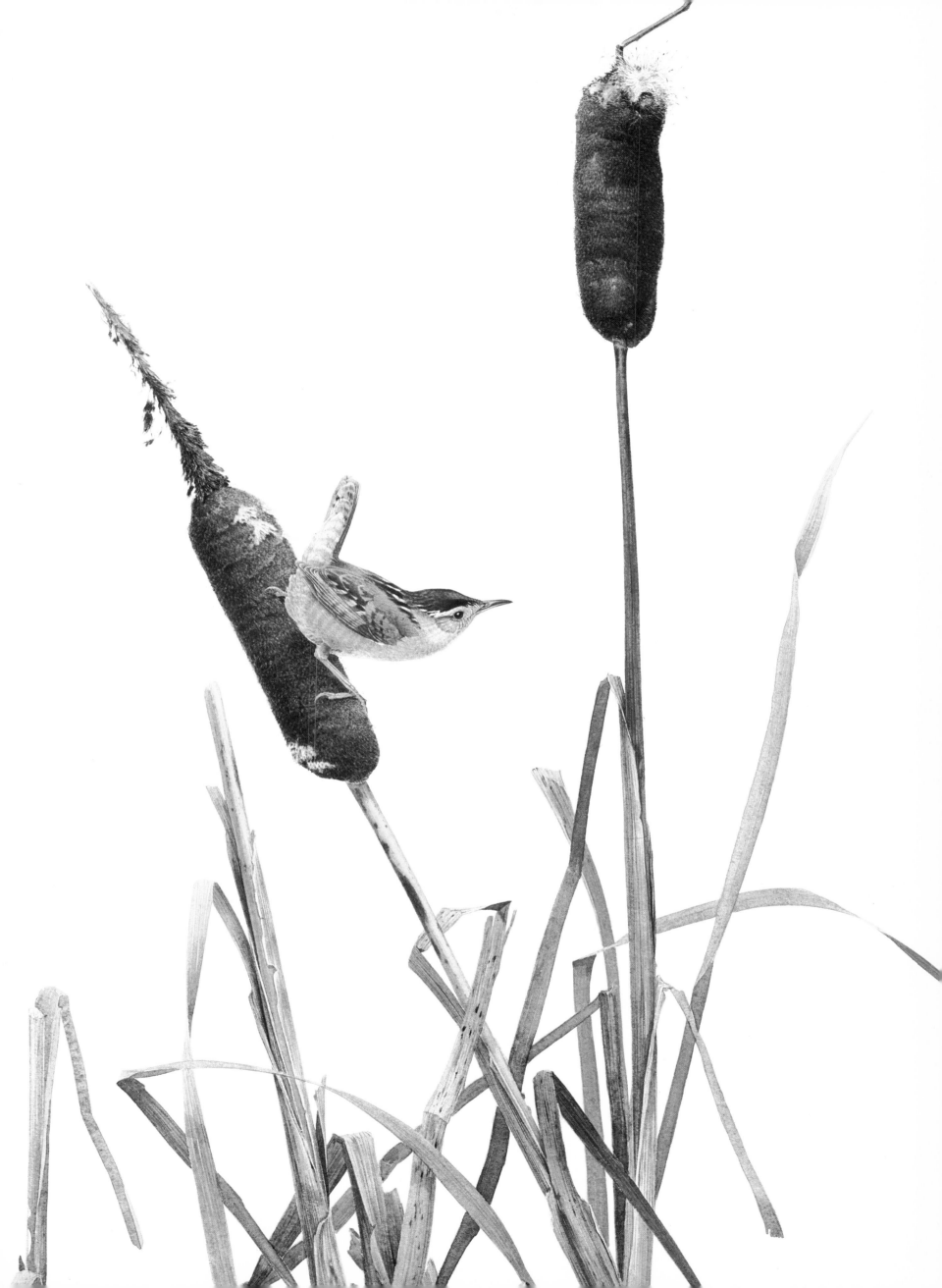

Sialia mexicana

Years ago the western bluebird was seen regularly on the coasts of British Columbia and Washington. The older books describe it as common in summer about Seattle, while in fall large numbers appeared in migration on parts of Vancouver Island. A friend who settled near Victoria at the beginning of the First World War tells me that many bluebirds nested here then and wintered, too.

Even recently, though only occasionally nesting, the bluebirds were visitors that could be looked for in late summer along the borders of fields, on cleared land and in the Garry oak woods of the northwest. The main autumn migration passed through my part of the island in September and October, when small flocks of a dozen or two birds could be seen. To encounter one of these in a day's birding and to hear all about one the soft calls of the little travellers was a treasured experience of fall, talked of and remembered long afterwards.

Now starlings, pesticides, and man's presence have intruded upon the bluebirds' lives and their numbers have dwindled, so that they do not come to us as they used to do.

There is something in this lovely species that earns for it a place of special affection in our hearts. Partly, it is the wonderful colouring, chestnut together with a changeable, unbelievable blue that, when first seen, invariably brings exclamations of pleasure. The magic is more than this, however, and may lie in the ethereal quality of this liquid-voiced, gentle thrush. If any birds could be the re-embodied souls of the departed, they would be the delicate bluebirds.

The western bluebird, in general appearance much like its more celebrated eastern relative, though with greater amounts of chestnut to its plumage, ranges over western America from Mexico to the dry interior of British Columbia. In places it shares an open, rangeland habitat with the mountain bluebird, another celestial species of a more northerly summer distribution and with a preference for higher elevations.

All three species breed in cavities and build their simple nests of grass and feathers in rotting stumps or in dead, freestanding trees. They will use boxes, but natural hollows formed by the breaking of limbs are favoured, and woodpecker excavations are frequently occupied. In California, the acorn woodpecker is often the bluebirds' house builder. Two broods are raised each year in most places, with the parents still feeding their first four to six offspring at the time of the second laying.

A fall moult produces a more softly coloured winter plumage, with the blue dulled by brownish grey edgings to the feathers. By the time the bluebird's simple, robin-like carolling is heard in spring, these feather edgings have worn away to reveal the pure, hard blue of early summer.

The food of the western bluebird consists mostly of grass insects including grasshoppers and crickets, while in fall and winter various wild fruits and berries are eaten.

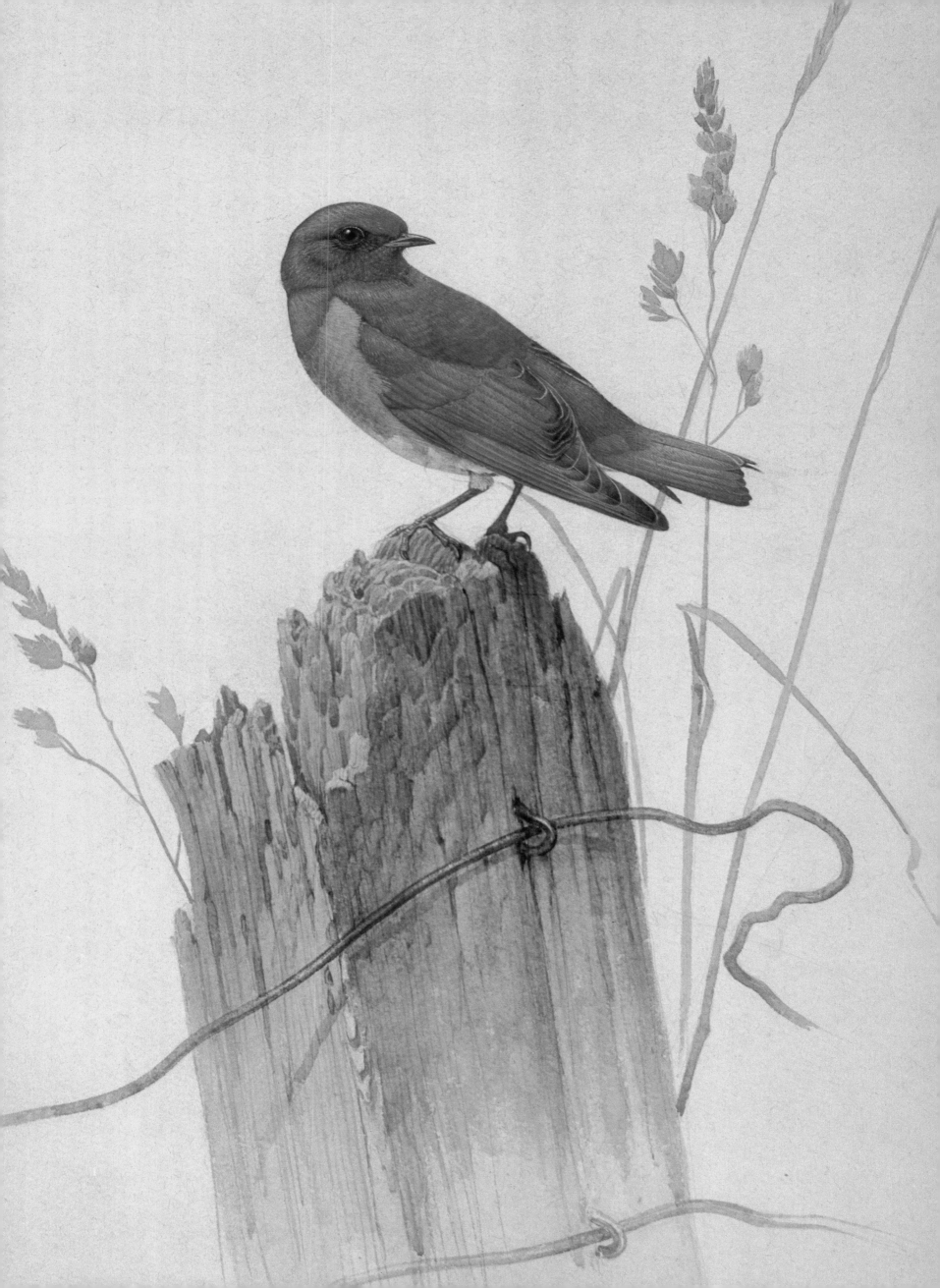

41 Golden-crowned Kinglet

Regulus satrapa

Kinglets are very small birds. Clothed in olive-greys and yellow-greens, they are distinguished by their brilliant caps or crowns of red and yellow, and it is these regal adornments that have suggested the apt and picturesque family name.

The golden-crowned kinglet, one of two species in America, is a tiny, exquisitely marked denizen of the coniferous forests, living in the evergreen canopy high above the ground. Its small size and its habit of feeding mostly in the upper branches of firs make this kinglet a bird less often seen than heard; the usual indications of its presence are auditory. If a person walking through the woods hesitates and listens, the high, thin notes of kinglets or "goldcrests," as the English call them, will come faintly down to him, although the birds themselves remain hidden from view.

Fortunately, these attractive birds do not always remain in the upper strata but sometimes descend to the ground or at least to lower branches, where growth is sparser and a better view of them is possible. Here they flutter about unconcernedly within a few feet of human beings and behave rather in the upside-down way of chickadees, though they display more delicacy and are not as boisterous in their manner. Chickadees often are their companions, however, and in groups with creepers and nuthatches they roam the woods in fall and winter.

The nest of the golden-crowned kinglet rivals the bushtit's in beauty and ingenuity of construction. Forty or fifty feet above the forest floor a delicate basket is made and suspended from the thin, swaying outer branches of a fir, spruce or redwood. Using mosses and lichens with fir needles and strands of spider web to bind it, the little builders weave a globular structure with an open top. Small, pliant twigs are incorporated into the outer body as strengthening ribs, and the interior is lined with softer material. For this lining are gathered finely torn strips of inner bark, grasses and the breast and flank feathers of grouse and other forest birds. The feathers are so arranged on the inner walls that they curve inward over the opening to form a screen for eggs and young.

Broods are large, and eight or ten eggs are laid in this rocking, aerial cradle. The food of babies and adults alike consists entirely of small insects.

When cold weather strikes there is an altitudinal migration of golden-crowned kinglets that descend from the higher elevations to the more sheltered valleys.

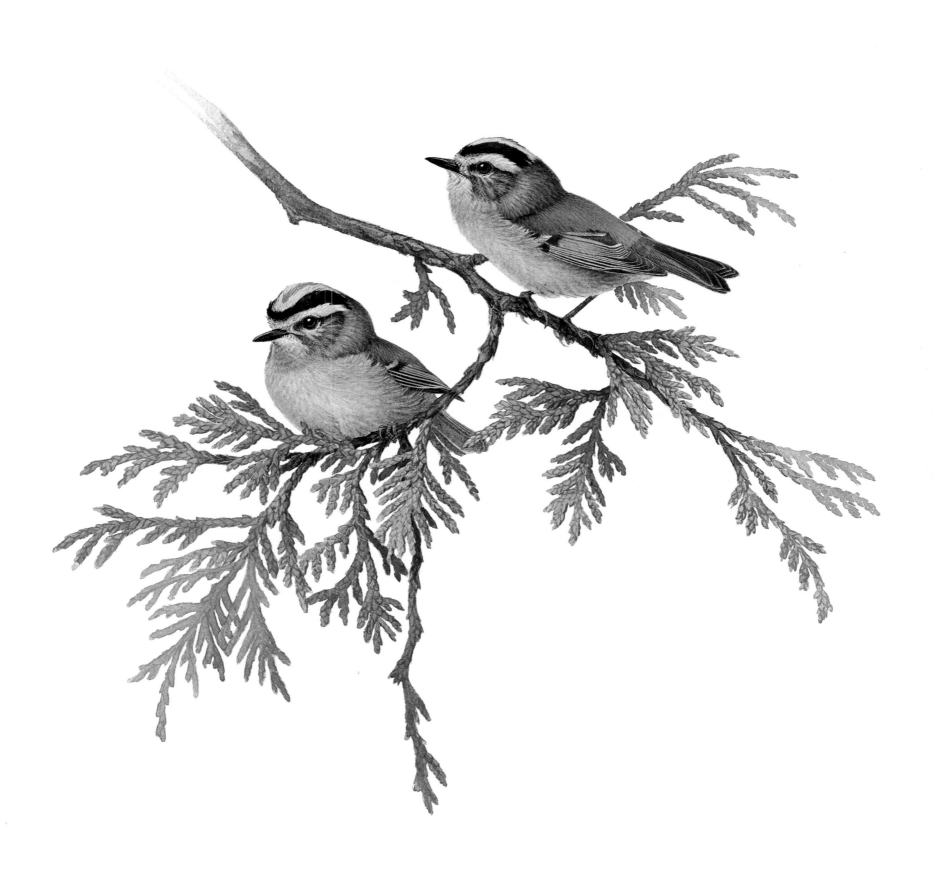

Dendroica nigrescens

In the northwest and in California, we do not see the profusion of warblers that every year sweeps into the eastern hardwoods from Central and South America. Of the more than fifty butterfly-bright, insectivorous species found in the United States and Canada during spring and summer, less than a dozen are native to the west coast.

Among the few is a true westerner, the black-throated gray, a bird with a breeding range confined to an area from British Columbia and parts south to California and Arizona. It is less colourful than some species of the family in which acid yellows, orange, black and slate-blue appear in almost endless variations of pattern. Its sole flamboyance is a small spot of yellow before the eye, but even in its sober black, white and grey this is a handsome warbler.

Where it concerns us, the black-throated gray warbler is often found in open stands of second growth conifers interspersed with brush and clearings. Here it forages mostly in the upper branches, leaving denser woods and older timber to the closely-related and more brightly-coloured Townsend's warbler. Farther to the south it inhabits a different kind of country and there favours oaks and other deciduous trees.

This species is met with at higher elevations, as well as lower, and is a plentiful bird at altitudes of up to eight thousand feet. At least in the northwest, the black-throated gray warbler breeds almost exclusively in coniferous trees and builds a conventionally shaped nest cup of grass, plant fibres and weed stems; the lining is of soft feathers and sometimes a little hair. The whole structure is placed on or beside a horizontal limb, several feet out from the trunk and as much as thirty-five feet above the ground, although it may be much lower. Three to five eggs are laid.

The black-throated gray is a fairly common warbler on the coast, both as a migrant and a breeding bird, but until recently was not considered to occur on Vancouver Island. Perhaps it has expanded its range, as several other species mentioned in this book have done, but whatever the reason it is now seen on the island regularly each year. Spring and fall sightings indicate that this warbler is not at all uncommon, and summer records show that most likely it is a breeding bird here.

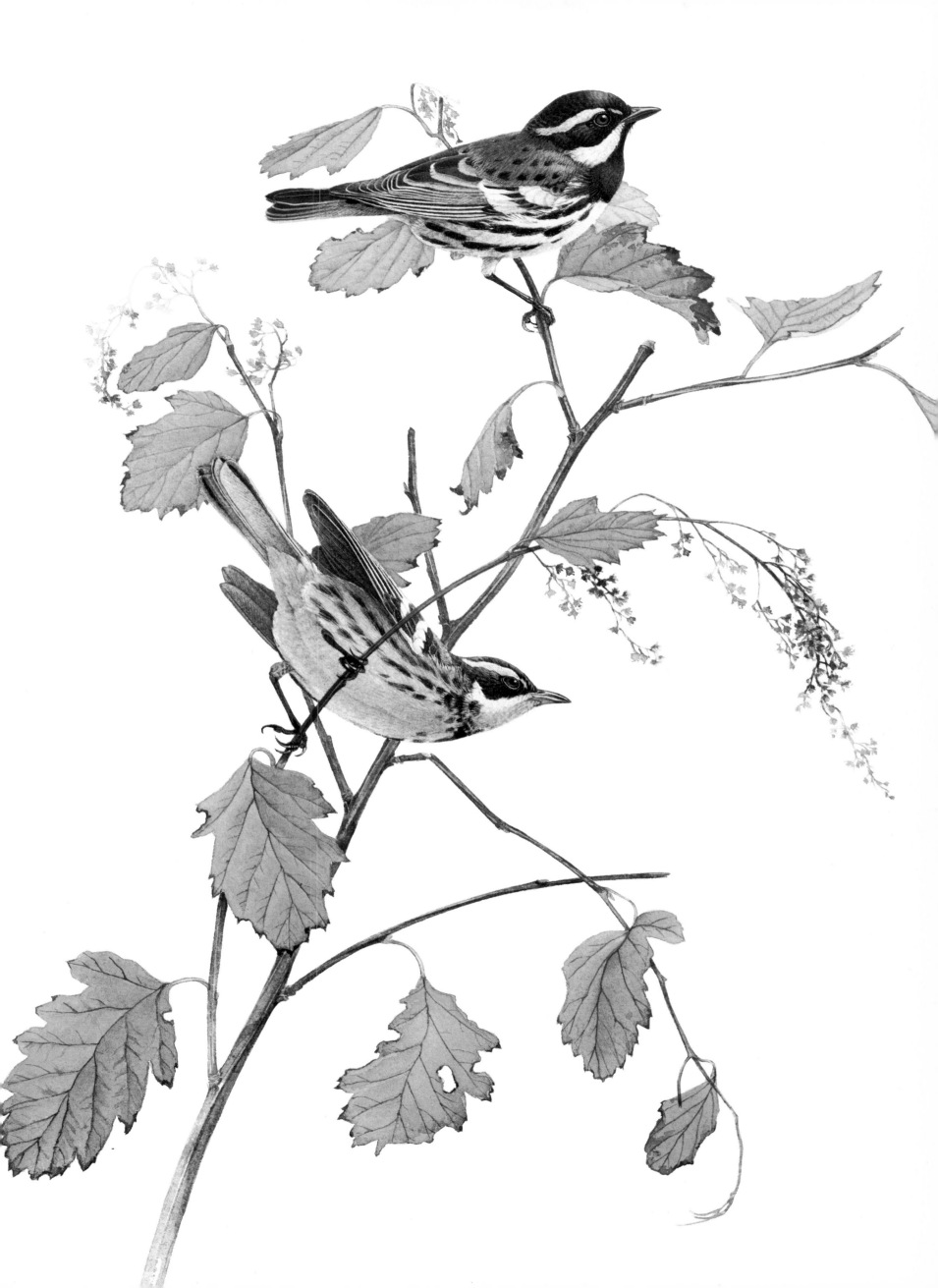

Red-winged Blackbird

Agelaius phoeniceus

The red-winged blackbird inhabits practically the whole of this continent and is probably our most numerous species. Using size, small differences in plumage, the relative heaviness of bills and other such determining factors, scientists have divided the species into several geographical races. The birds shown here belong to one of the most plainly marked of these.

These are red-wings of a "bi-coloured" race found locally in the San Francisco area of northern California. It will be seen at once that the female is dark and that the males almost entirely lack the broad, yellow edgings to the red of their "epaulets". This gives them an interesting and strange appearance to a person familiar with the birds found elsewhere. So intrigued by this departure from the norm was I that the San Francisco red-wings immediately won a place among the birds in this book.

In behaviour and habits, and in all respects except colouring, these blackbirds resemble their multitudinous brethren that dwell in other parts of North America. They belong to a numerous family that, as well as including other kinds of blackbird, also embraces meadowlarks, cowbirds, the bobolink and the orioles of the New World. Its origins are South American and there, where most of its members occur, one finds species that sport many different combinations of the family colours: red, black and yellow.

Our well-known red-winged blackbird was once confined to the wetlands, living and breeding in the tule or bulrush beds of marshes across America. It still favours this marsh habitat, and the voice of the red-wing is an integral part of it, but the species has pushed into other kinds of country as well. Now this harsh-voiced, grain-loving bird is found everywhere on open agricultural land. Marshes have been drained, but instead of vanishing, the red-wing has increased tremendously, feeding and thriving on the crops planted by man and taking advantage of new habitats that, before the forests were cut and cleared, were not available. When so many kinds of wildlife have vanished or been decimated by our inexorable greed and multiplying numbers, it is cheering to find a species that has found benefit in our progress. The red-winged blackbird has done so, even to the point of becoming a chronic nuisance.

The birds of the San Francisco race are resident, but in my part of the country, the northwest, red-winged blackbirds are migratory. The sexes seem to travel separately, and in the pale sunshine of February the first groups of males appear from the south, settling in trees to sing their bugling songs in chorus.

Courtship begins a little later with the arrival of the hens, and in April and May singing and display are at their height. Characteristically, male red-wings are seen clinging to the swaying heads of marsh plants, each bird holding and defending his territory against all intruders of whatever kind. With each strangled burst of melody forced from their glossy bodies, they fan their tails and partly spread their wings. The scarlet wrist or "shoulder" patches are raised for a moment of brilliant intensity.

Red-wings build nests over or near water, favouring reeds, rushes and other marsh growth or the surrounding low bushes. Employing a method of construction like that of marsh wrens and using similar materials, they lash to several vertical stems a loose frame of coarse, dry rushes. An inner layer of soft, wet plant matter is added to give the deep nest cup a strongly walled form in which is placed a lining woven of fine, dry grass stems. Three or four eggs, sometimes more, are laid.

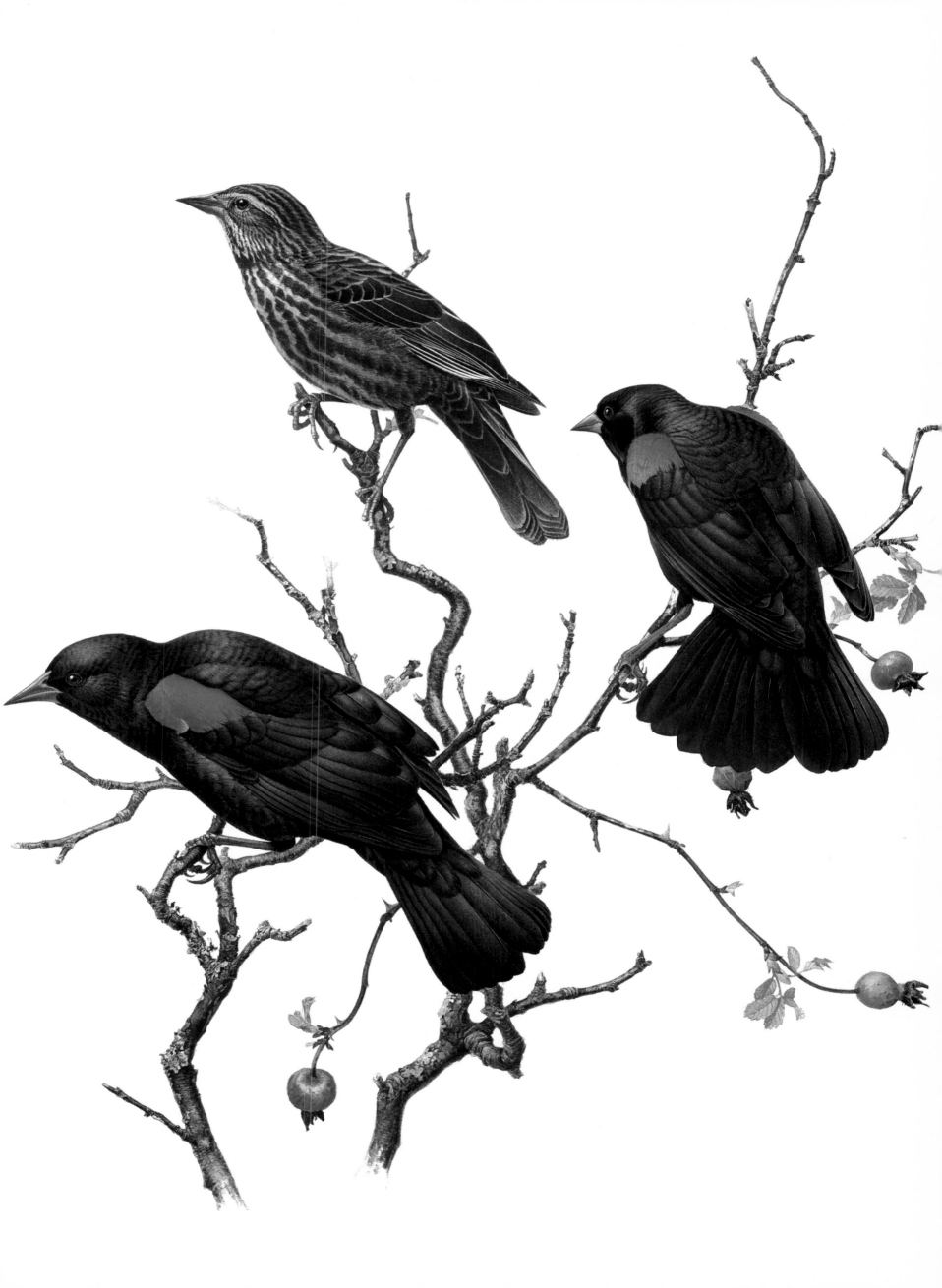

House Finch

Carpodacus mexicanus

The sprightly house finch or linnet cheers the residential parts of towns throughout western America. In the Pacific northwest and particularly on my Vancouver Island, it is of comparatively recent arrival and now adds its rich, warbling song to the chorus of bird voices, while it brightens feeding stations in hundreds of suburban gardens.

This is a bird of the west, although there are introduced populations in New England and the Hawaiian Islands. Where it occurs naturally, from southern British Columbia to Mexico, it is one of the most abundant and familiar song birds, especially near habitations and on well-watered agricultural land. Like the crow and the red-winged blackbird, it is a species that seems to have gained by man's clearing and cultivation of the country.

House finches are among the first birds to sing each year. On mild days in February the males hasten the beginning of spring and the end of wet, winter days by pouring out their mellow, unhurried melody from powerlines and other conspicuous perches. Two or three weeks later they have mated and begun nesting. House finches are so adaptable, or so indiscriminate, in their choice of sites that it is difficult to guess their preferences. Perhaps most frequently they nest on or around buildings, in holes and openings or on beams and ledges. Where they inhabit wilder, less populated districts, they place their simple, rather rudimentary nests in the branches of low trees, using grass, plant fibres, weeds and whatever materials happen to be handy.

In Victoria, a favourite place for a house finch to build is on an ivy or creeper-clad wall, and the old vines that sheath the Empress Hotel and a former girls' academy nearby have held many broods. A less successful choice was made by a house finch whose mummified body I once found on the Arizona desert: having built in a cholla cactus, he had flown in and fatally transfixed himself on one of its long spines.

In the warm and easy climate of California and other parts of the west, the breeding season of this sometimes polygamous species is not confined to spring. Two or even three broods may be brought off, and there is evidence of nesting in almost all months of the year. Four eggs is the average number to a clutch.

House finches are mostly ground feeders, although the red and orange berries of *Pyrocantha,* growing on house walls, are very popular with them. In fall, flocks composed of what seem to be family groups gather on lawns and grassy places attracted by the weed seeds. They move from spot to spot with little chirps and with a distinctive flirting flight.

Where they come in contact with purple finches, the identities of the two species are often confused. The resemblance between them is only superficial, at least in the red males. To one who knows them both the house finch is a much slimmer bird with a brighter red that is confined to the head, chest and rump. In comparison, the heavy-jawed purple finch is more uniformly suffused with a shade of red that is crushed-raspberry-and-cream. The females may require a second look to separate them, but the house finch hen is the paler and greyer of the two.

As with other red finches, there is great variation in intensity of the colouring between individuals. Male house finches range from almost blood red to pink and to orange-yellow.

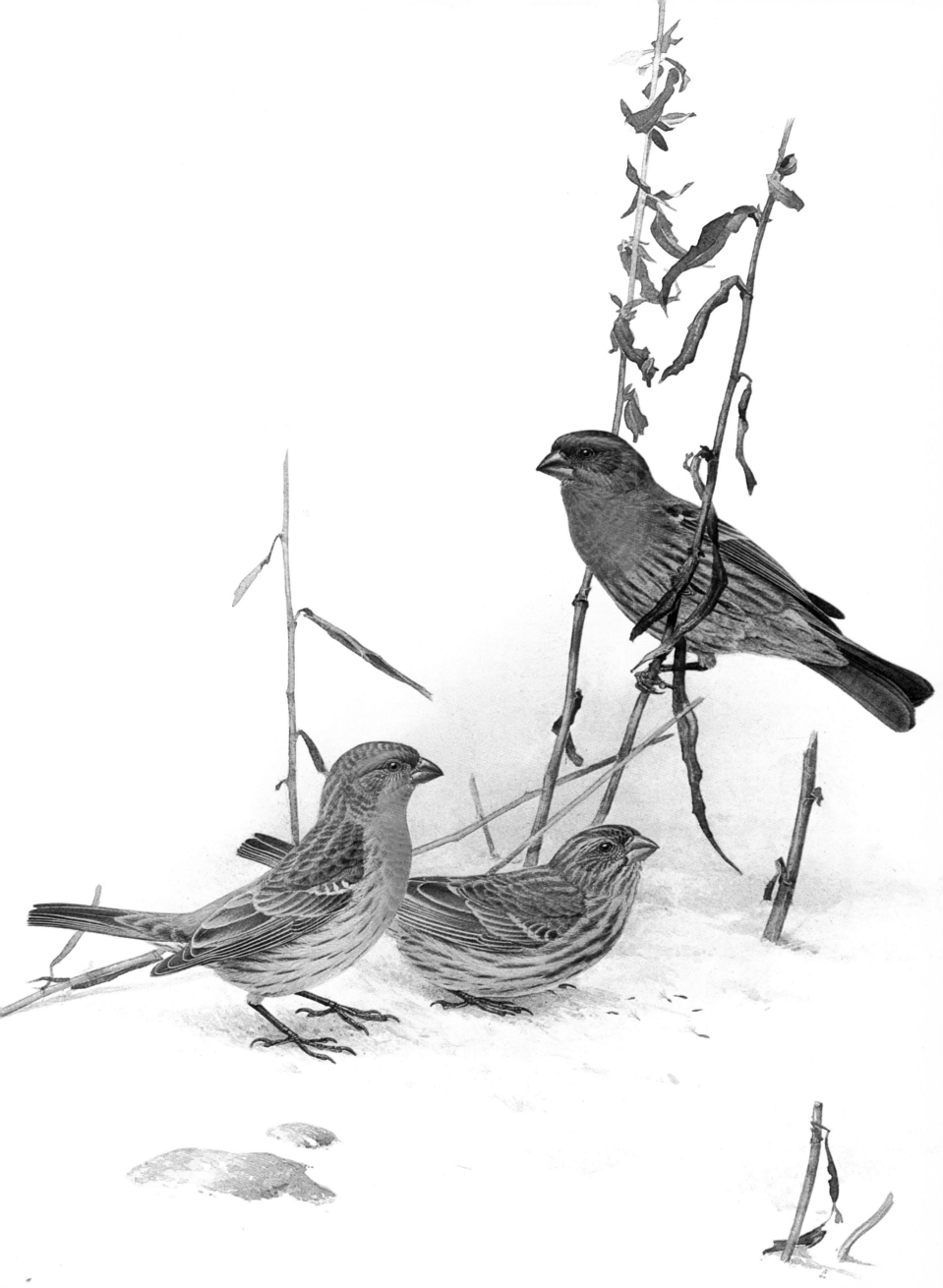

Rufous-sided Towhee

Pipilo erythrophthalmus

The rufous-sided towhee is uniquely American, both in distribution and character. It is a resident or summer visitor in most regions of Canada and the United States, and at some time of the year, in some part of the continent, its wheezy "tow hee" may be heard coming from the underbrush of a wood or from dense growth at the edge of a clearing.

In the west, the towhee is as much at home as elsewhere, and may be sought either in the blackberry tangles and the snowberry bushes of Washington or in California's chaparral. In our mild climate, this species is not migrant as it is in the cold-wintered east. Indeed, in winter towhees seem to be more noticeable here, although possibly this is only because our attention is drawn more to them in the seasonal absence of many other small birds. At this season, they are frequently seen in our gardens and yards, keeping discreetly in the background. Unlike the juncos, they come only reluctantly to the feeding table and dash away on the slightest provocation.

Towhees of the east are plain-backed and spotless, but the western races are beautifully dashed with white on the scapular feathers; at one time this caused their classification as a separate species, the "spotted towhee". Why the difference exists is not certain, but there may be a better reason than mere chance. As all races live near the ground in shady places, one possibility is that the spotted plumage of western birds may have a camouflaging advantage where cover is sparse and the dappling effects of light more pronounced than in eastern forest land.

Each ground-feeding bird, and the rufous-sided towhee is one, has developed its own method of finding its food. For example, a robin on the ground may be seen turning over the leaf mould with vigorous flicks of its bill. Towhees rake the ground with backward kicks of their long-spurred toes, scattering leaves and humus at each jump. The action is a quick jump, a kick and a forward jump to regain balance, the whole sequence bringing to mind the mechanical windup birds that hop and peck at the same time. Often the tell-tale rustling of leaf litter is the first indication that a towhee is somewhere near, even though not visible.

The white markings of the wings and tails are flashed with evident effect in spring. The males pursue their mates in flight through the bushes or fluff their handsome feathers and sing a simple, rather tuneless "churchée" with monotonous repetition. At this time, the males are quite conspicuous as they mount to prominent singing perches within their territories and stay there with relaxed plumage and down-hanging tails announcing their claims. Any alarm sends them diving for cover.

The nest of this species is very well-concealed and is built by the dusky female with little or no help from her mate. In its construction she uses grass, dead leaves and strips of bark, lining it with finer, dry grass stems. In the majority of instances, the nest will be on the ground, in thick cover, its rim flush with the surface. This is not an unfailing rule, and occasionally a bird will depart from the usual and build in a low bush.

The three or four eggs, like the nest, are the sole responsibility of the mother, though she has the active assistance of her mate in feeding the young brood.

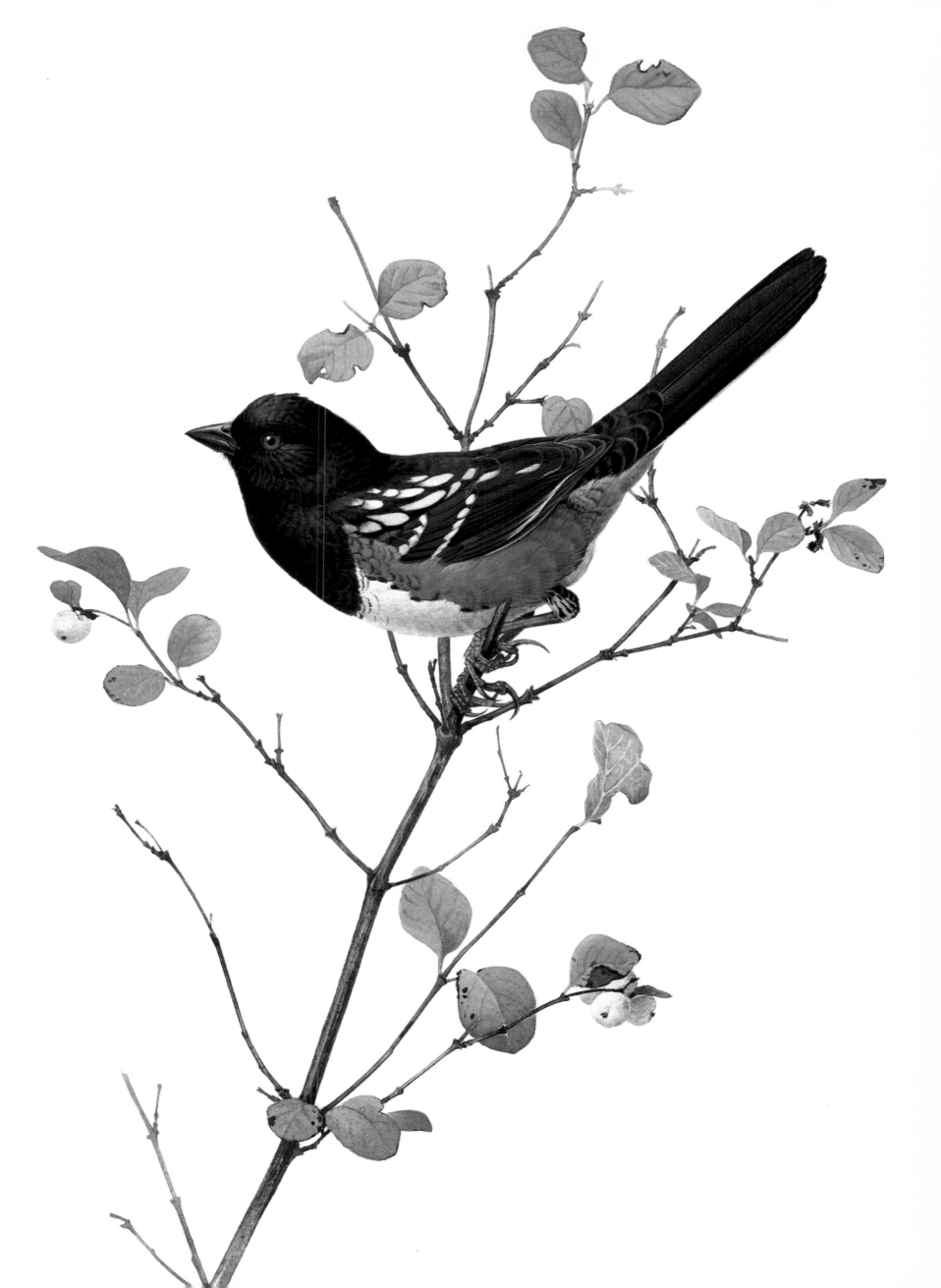

Pipilo fuscus

I have always enjoyed painting birds of sober colouring, not seeing them as dull but taking pleasure in the subtle values and the interplay of shade and shade. The brown towhee is such a bird. Quiet umbers and ochres in its plumage blend with the surroundings and tend to obscure its significant place in the bird-life of the western states.

This rather large and long-tailed finch with a preference for brush and clearings occurs in Oregon and California, as well as in adjacent areas. Keeping to the ground or to the lower levels of plant growth, the brown towhee is a common bird within its range, but for all its abundance, might easily be overlooked or dismissed because of its undistinguished appearance and simple song. It is often seen emerging from the protection of dense shrubbery to hop stiff-legged among leaves and plant debris. The least alarm sends it fleeing to cover.

Yards and gardens, with their lawns and artificially arranged plantings of ornamental shrubs, have provided the brown towhee with ideal habitat that it has not failed to accept; it lives in close association with people and is a regular attendant at bird feeders. Except for a dispersal of young birds in fall and possibly for some local movement, this species is resident throughout its range and there is no migration.

Brown towhees are strongly territorial birds, and a pair that has taken up residence in a given area will vigorously defend it against other towhees. This defence of holdings, the patrolling of boundaries and the challenging and driving away of interlopers, naturally reaches a peak in the courting and breeding weeks of spring and summer. In late fall and winter when the borders have been established and accepted, rules are relaxed and pairs from adjoining territories will meet in harmony at bird feeders. Apart from the offerings of bread crumbs and seed put out by kindly people, the food of brown towhees consists very largely of weed seeds and insects, with some grain and a little fruit.

Despite foraging so much on the ground, towhees most often make their nests a few feet above it. Described as being of bulky size and rough construction, the nests are built of grass, small twigs, bark and weeds. Frequently, they are placed securely in the forks of branches, in the thickest, most leafy parts of trees, at an average height of five or ten feet. Four or five light blue, brown-spotted eggs are laid.

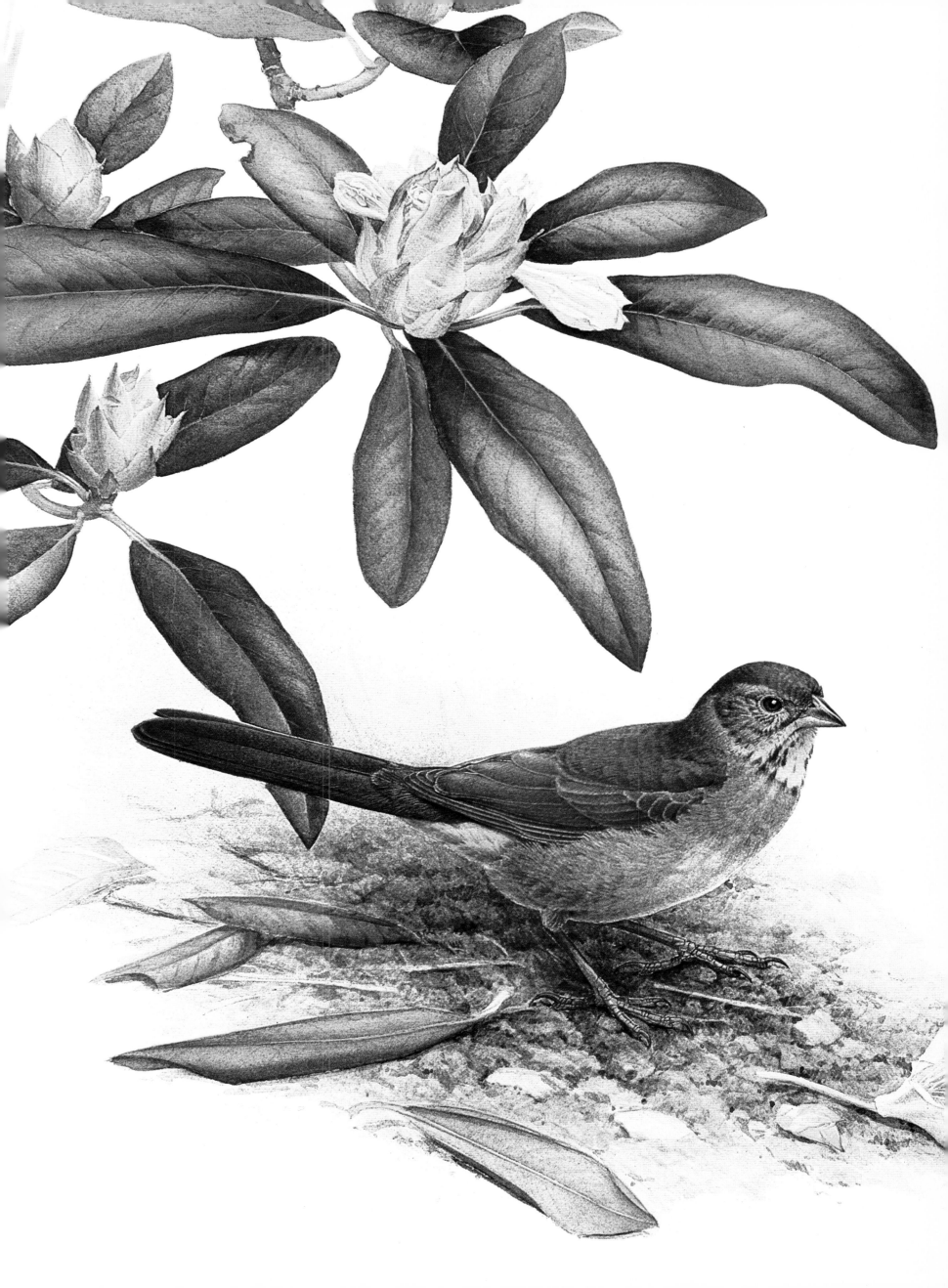

47 *White-crowned Sparrow*

Zonotrichia leucophrys

The handsome, vivacious white-crowned sparrows with their sweet and rollicking song are positive elements of spring and summer days from California to Labrador. They are among my best-loved birds; from the first songster of April to the birds that slip through the red-berried hedgerows of fall, I note them with gladness at each encounter.

This species is a breeding bird in the more northerly parts of America and in the west, where several races differ in patterns of migration and to some small extent in voice and appearance. In winter months, it withdraws to the southern states and to Mexico, thus occupying, at one time of the year or another, most of the continent.

Depending upon where we are on the Pacific coast, we find white-crowned sparrows either as residents, as on the misty coast of California near San Francisco, as migrant, breeding birds in the northwest, or as passing migrants that have bred in the higher latitudes of Alaska. Generally speaking, it is perhaps not important to distinguish these subspecies from each other, yet it is interesting and somehow impressive in migration time to recognize birds that have come from distant places. Birds of the coast, the so-called Nuttall's and Puget Sound white-crowned sparrows, have yellow bills and brownish rumps, while the Gambel's birds from the north are grey rumped and have reddish pink bills. There are other small, not always reliable physical differences and, more noticeable, there are their songs.

Bird populations, like those of people, speak in dialects, identifiable as to place of origin. White-crowned sparrows have songs that differ considerably in richness and quality, according to race and locality. Some subspecies utter generally simpler melodies than others. Along the dense green slopes of the Oregon coast around Cannon Beach the most pervasive sound of summer is the white-crown's song. There it is flung into the sea wind day and night with an almost lark-like abandon, and in its phrasing there is a lyrical sweetness absent from the more rigidly structured form heard further north or the plainer song to the south.

The white-crowns of the Puget Sound area and of southern Vancouver Island arrive in early April, and sometime in the first week of that month I usually hear the first one. In my part, they favour the immediate vicinity of the coast and it is invariably from the seaward slopes above the beaches that the singing comes. Most of them are paired by the time they appear, and the males at once take possession of territories, the choicest going to the first-comers. The boundaries are not well-defined, and in the beginning there is a lot of singing and fighting as lines are drawn.

Some two weeks later the females begin nest-building, while their mates sing from nearby perches or call encouragement with a distinctive "seep" note. In the little nests of grass, rootlets, hair and weed fibres, built either at ground level or in low bushes, clutches of between two and five eggs are deposited. As though in pride and admiration of the eggs with their delicate, brown-spotted, blue-green colouring, the males sing most strongly and almost continuously during incubation.

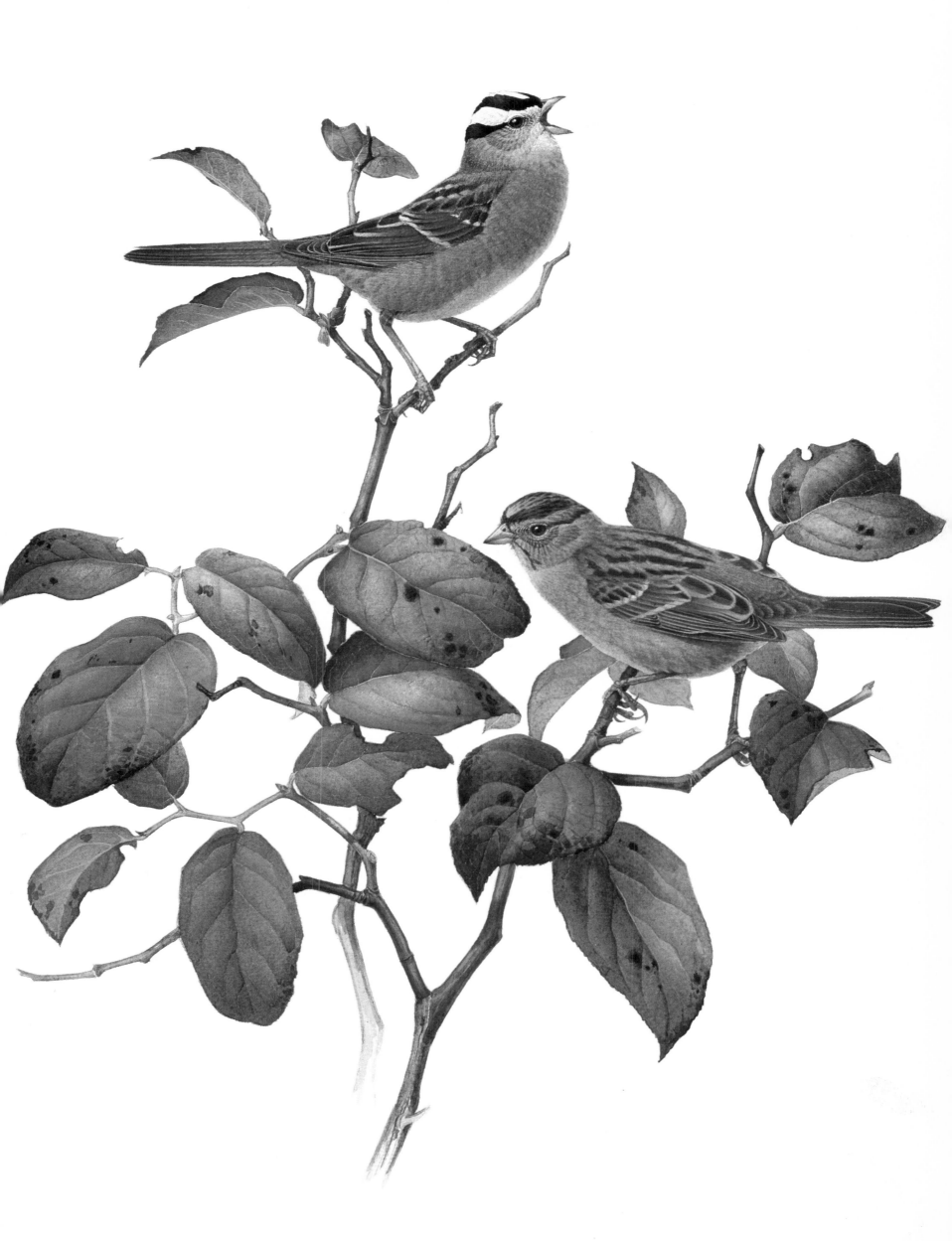

48 *Song Sparrow*

Melospiza melodia

The song sparrow is a bird of considerable interest to ornithologists, because of its ready and visible response to the effects of differing environments and climatic conditions.

Found abundantly all over North America from Mexico to Alaska and between the two oceans, it shows great variation in its appearance. No other of our native birds exhibits such a remarkable capacity for change within its overall range. Among the pale, sandy sparrows of the California desert, the large, big-billed birds of the Aleutian Islands, and the mouse-like, blackish brown foragers of the Queen Charlotte Islands beaches there is little outward resemblance, yet all are song sparrows, birds of a single species, only altered by their surroundings.

To any but a serious student of birds these variations matter very little. The behaviour of birds of the many races is the same, and a birder in California need not try to separate, except in a general way, the seventeen subspecies that occur in that state. For all practical purposes, a song sparrow is a song sparrow.

Wherever they are found, song sparrows are birds of brush and thickets with a liking for the vicinity of water. They are found in swamps, in marshes, along the boggy margins of streams and in near proximity to the sea, as well as on the edges of fields and woods. Though not strikingly plumaged, song sparrows are easily identified by their colouring and actions: a small, striped, reddish or chocolate brown bird seen near the ground or flitting with upraised tail into cover is usually of this species.

On mild days in winter and early spring, the males sing from exposed perches in their territories. Any warming of the weather at these times brings on an incipient surge of the territorial possessiveness that a few weeks later becomes paramount. It is the male song sparrow that takes over and defends a territory of an acre or so, while his mate builds the nest and does most of the raising of the young.

The nests, always made low, are often on the ground, especially with first broods. If subsequent families are raised or if the first attempt to breed comes to grief, the second or third nests are likely to be built off the ground, in bushes at progressively greater heights. The nests themselves are composed rather simply of weed stems, grass, old leaves and strips of bark, with a softer lining that may incorporate hair of some kind. The three to six eggs have as a ground colour pale green to white and are nicely splashed and speckled with shades of brown.

The young song sparrows in the nest are fed small, soft-bodied insects, and even when they become adult, insects will form approximately half their food. The rest will be made up of many kinds of seeds and, to a lesser extent, wild fruit in fall and winter. Song sparrows will come to bird feeders, but there is a wildness about them that seems to prevent a wholehearted acceptance of the bounty. Unlike the more trusting garden birds, they feed with a wary, nervous air, poised for flight.

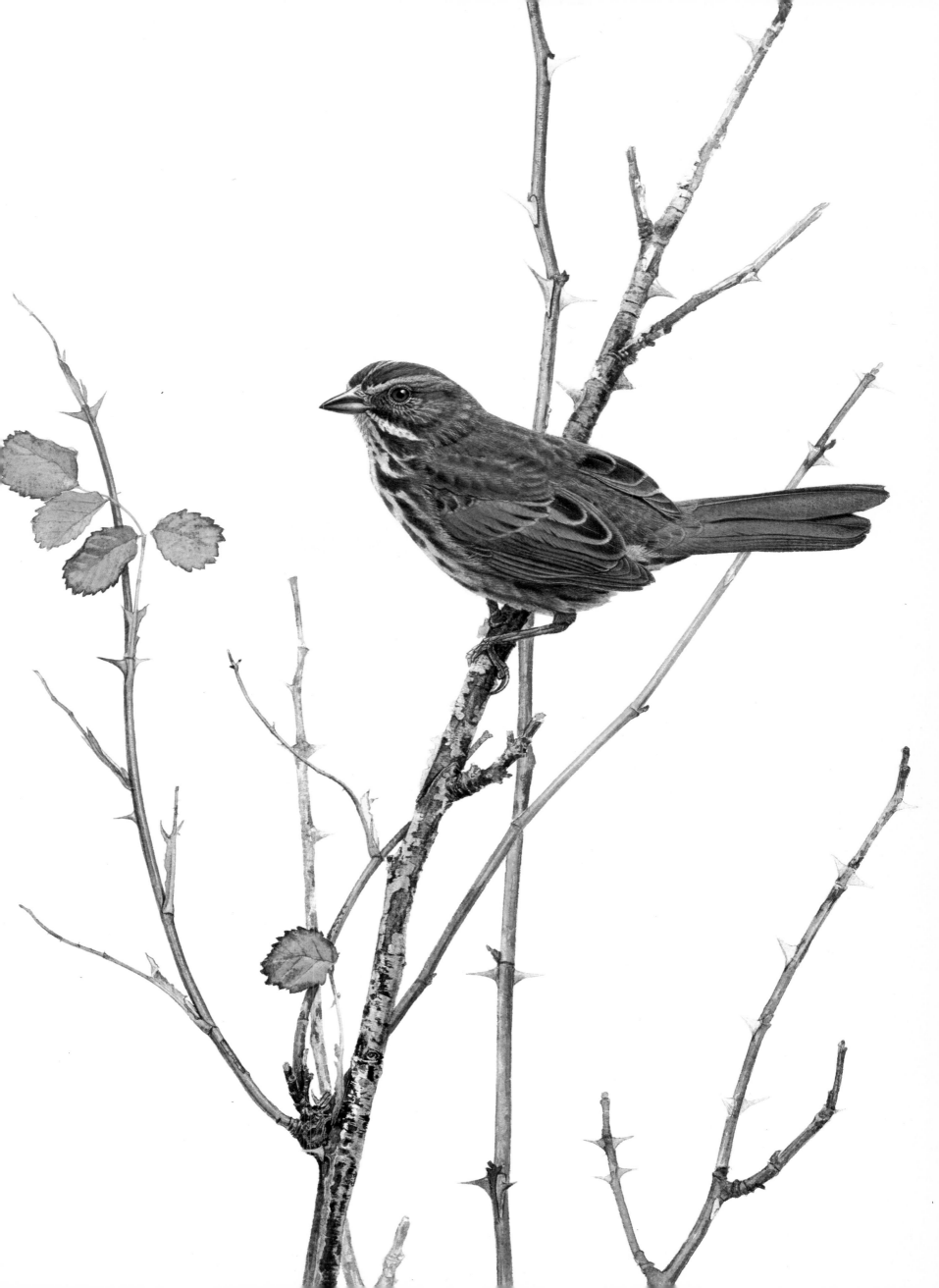

Drawings

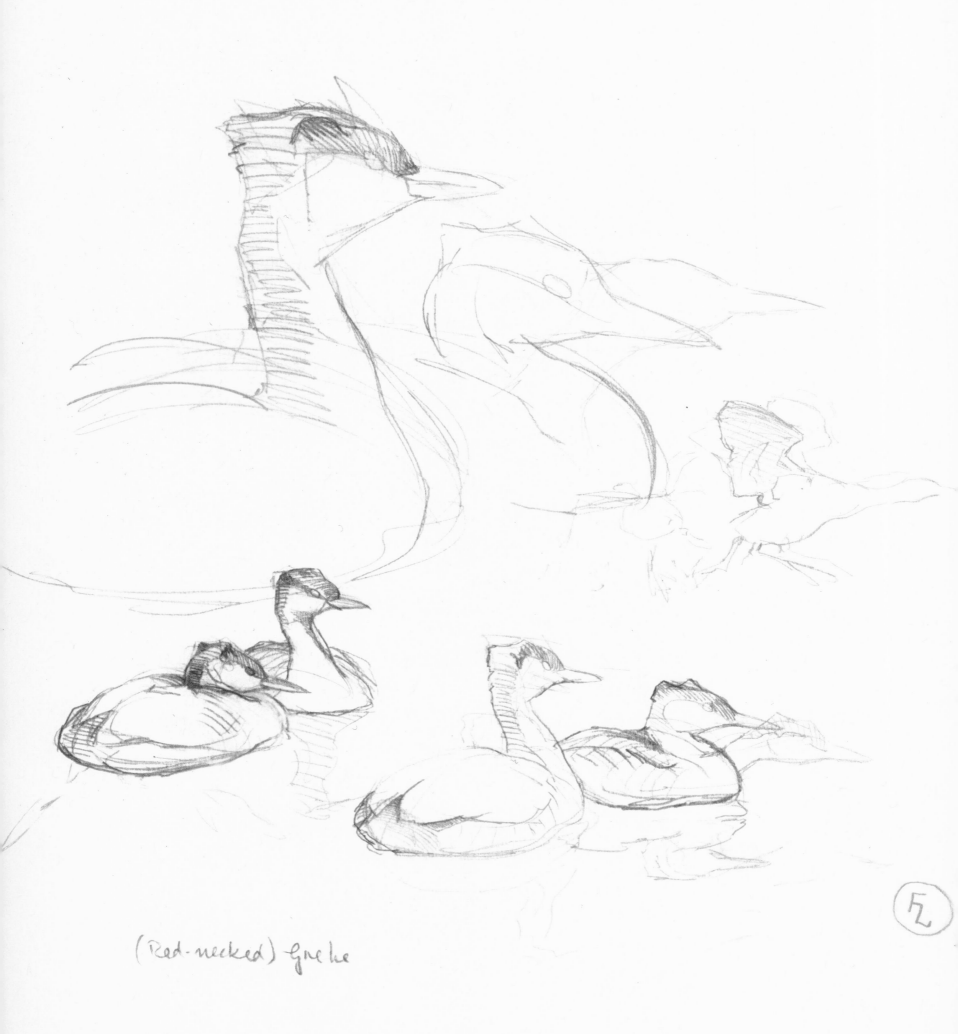

(Red-necked) Grebe

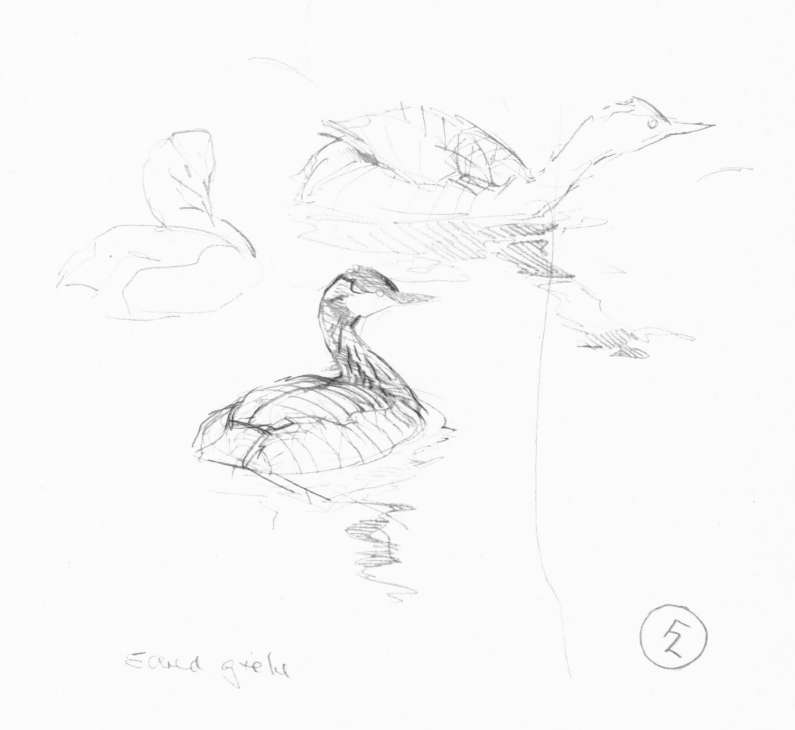

Eared grebe

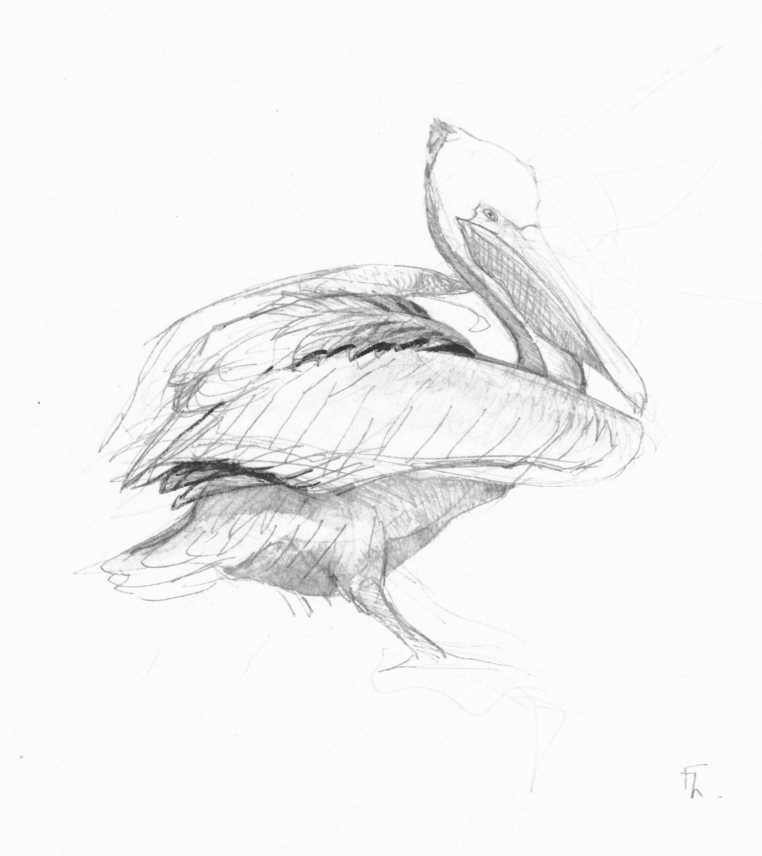

Brown Pelican

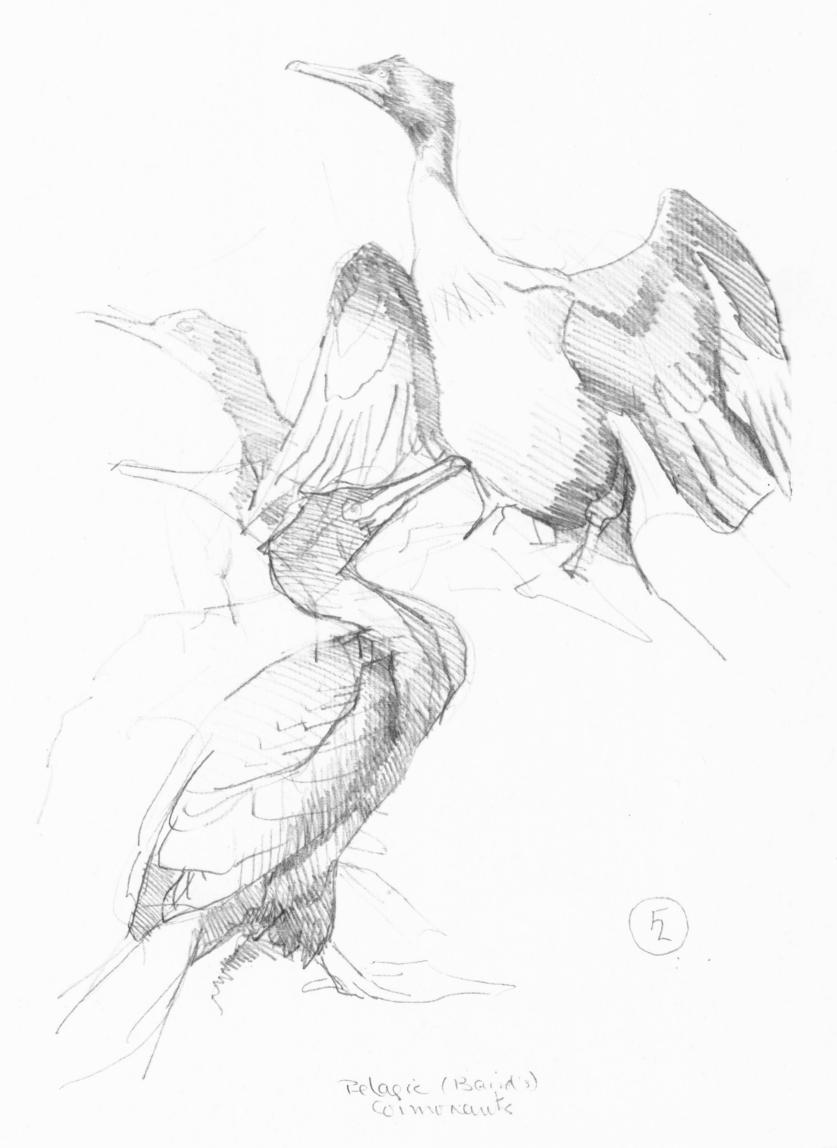

Pelagic (Baird's)
Cormorant

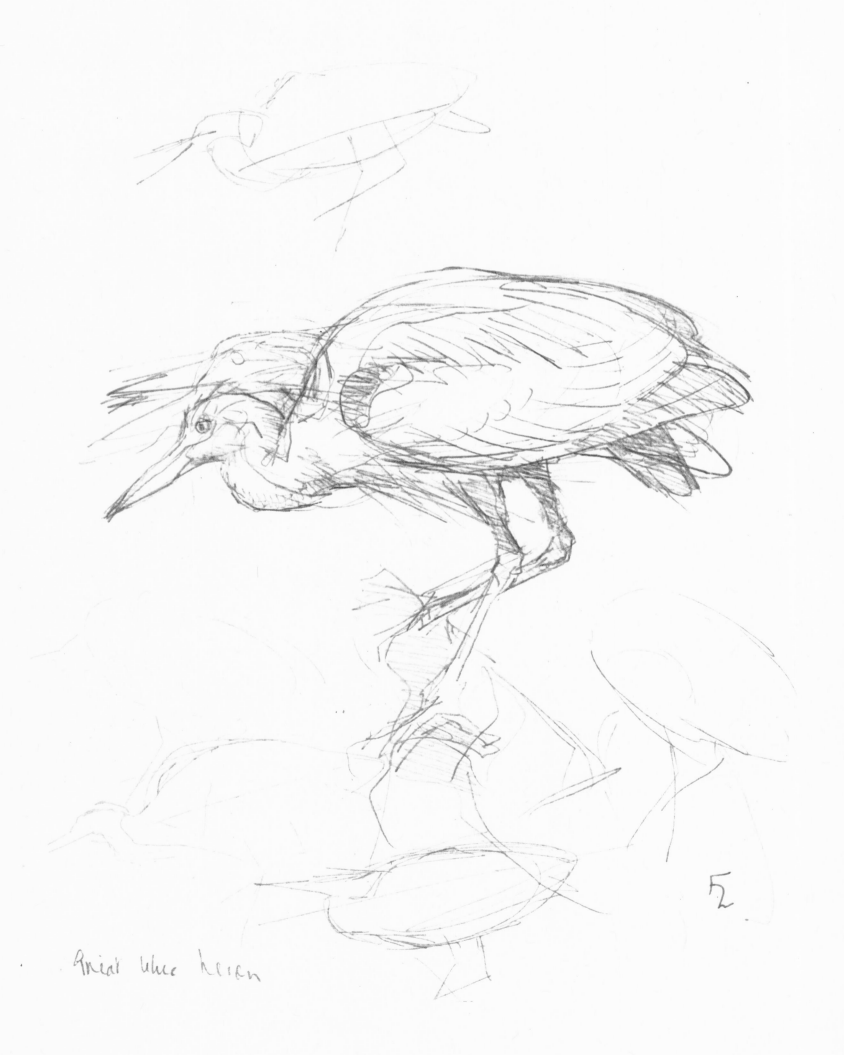

Great blue heron

52.

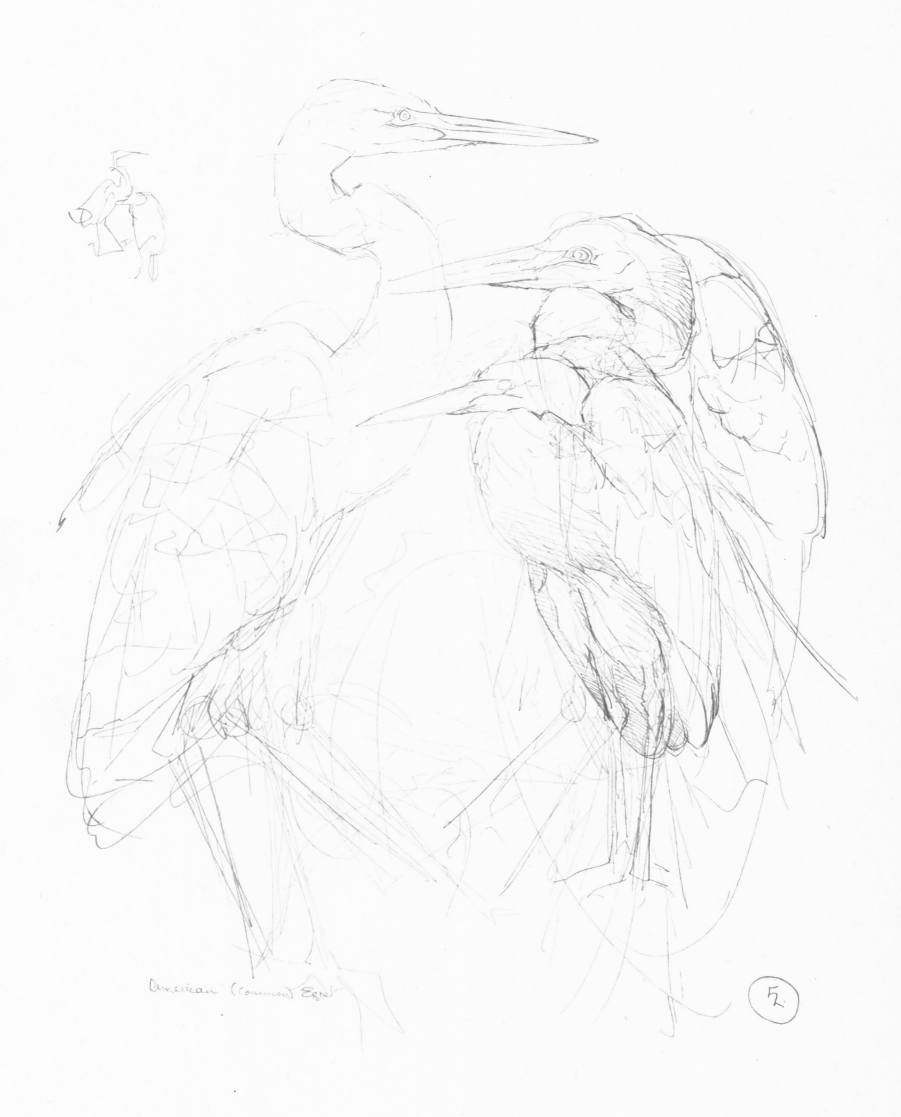

American (Common) Egret

52.

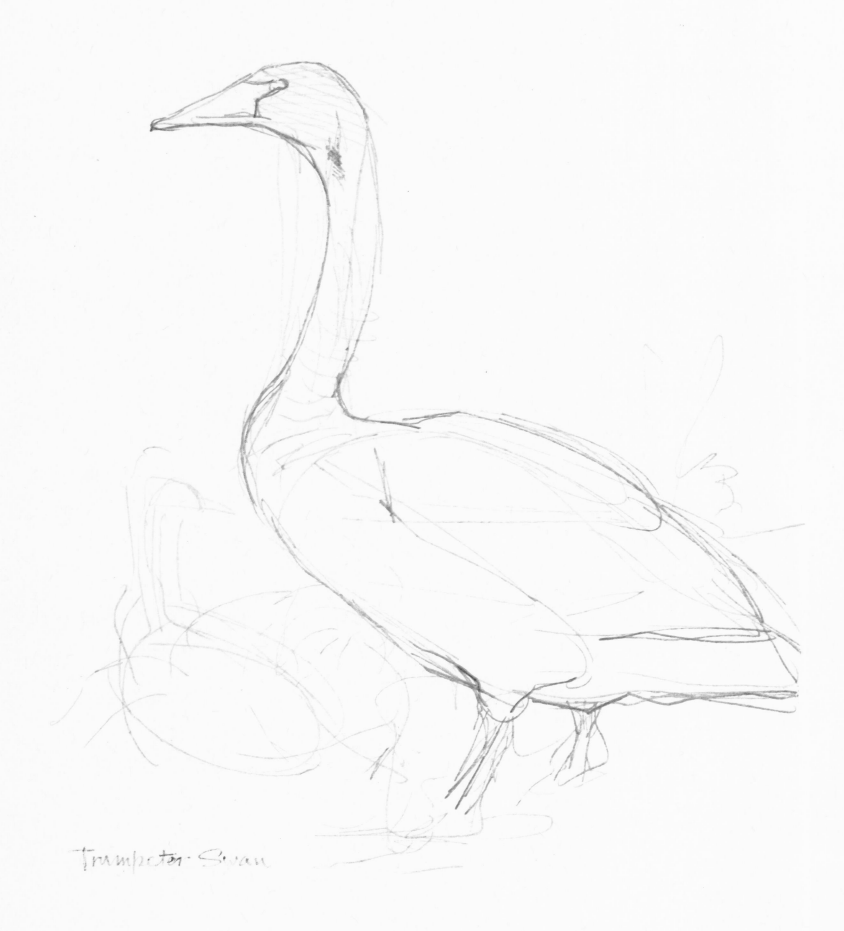

Trumpeter Swan

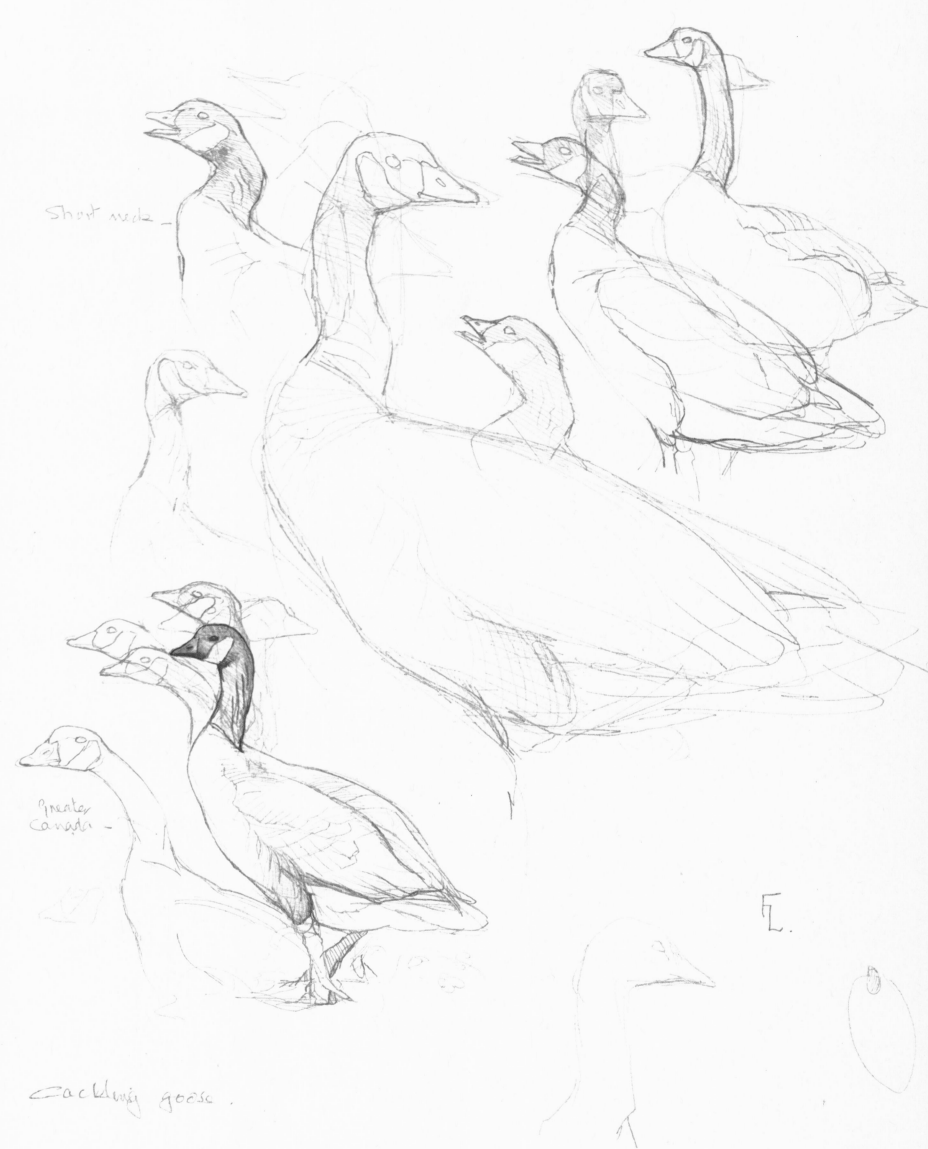

Short neck —

Greater
Canada —

Cackling goose.

E.

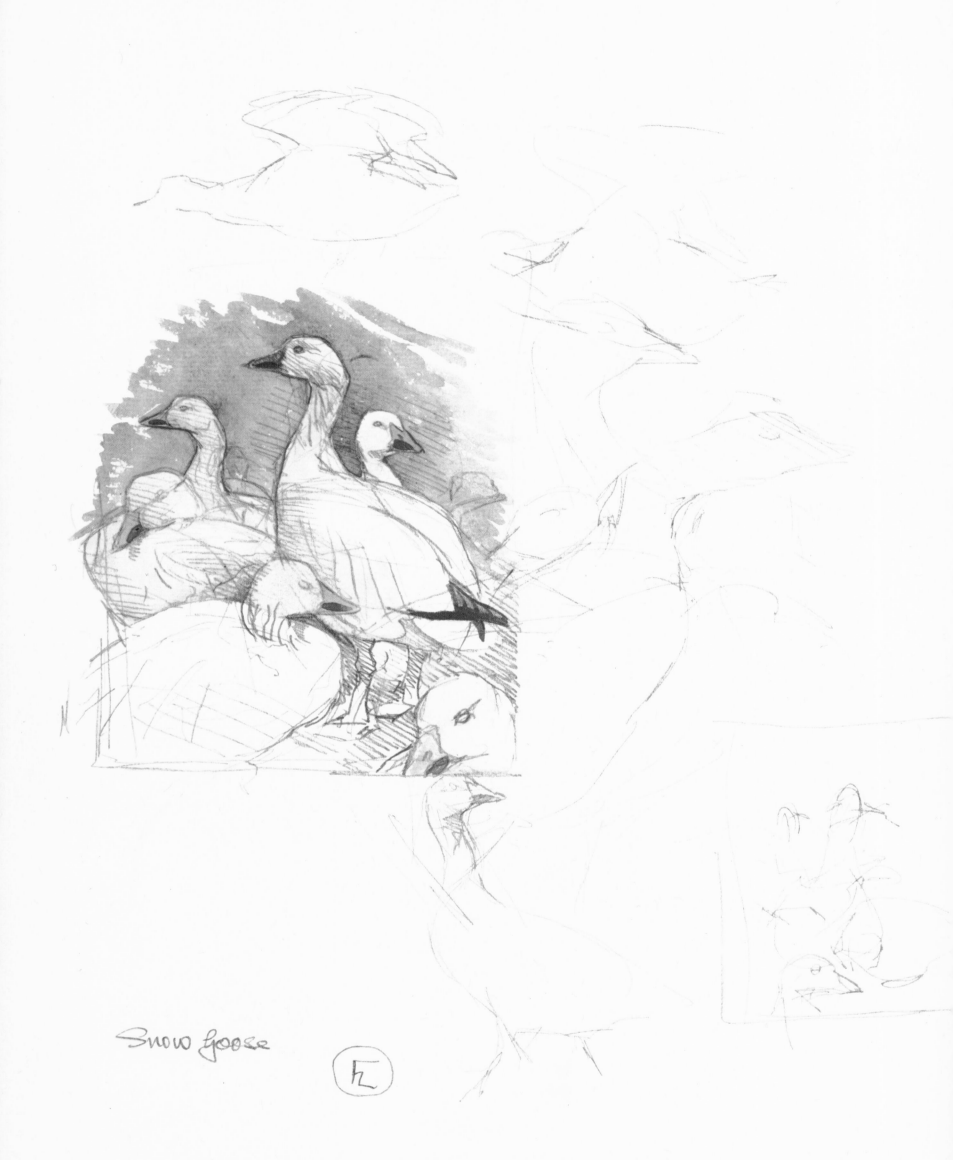

Snow Goose

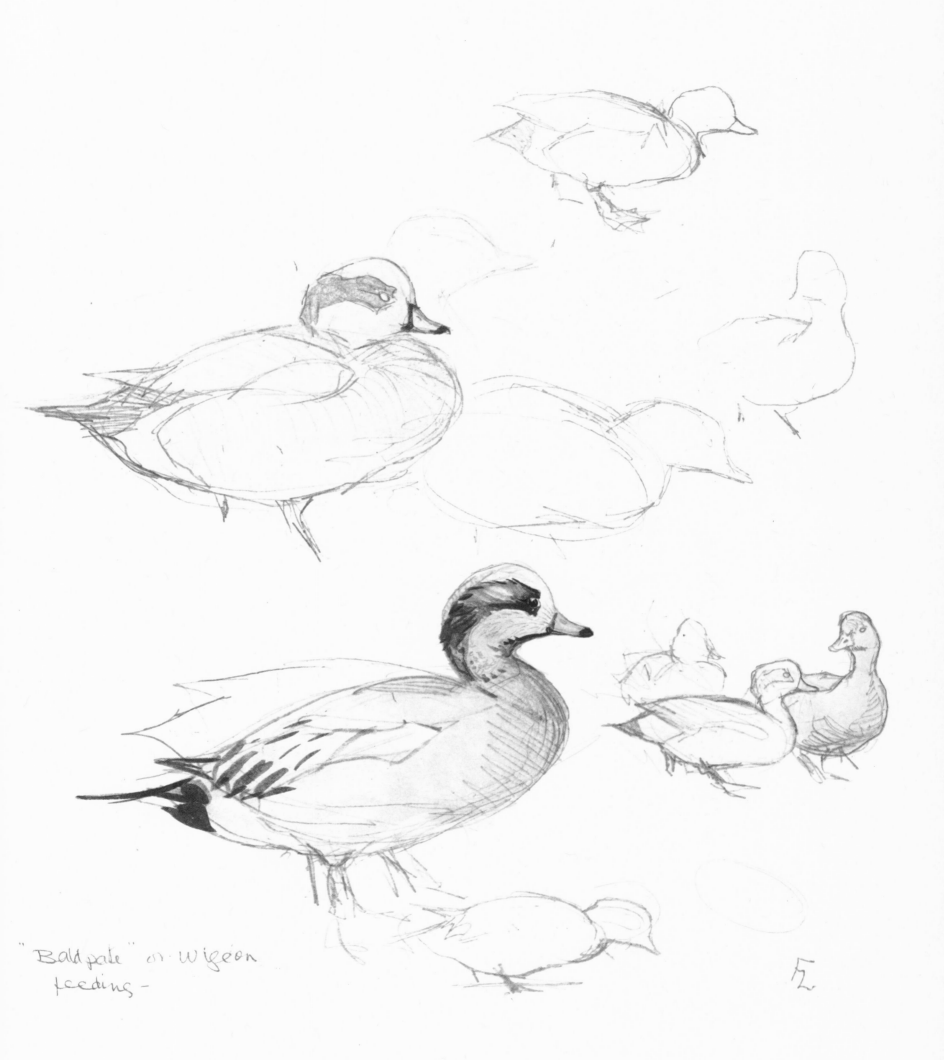

"Baldpate" or Wigeon
feeding –

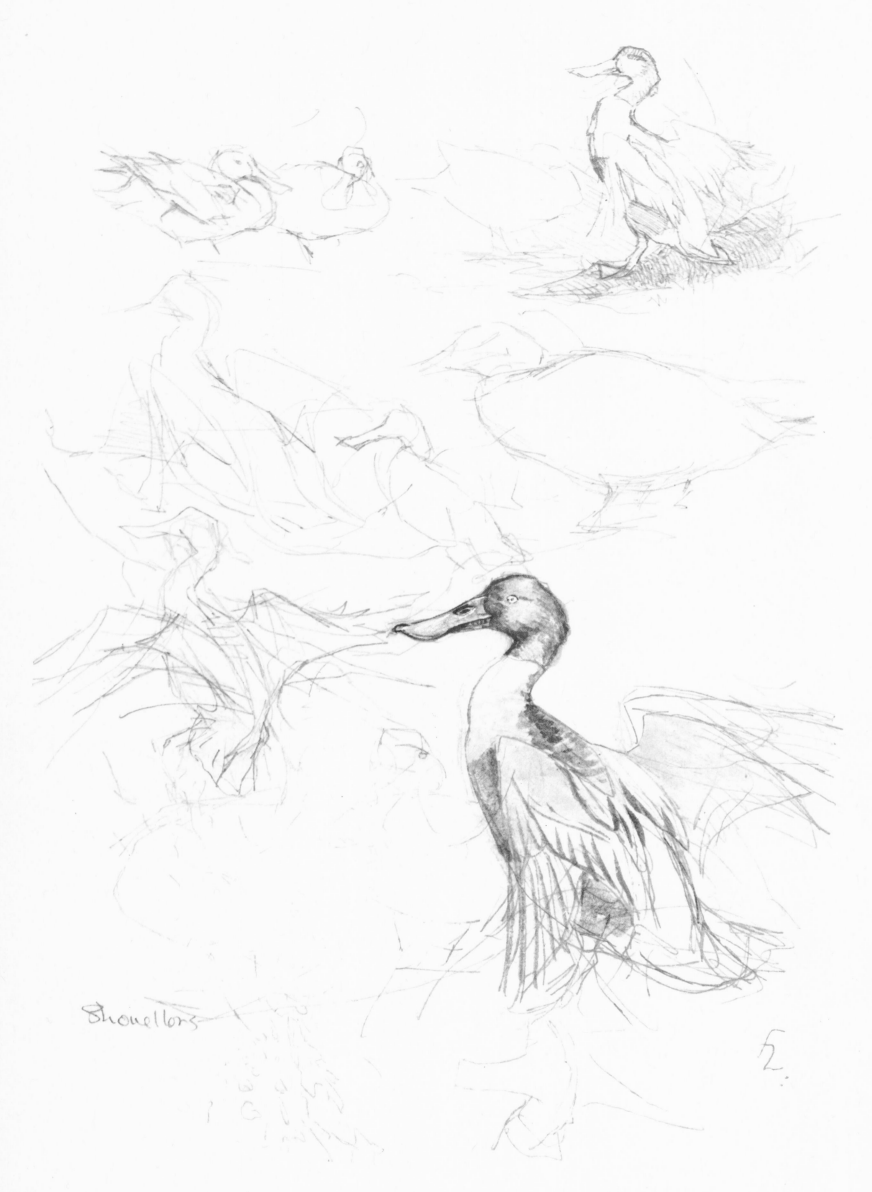

Shovellers

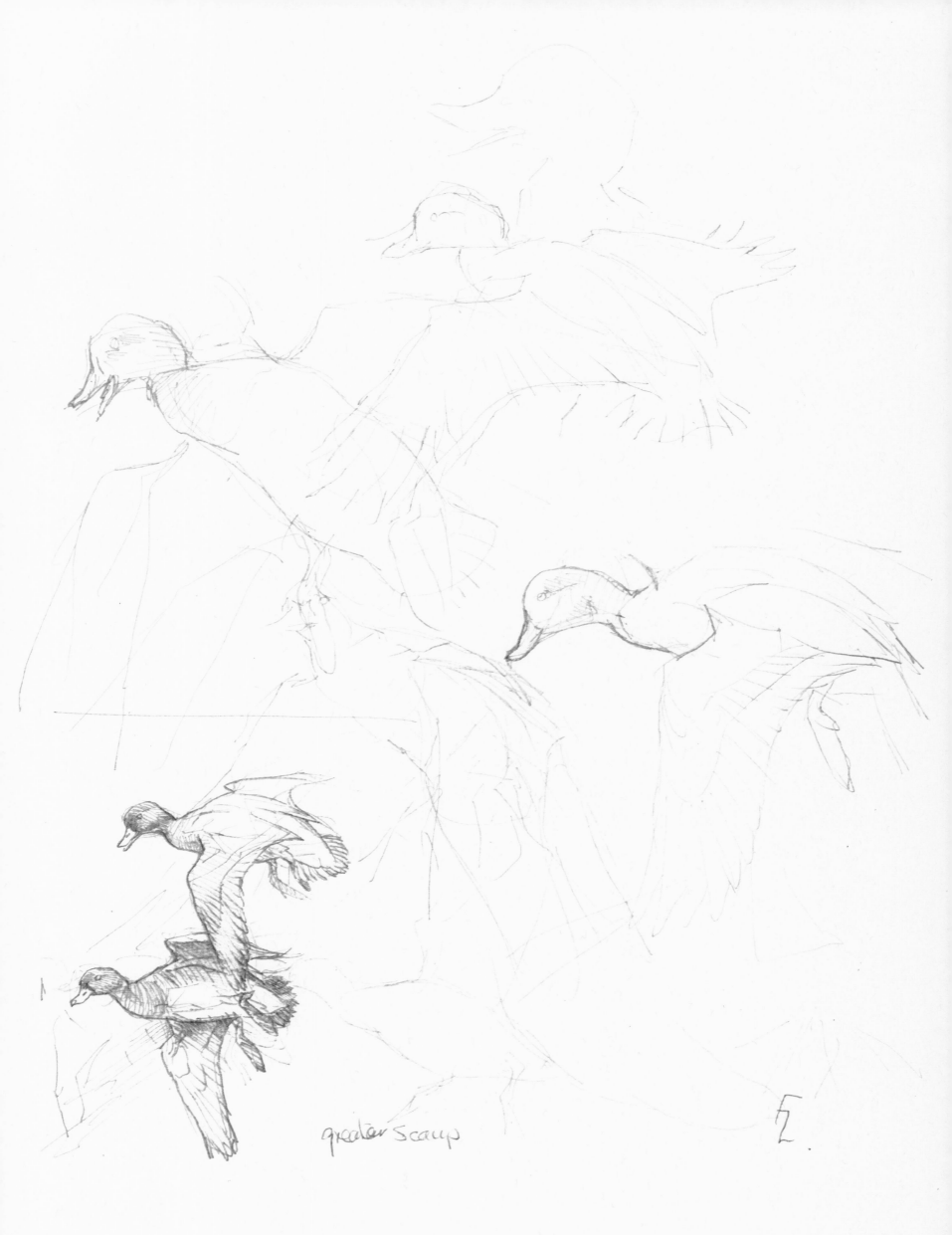

greater Scaup

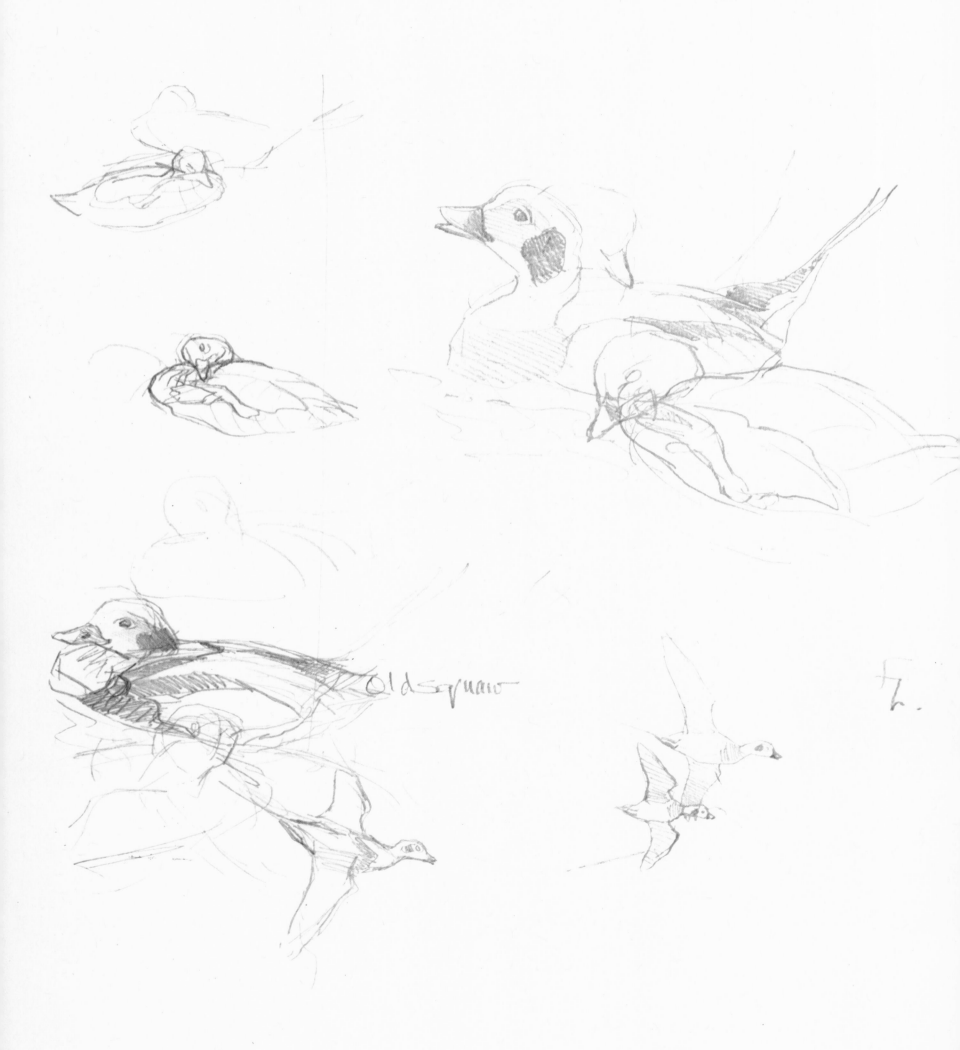

Oldsquaw

white-winged scoter.

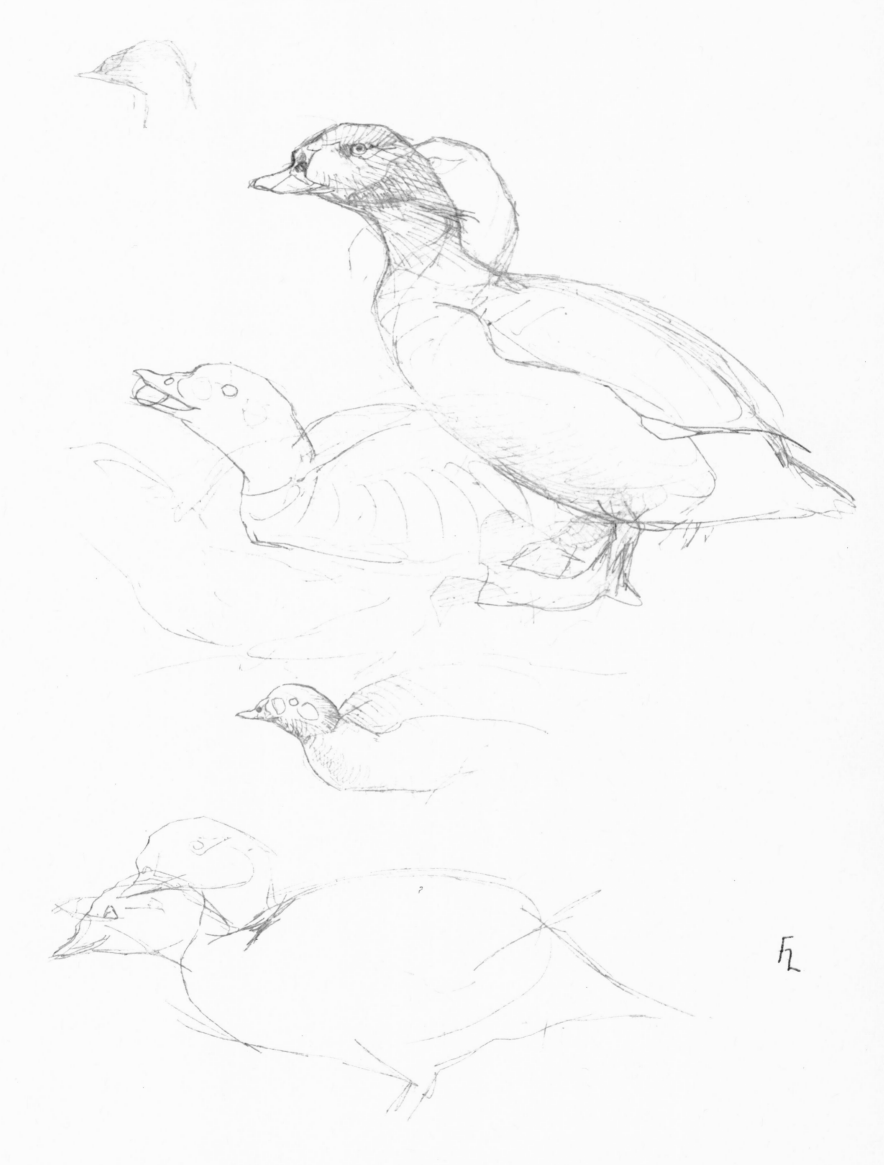

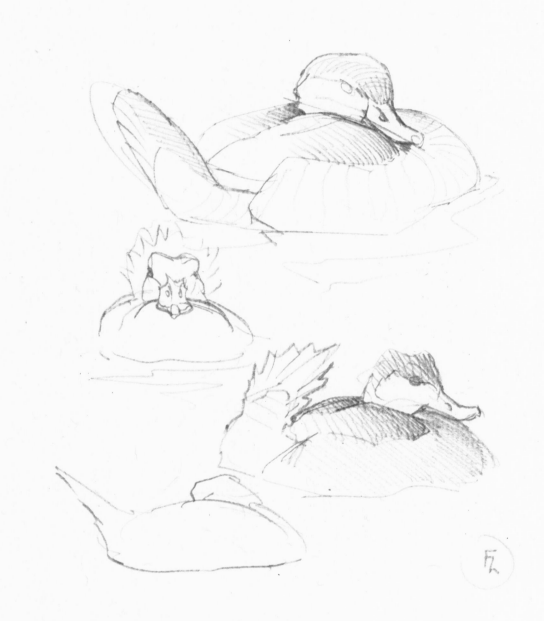

Ruddy·duck

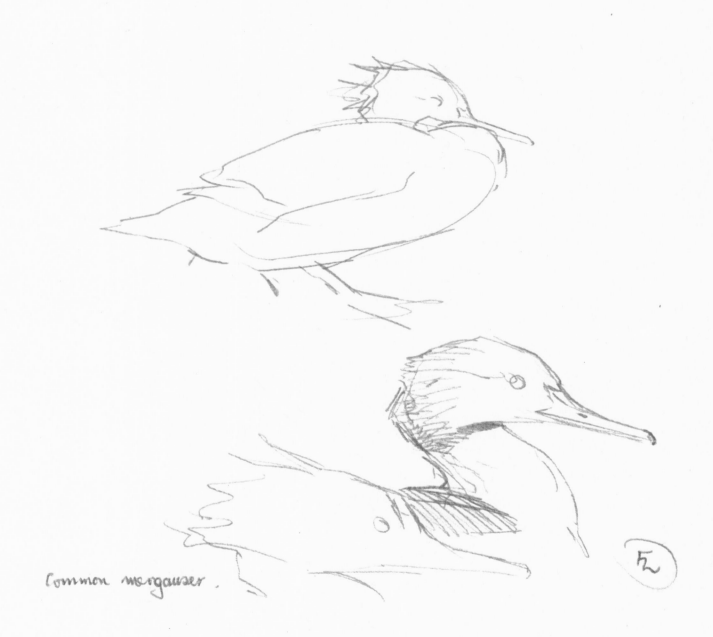

common merganser.

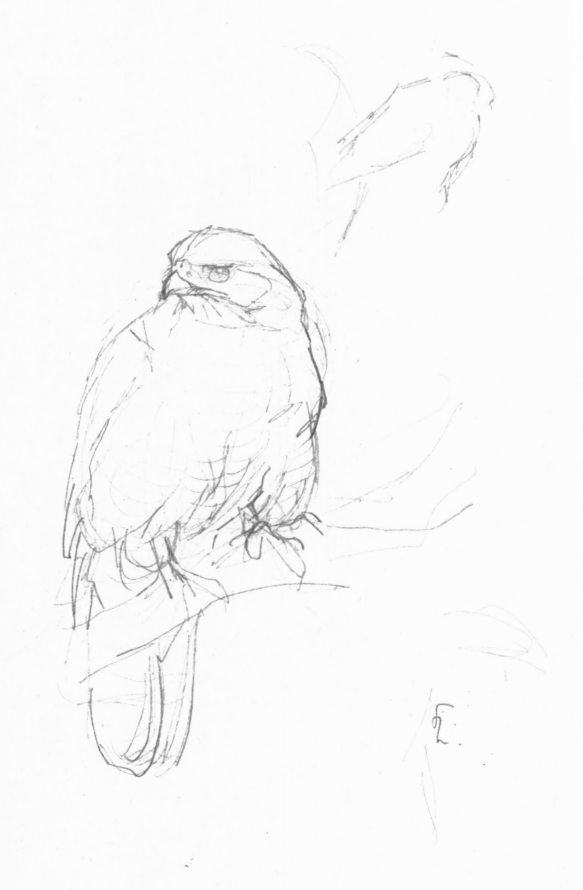

Red-shouldered hawk

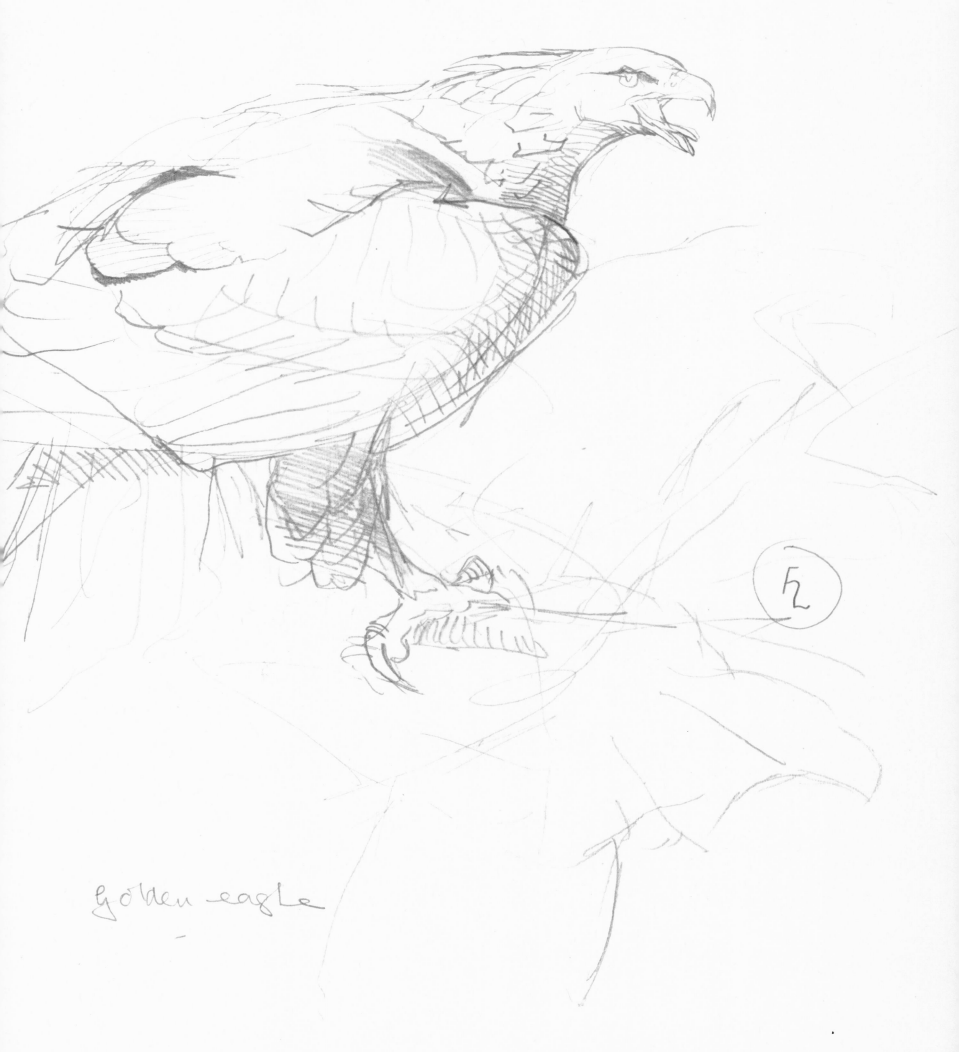

golden eagle

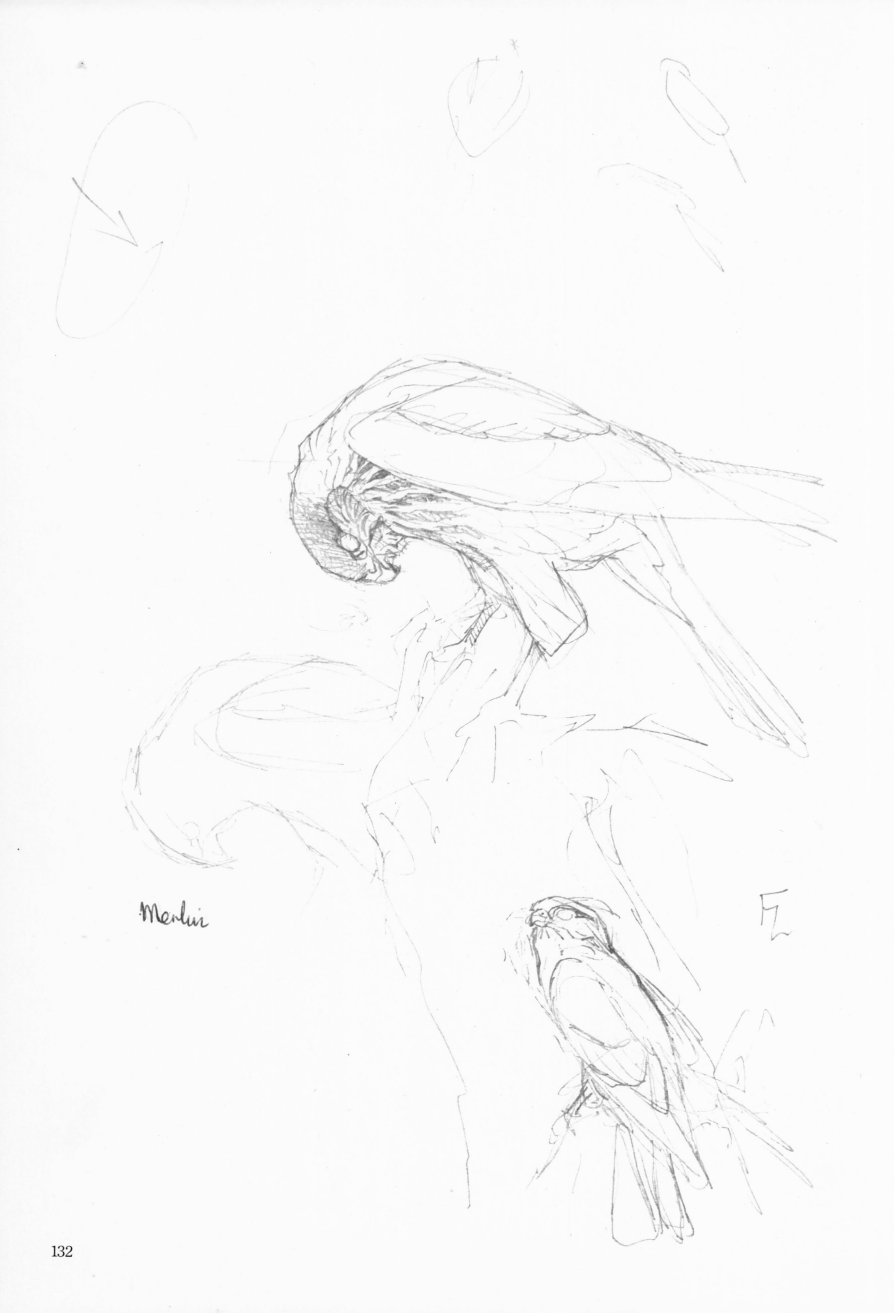

Merlin

FL

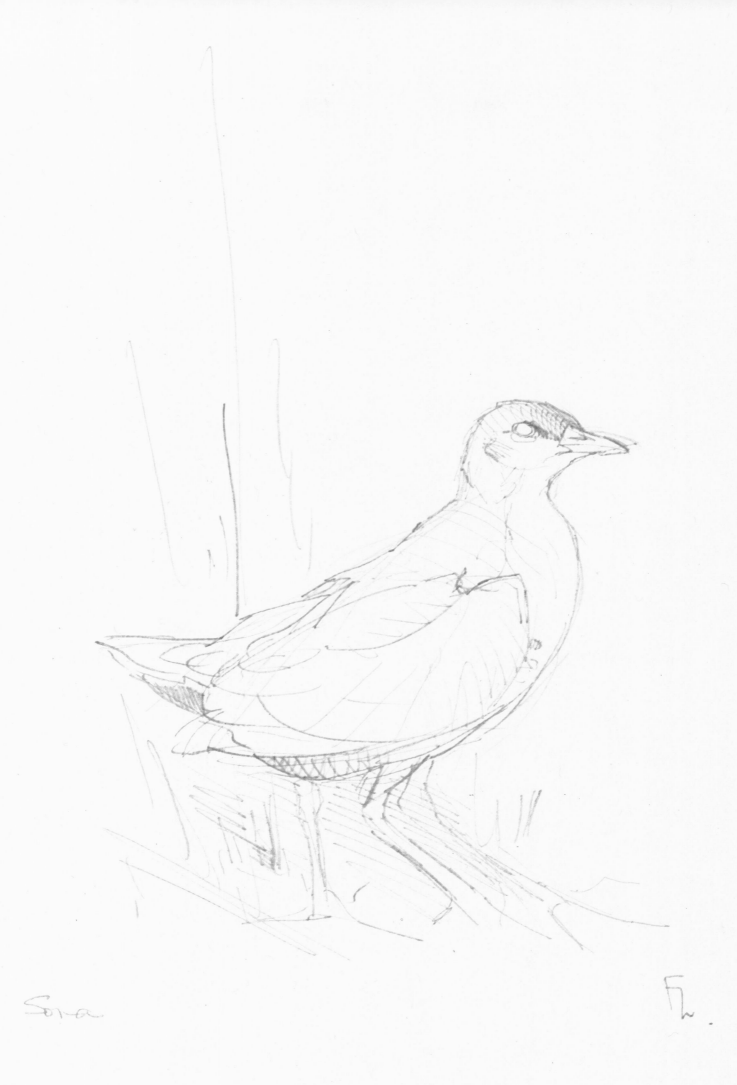

Sora

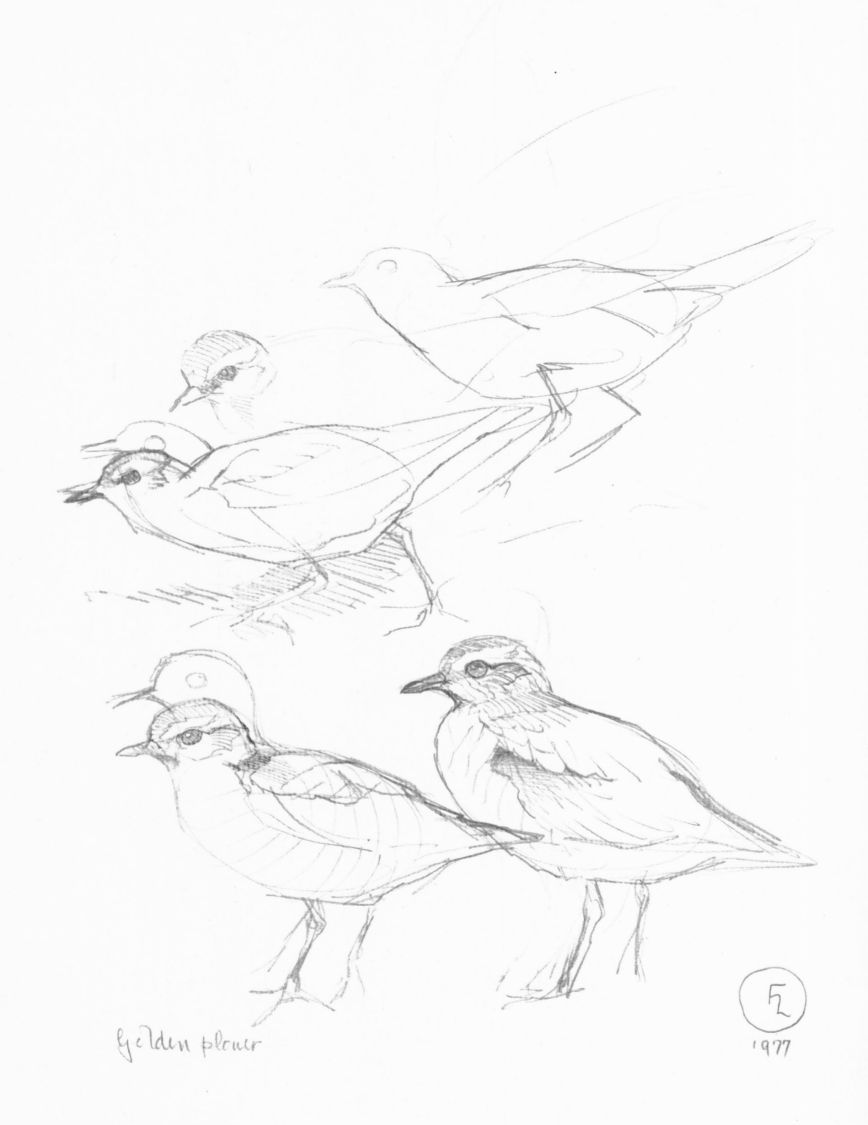

Golden plover

1977

134

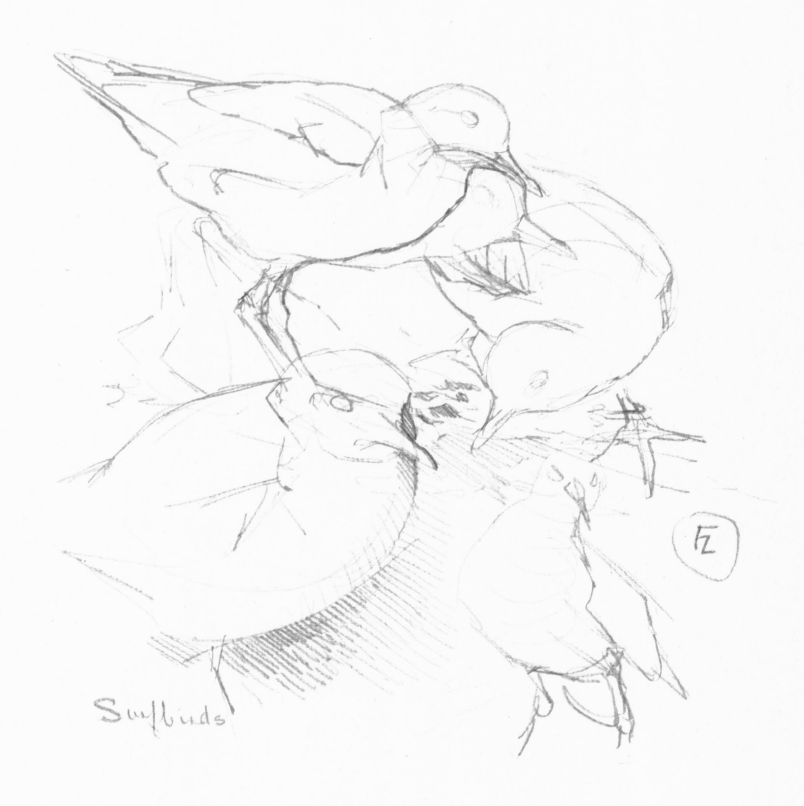

Surfbirds

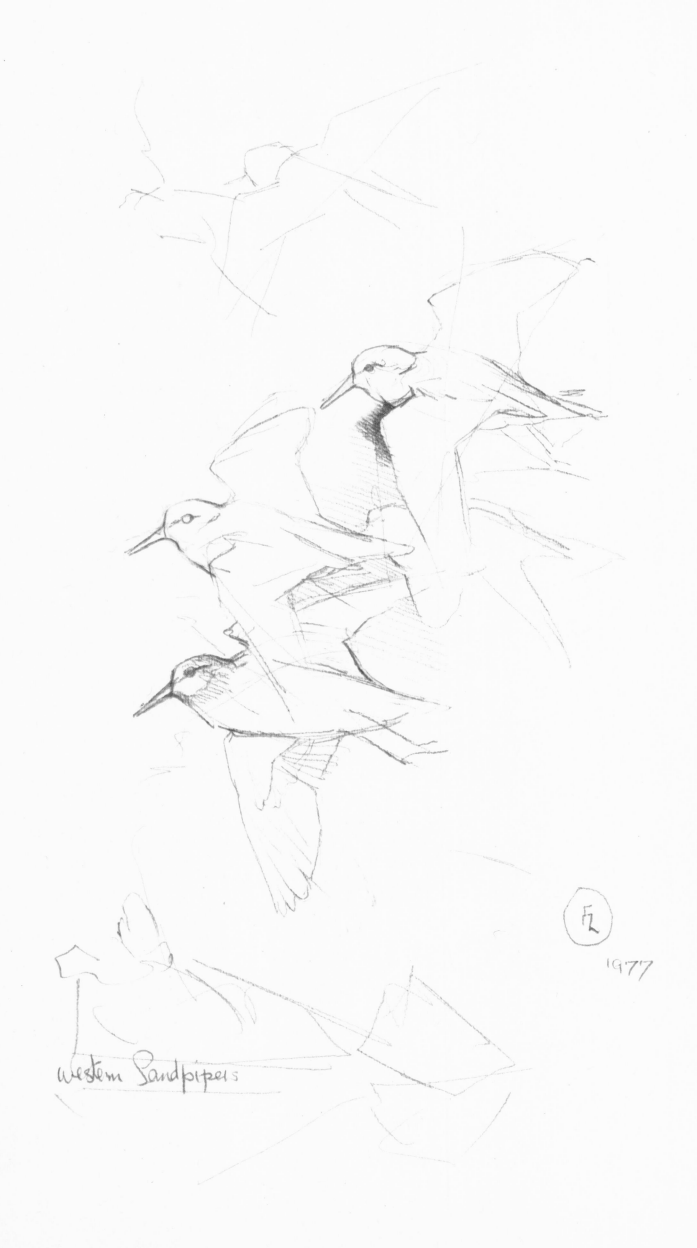

western Sandpipers

1977

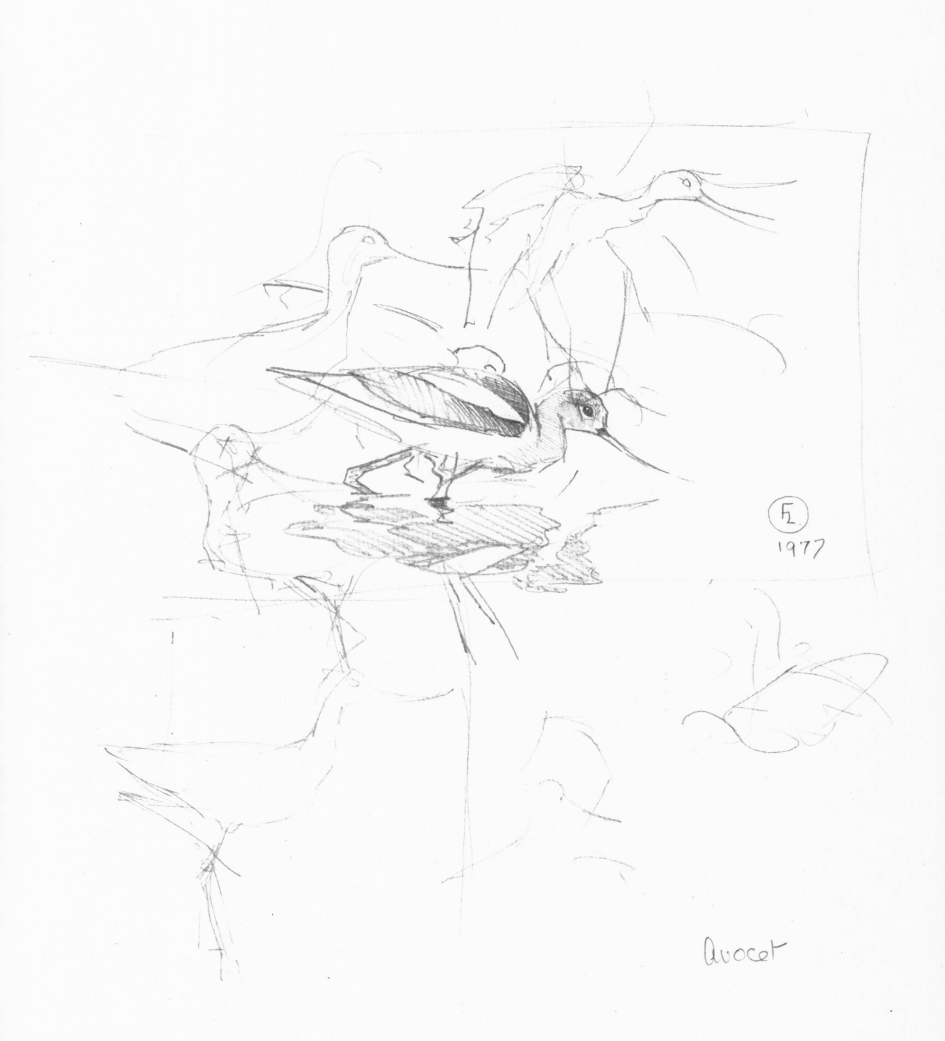

Avocet

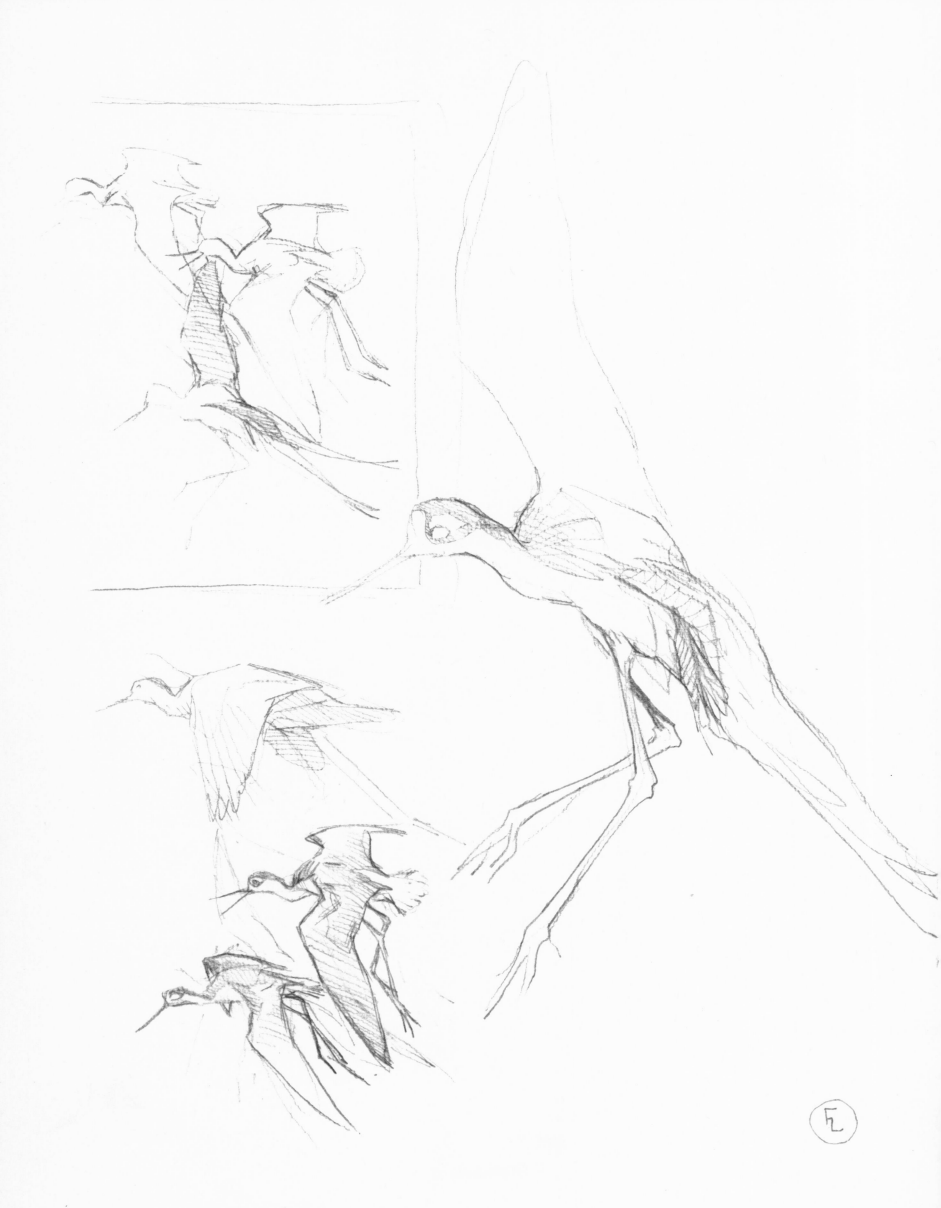

Black-necked stilts.

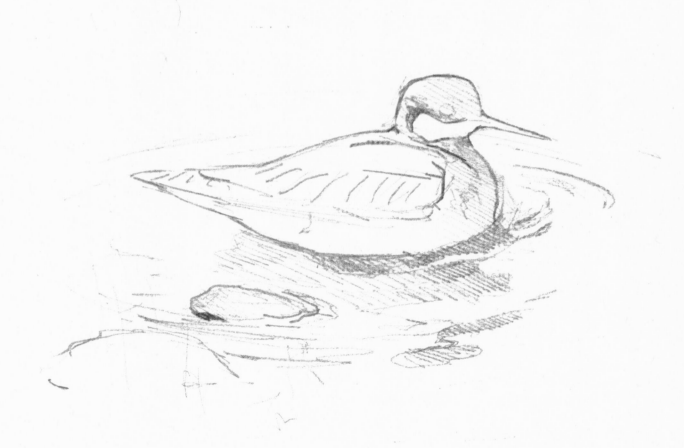

Northern Phalarope

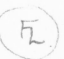

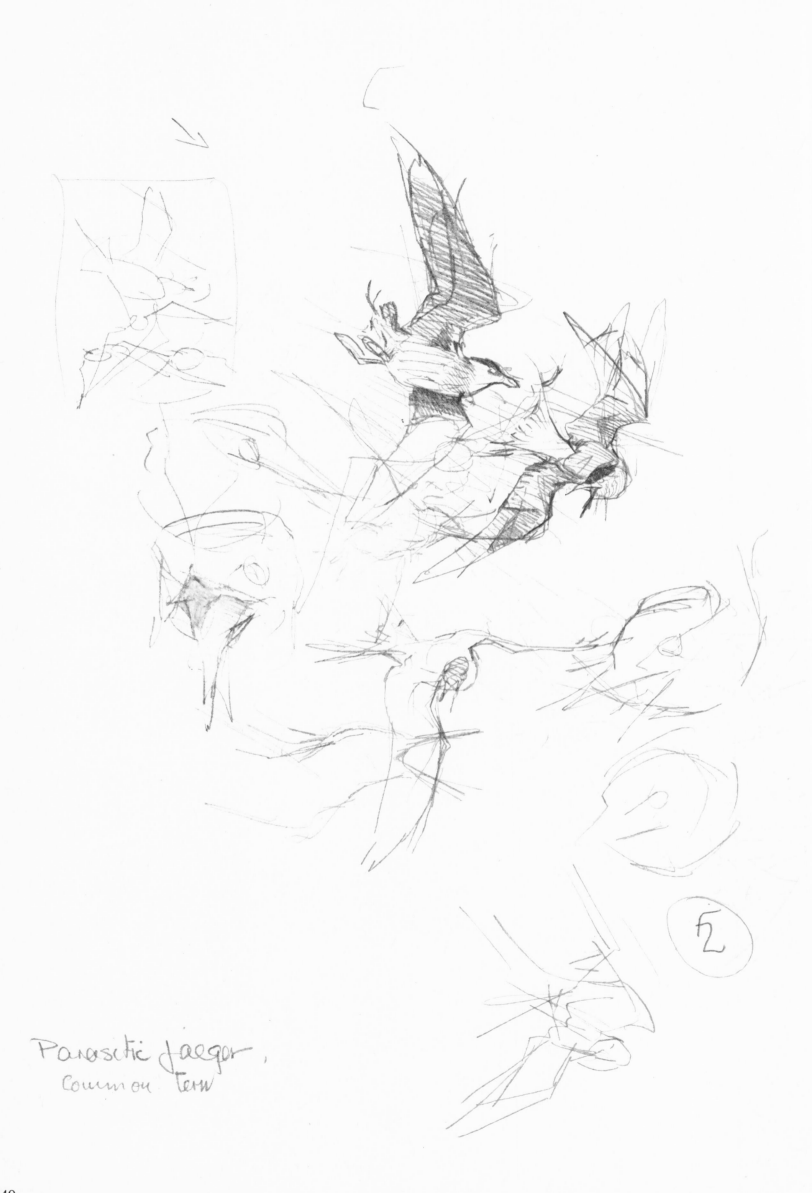

Parasitic Jaeger,
Common Tern

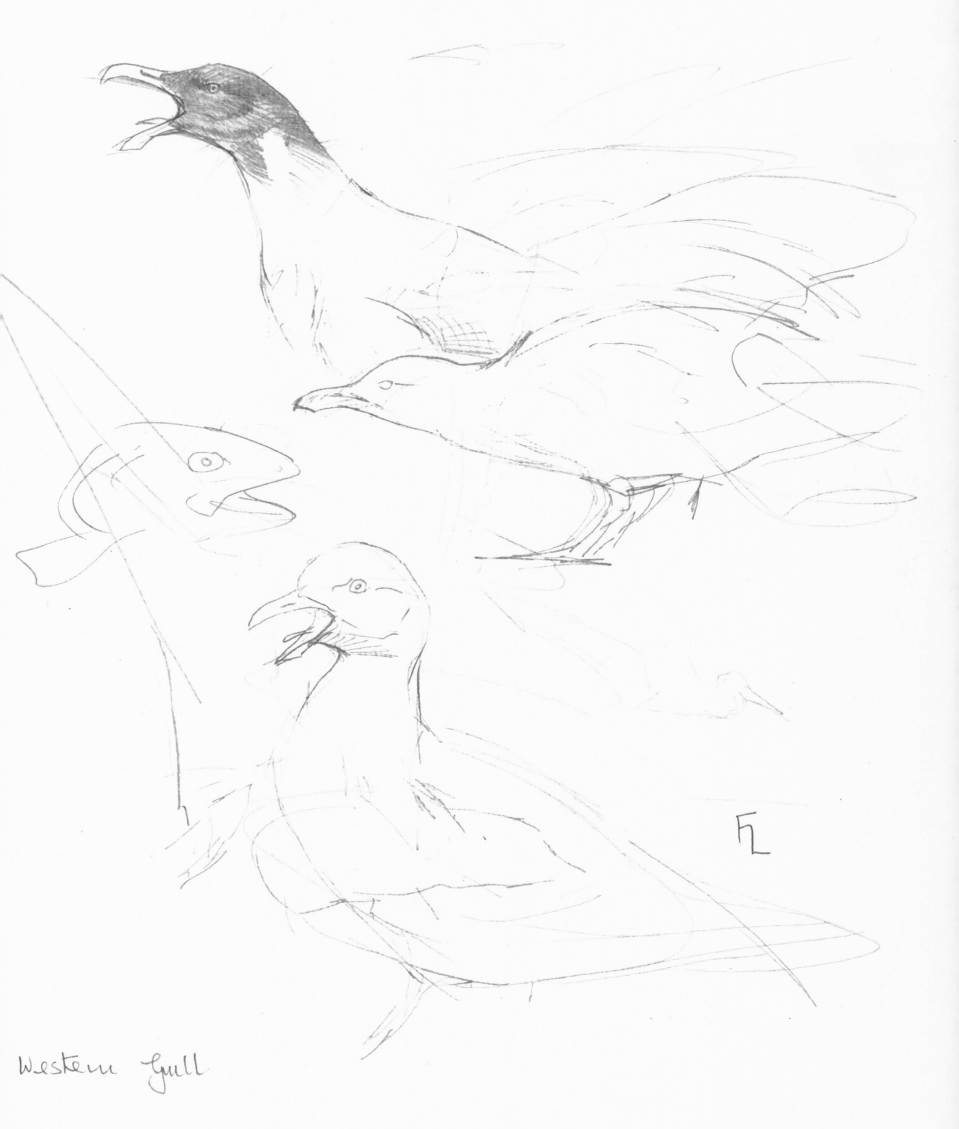

Western Gull

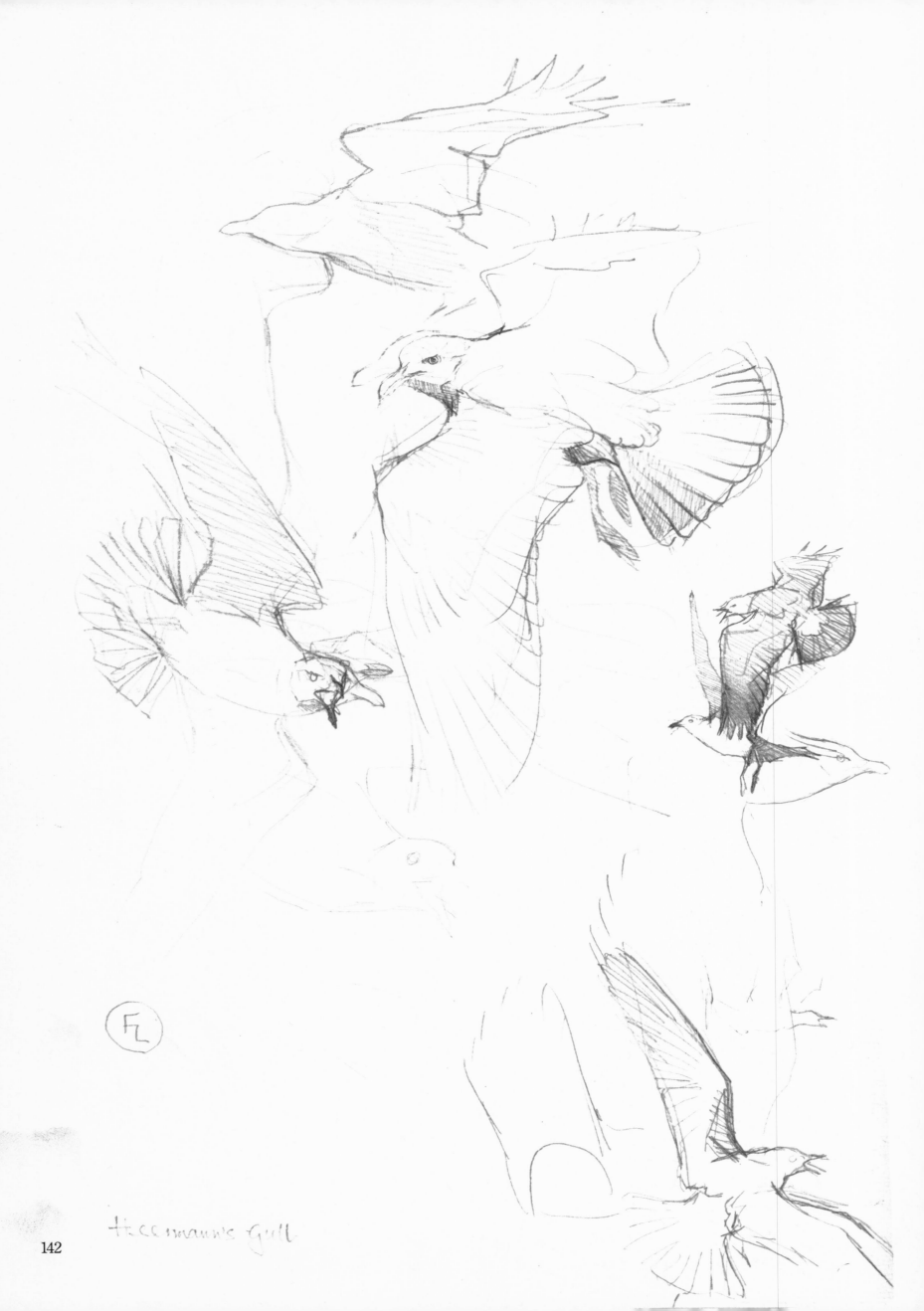

Heermann's Gull

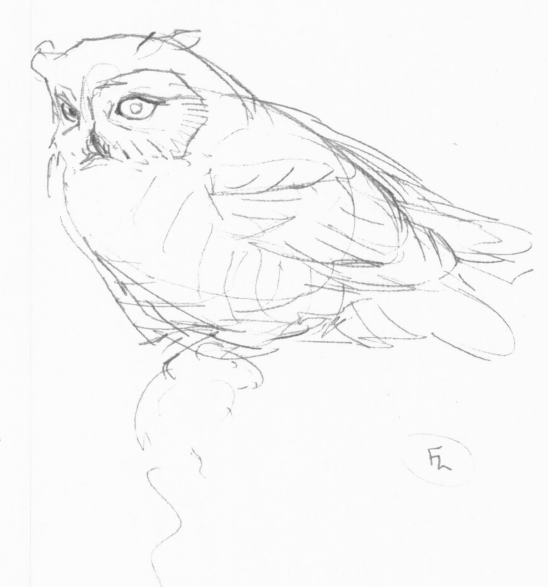

Screech owl

143

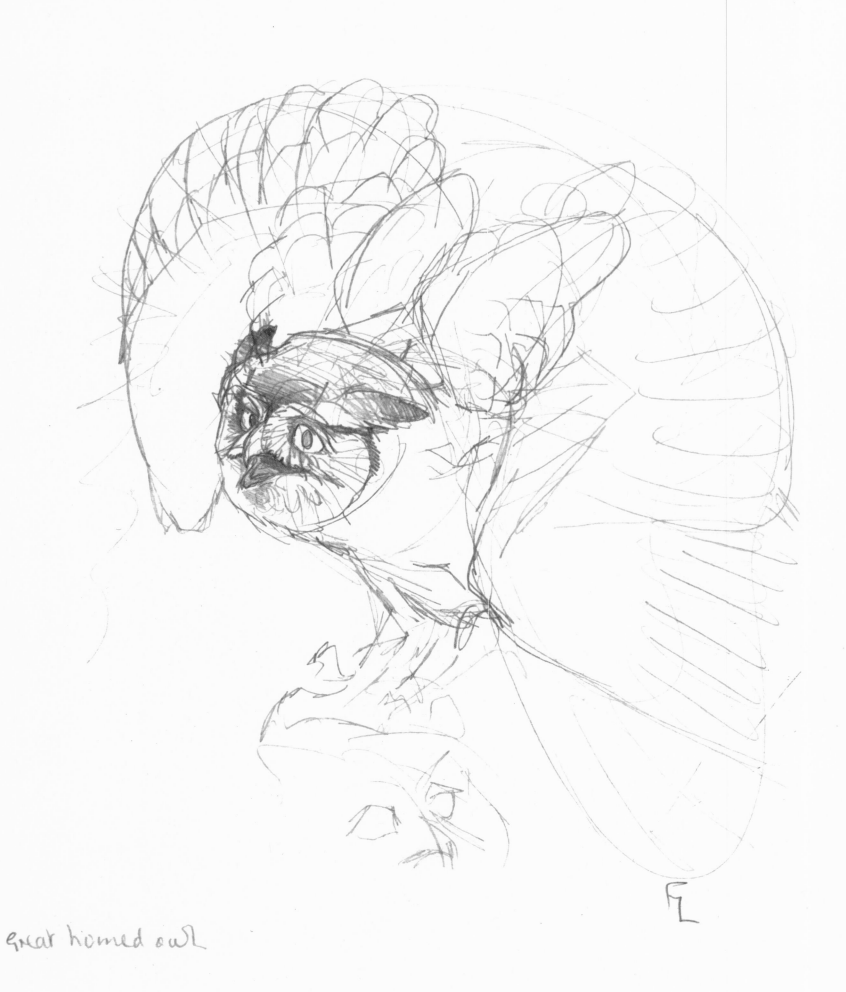

great horned owl

Anna's hummingbird –

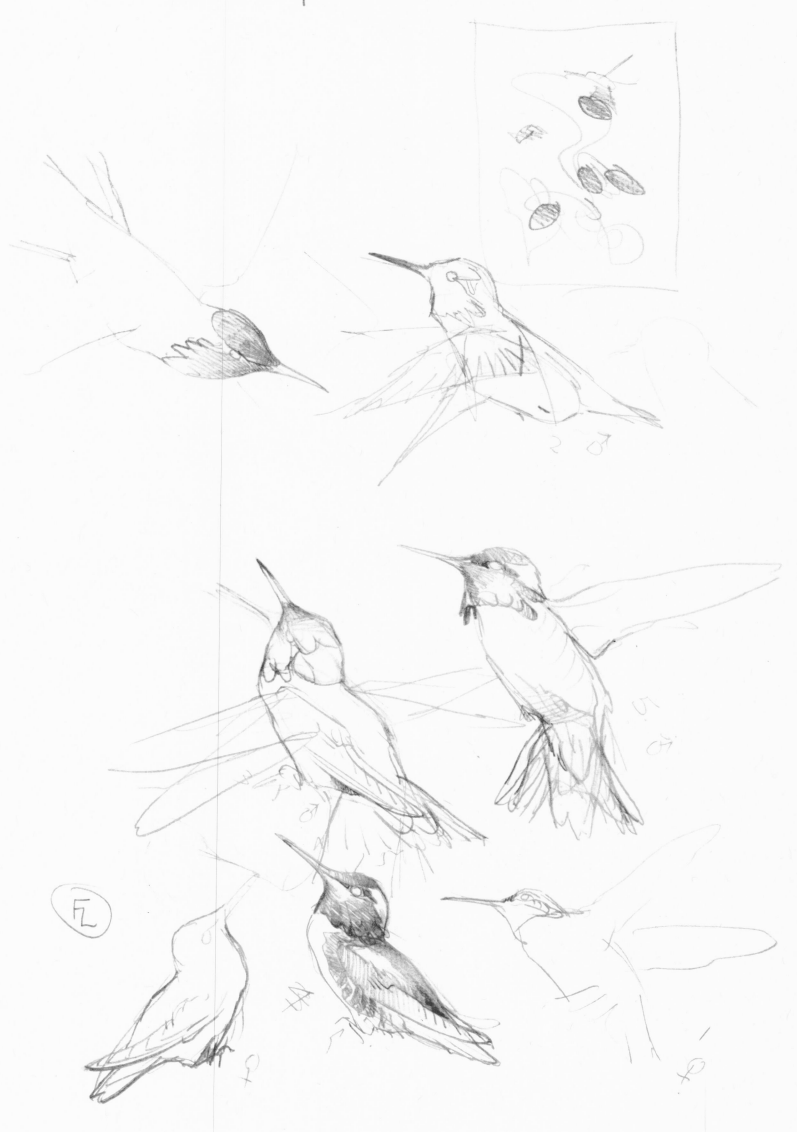

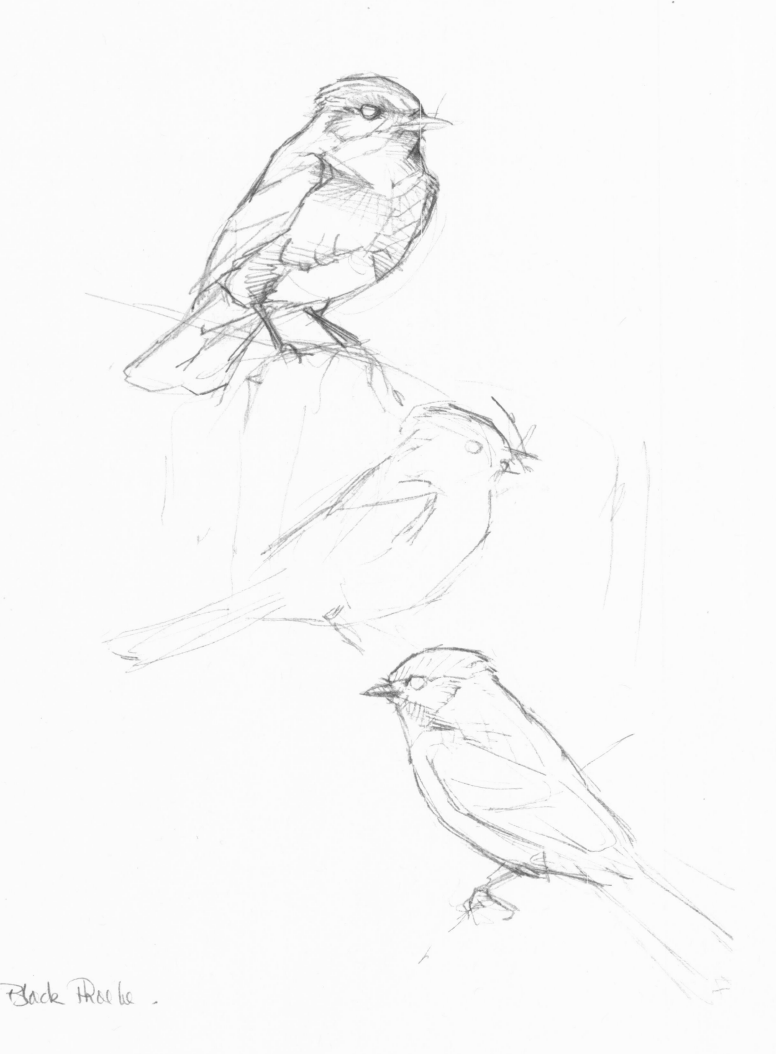

Black Phoebe.

scrub jay

Crow

Bushtit

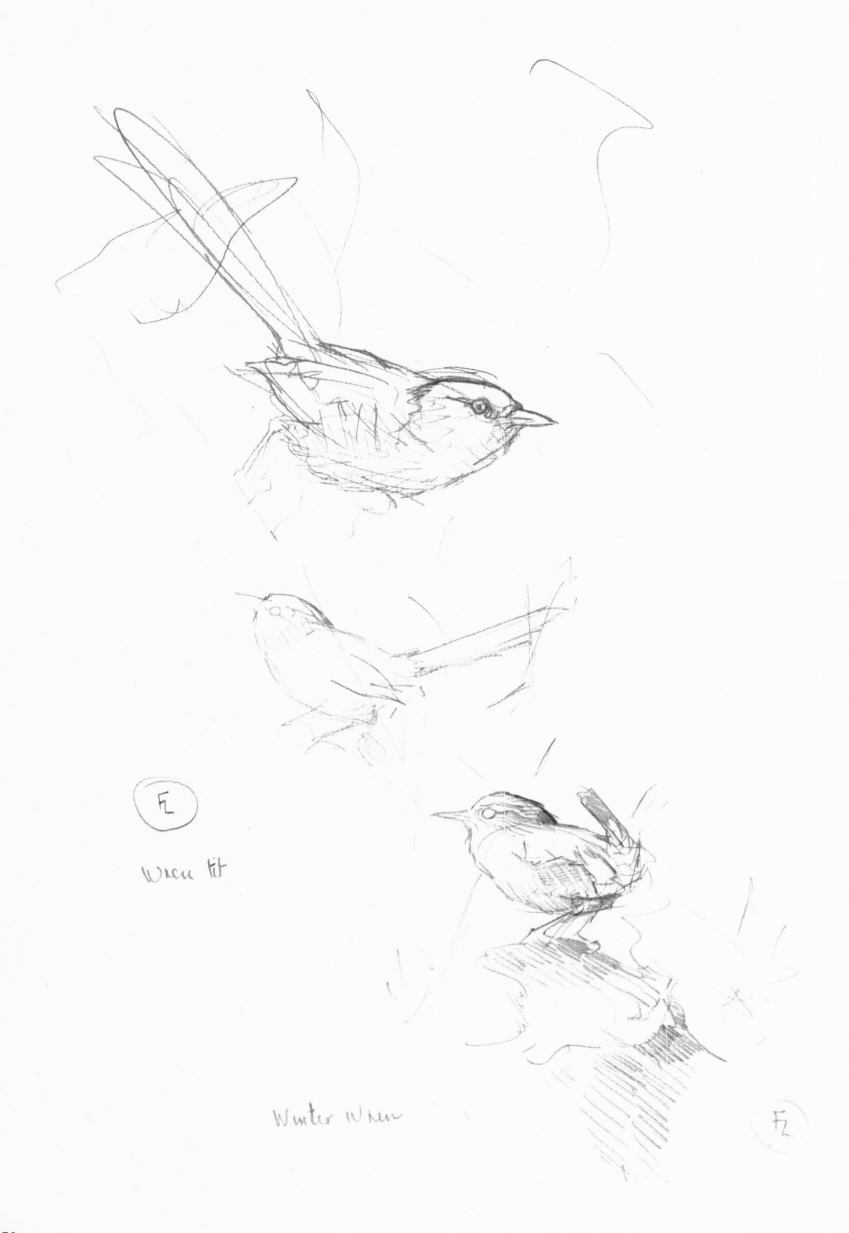

Wren Tit

Winter Wren

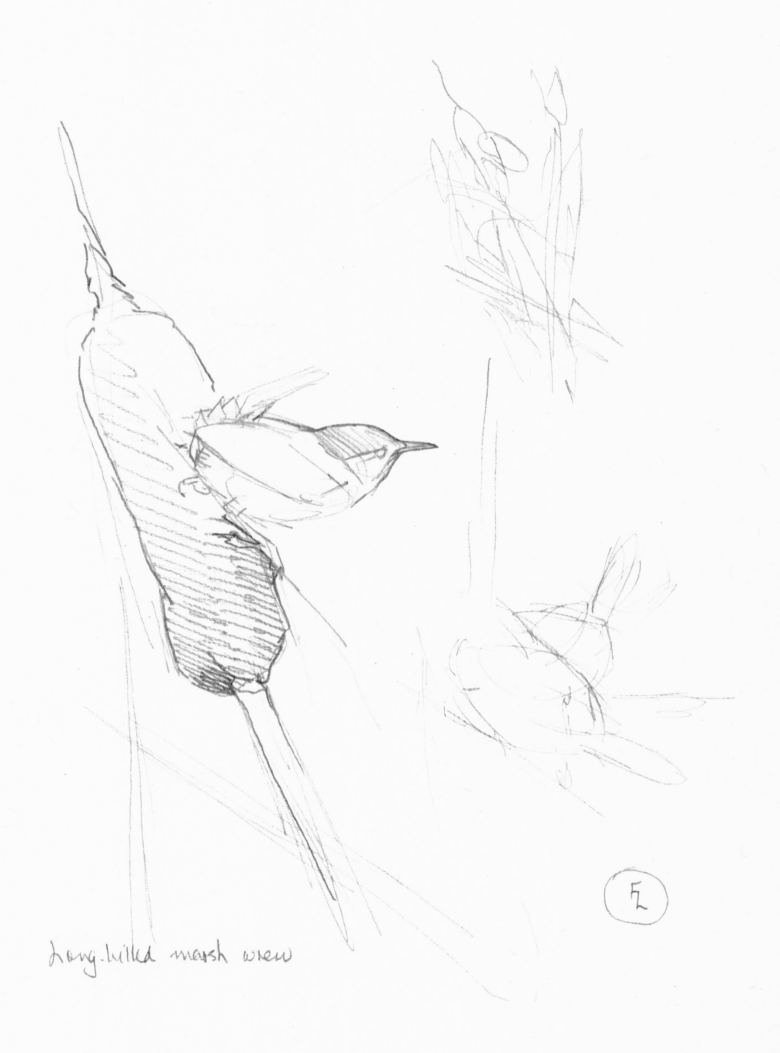

Long-billed marsh wren

Western Bluebird

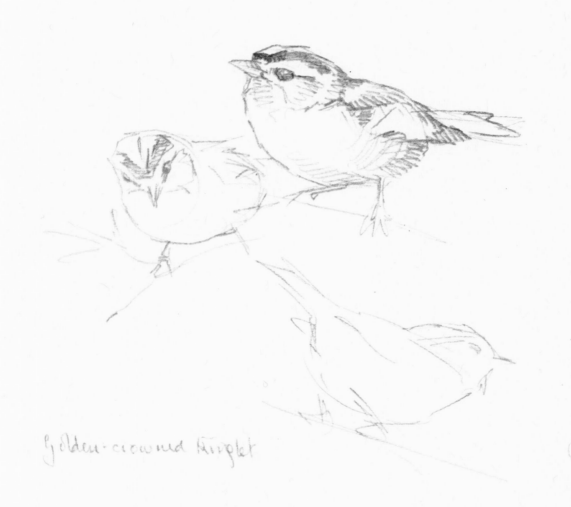

Golden-crowned Kinglet

F_2

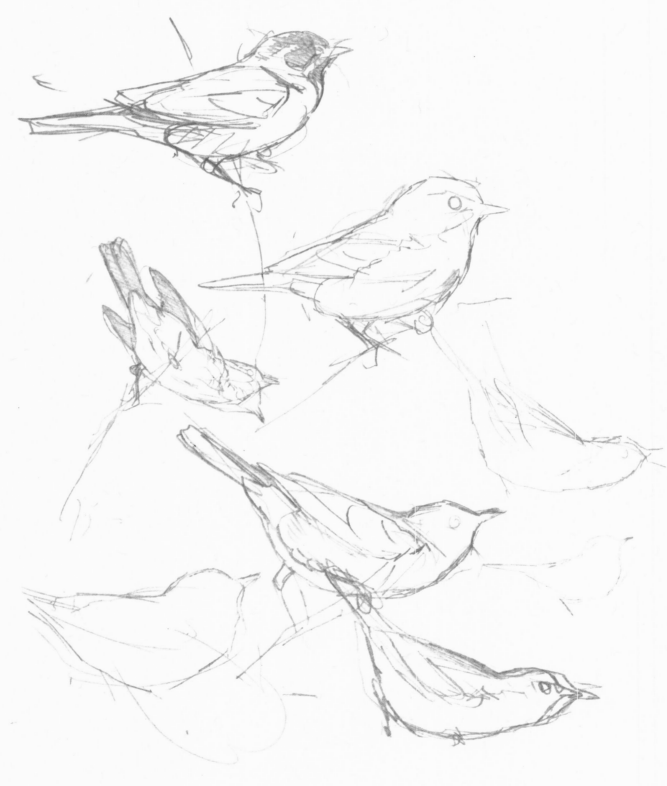

Black-throated gray warbler

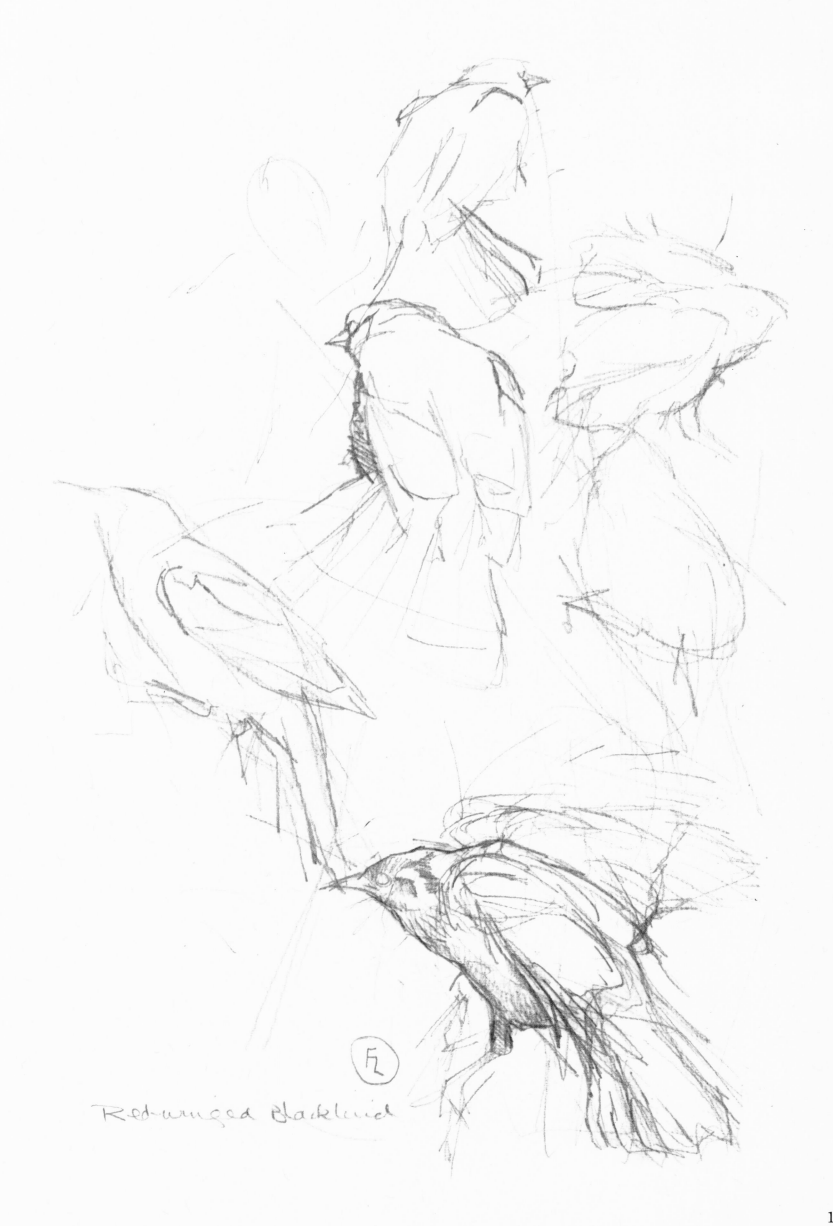

Red-winged Blackbird

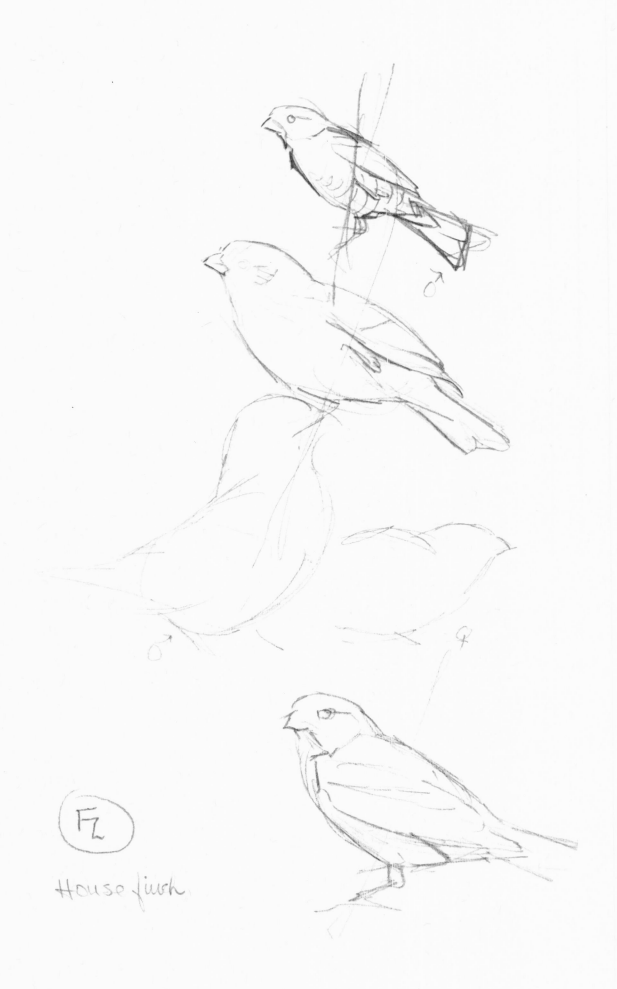

House finch

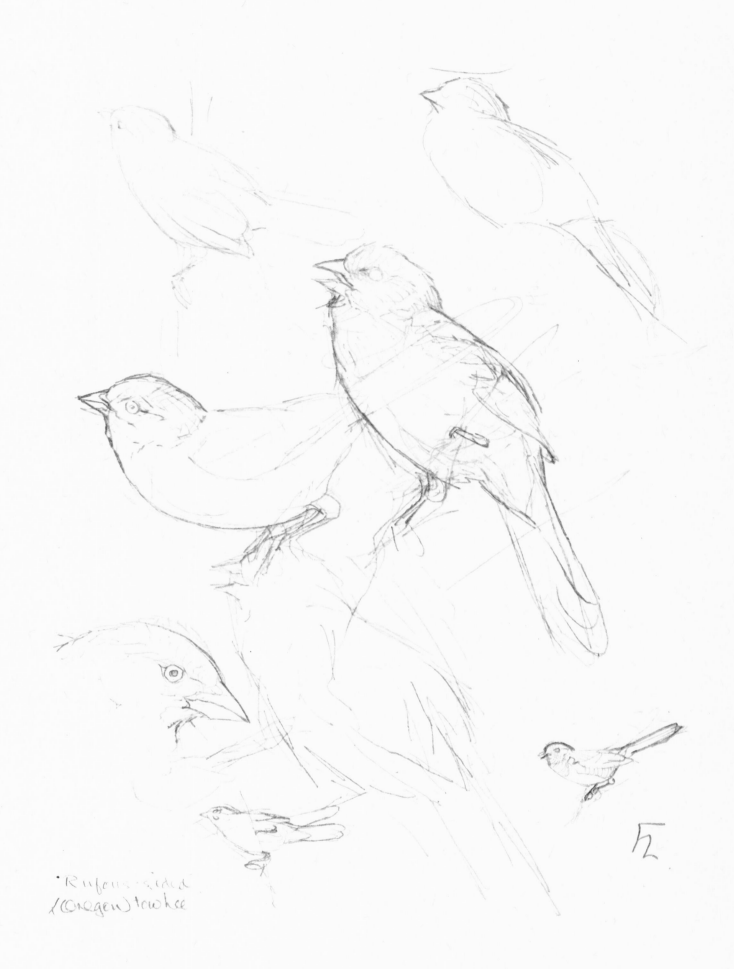

*Rufous-sided
(Oregon) towhee

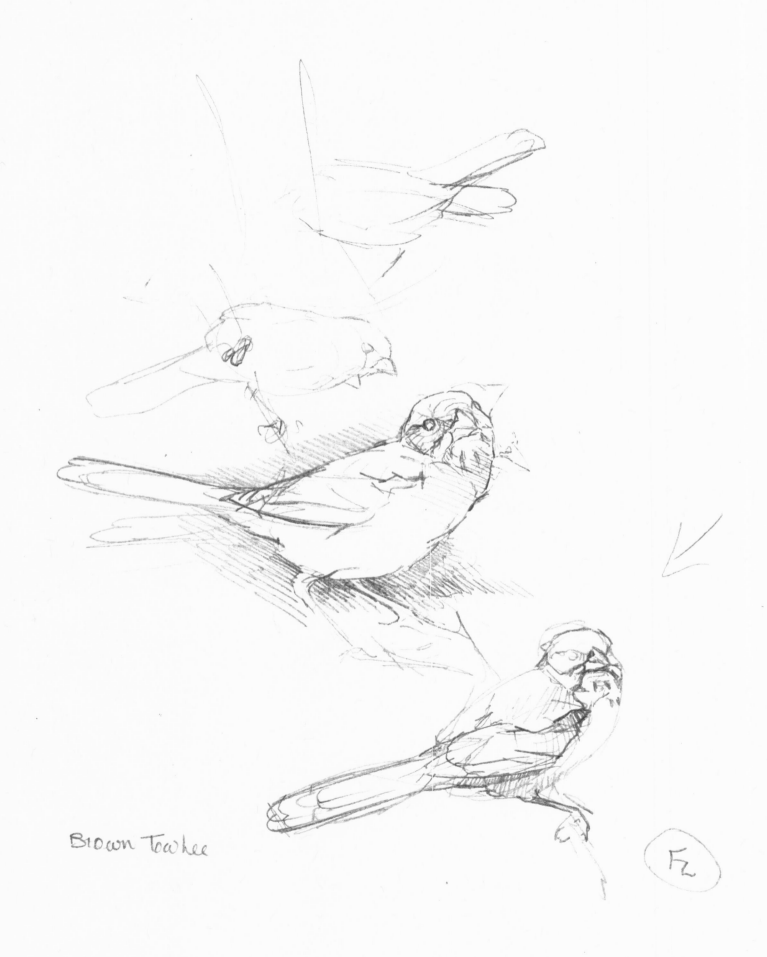

Brown Towhee

F↙

FL

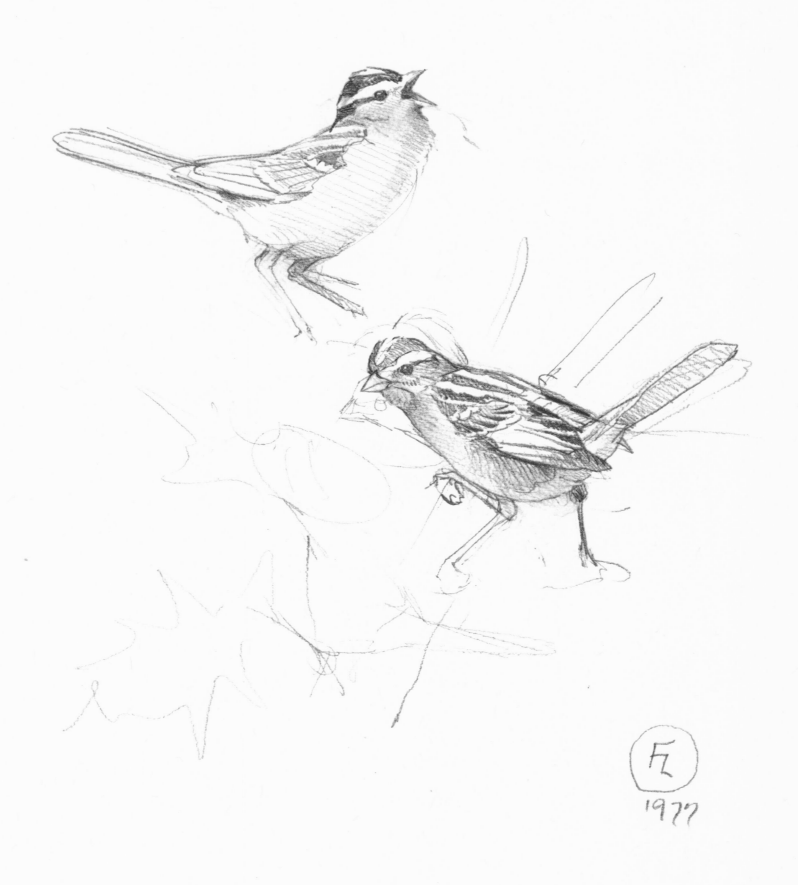

white - crowned sparrow

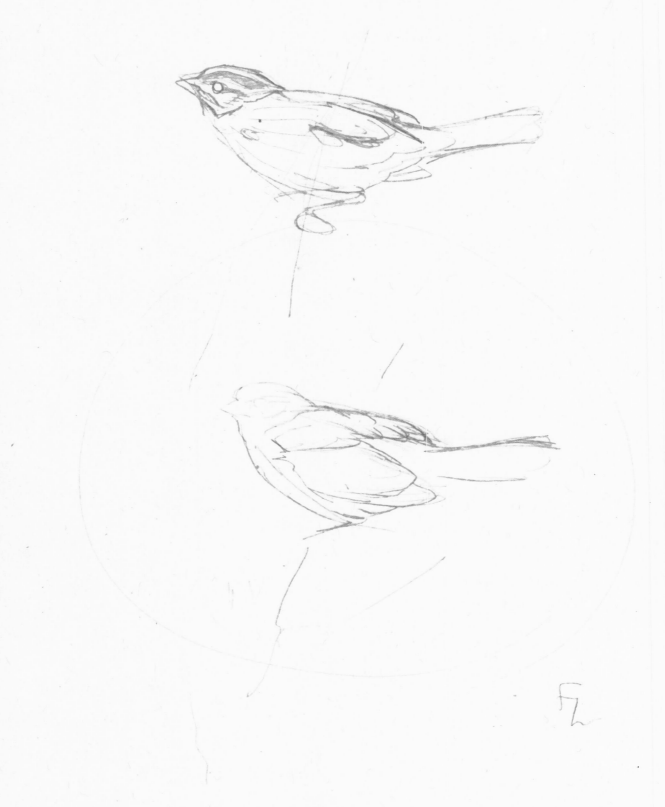

Song sparrow

List of Drawings

Bibliography and Index

Bibliography

AMERICAN ORNITHOLOGISTS' UNION. *Check-list of North American Birds*
(5th edition). Baltimore: A.O.U., 1957.

AUDUBON, JOHN JAMES. *Ornithological Biographies.* Edinburgh: A. Black,
Philadelphia: J. Dobson, 1837-1849.

BENT, ARTHUR C. *Life Histories of North American Birds* (20 volumes).
Washington: United States National Museum, 1919-1958.

DAWSON, WILLIAM L. *The Birds of California.* San Diego:
South Moulton Co., 1923.

DELACOUR, JEAN. *The Waterfowl of the World.* London: Country Life Ltd., 1964.

FORBUSH, E. H. and MAY, JOHN B. *A Natural History of the Birds of Eastern
and Central North America.* Boston: Houghton Mifflin Company, 1939.

GODFREY, W. EARL. *The Birds of Canada.* Ottawa: National Museum
of Canada, 1966.

GREENEWALT, CRAWFORD H. *Hummingbirds.* Garden City, N.Y.:
Doubleday & Co. Inc., 1960.

GRISCOM, L. and SPRUNT, A. *The Warblers of North America.*
New York: The Devin-Adair Co., 1957.

KORTRIGHT, F. H. *Ducks, Geese and Swans of North America.*
Washington: American Wildlife Institute, 1942.

LIVINGSTON, J. A. and SINCLAIR, LISTER. *Darwin and the Galapagos.*
Toronto: Canadian Broadcasting Corporation, 1966.

LOCKLEY, R. M. *Ocean Wanderers.* Vancouver: Douglas David and Charles Ltd., 1974.

MUNRO, J. A. and COWAN, IAN McTAGGART. *A Review of the Bird Fauna of
British Columbia.* Victoria, B.C. Provincial Museum,
Special Publication no. 2, 1947.

TAVERNER, P. A. *Birds of Canada.* Ottawa: Canadian Department of
Mines Bulletin no. 72, 1934.

WILSON, ALEXANDER. *Wilson's American Ornithology.*
New York: H. S. Samuels, 1853.

Index

Birds OF THE WEST COAST

Book Design: Earl H. Chow

Editing: James T. Wills, Sylvia L. Danter

Typography by Cooper & Beatty, Limited and
Script lettering by Lettering Designs Limited in Canada

The book was printed and bound in Verona, Italy,
by Arnoldo Mondadori, Officine Grafiche